Collins

Complete Photography Course

Collins
Complete
Photography
Course

JOHN GARRETT & GRAEME HARRIS

First published in 2008 by Collins
an imprint of HarperCollins*Publishers*
77–85 Fulham Palace Road
Hammersmith
London, W6 8JB

The Collins website address is:
www.collins.co.uk

12 11 10 09 08
7 6 5 4 3 2 1

A catalogue record for this book is available from the
British Library.

Editor: Diana Vowles
Designer: Kathryn Gammon

ISBN 978 0 00 727992 0

Colour reproduction by Colourscan, Singapore
Printed and bound in China by RR Donnelley

Contents

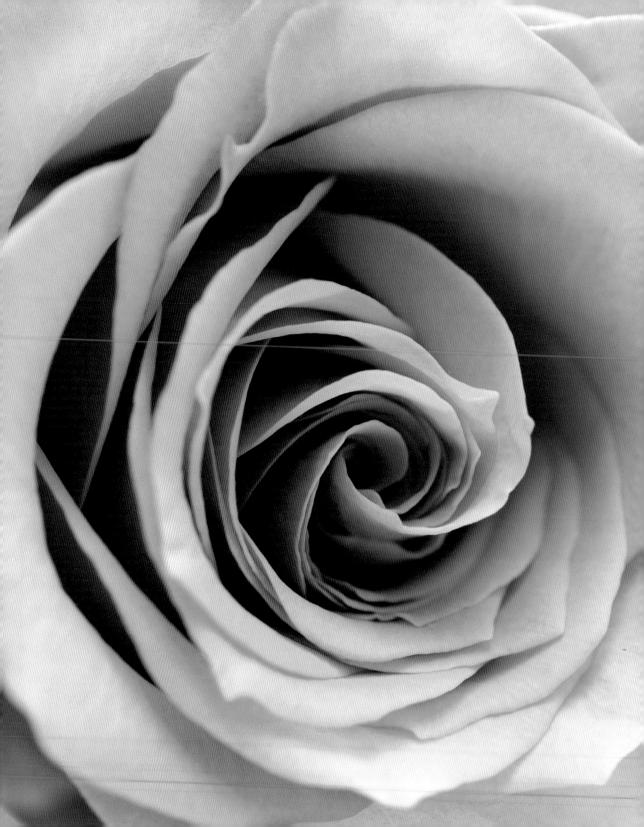

Introduction

This book assumes no previous knowledge of photography, though it is intended not only for beginners but also for those who have some experience and are looking for inspiration to take them on to the next level.

After an initial discussion of the equipment you are most likely to have or to acquire, the book is divided into lessons. Each includes a series of projects which are progressive, leading you from the most elementary information right through to more complicated assignments.

Your camera can be film or digital – the images in this book have been shot on both types of camera and the information is equally valid for both systems. However, it largely applies to SLR or DSLR cameras, as that is what a large number of people use for their photography today.

The thrust of the book is very definitely a creative one; it is not a techy book aimed at those photographers who like spending their time swapping the names of the newest camera models or attempting to obtain batteries from the same batch to ensure success.

Rather, it is written for people who would love to improve their photography without getting bogged down in page after page of technical information – stuff we don't believe is necessary, and which in fact often gets in the way, since worrying about it can act as a brake on your creativity and imagination. It is also designed to be a companion to students doing a formal photographic course.

Too much information

In retrospect, we both realize that we had trouble learning from the textbooks that we read when we studied photography at college. They were too dry and too heavily weighted towards technical information. Even today's textbooks, although more accessible, can still leave a beginner in a state of confusion.

We became aware that we could have saved ourselves considerable time and frustration in our earlier years if we had had access to a book that would lead us through progressive steps without bogging us down in reams of technical jargon, from which vital information had to be painstakingly extracted. With this in mind, we have distilled what we feel to be the most important basic steps for improving your photography quickly.

The learning process

This book aims to teach you the techniques that experience has shown us are the essence of photography, stressing that any technical decision is also a creative one.

The purpose of the projects is to cement the information in your mind by asking you to have a go for yourself. Our aim is that you will shoot examples that are based on the projects, using our pictures as a visual guide. Throughout, we are on your side, encouraging you to find the creative muse that lives inside us all.

You will contribute a great deal to the learning process if you complete the projects, as you can discover far more about photography by doing it rather than just reading about it. So pick up your camera, set out with confidence and a keen eye for an image and you will find that your photography really begins to take off.

In this close-up picture of a rose, the structure of the centre petals has a similar look to the diaphragm blades of the iris in a lens – irresistible for a photographer. GH

The story of photography

The history of photography, in terms of the understanding that light passing through an aperture can create an image, is a long one. However, it is only in relatively recent decades that photography has become so ubiquitous.

It was the Greek philosopher Aristotle (384–322 BC) who first noticed the phenomenon that light rays converge to pass through small holes and, on striking a surface behind them, produce an inverted image. However, it was not until the 16th century that the camera obscura came into use. This consisted of little more than a darkened room with a hole in one wall so that an image of the outside view was projected on the wall opposite the hole. The pinhole cameras that are still used today by a growing band of adherents are in fact a miniaturized camera obscura.

Who succeeded in making the first photograph is still argued over. In France, Joseph Nicéphore Niépce and Louis Daguerre collaborated in experiments in photography, but it was only in 1839, after the death of Niépce, that Daguerre published his technique. Around the same time, in England, William Fox-Talbot invented the first negative/positive process.

It was then possible to make any number of prints from one negative – basically the same process that we use today.

Photography took off with an enthusiasm in the Victorian era that is hard to imagine today. By 1853 New York alone had 80 professional studios, while London and Paris had similar numbers. Outside the studio environment, the effort that was required in those early days when photographers set out to record our world would seem extraordinary to us today, when we can just throw our cameras over our shoulders or slip them in our pockets.

The early travelling photographers needed a horse and cart to carry the very large and heavy glass plates and light-sensitive emulsion used to coat them in a lightproof tent, plus the tripod and heavy wooden cameras. Some of those photographers, the equivalent of the photojournalists of today, carried 45 kg (100lb) of gear in backpacks up mountains and into war

To combine the ancient pinhole camera with the latest digital technology, I drilled a hole in a camera body cap (black card would have sufficed). I then made a pinhole in a piece of kitchen foil and taped it over the hole in the cap. The image of the garden table and chairs were just visible in the viewfinder. I used a high ISO speed on the camera to keep the exposure time short. This was a very simple pinhole, but a very sophisticated pinhole camera. GH

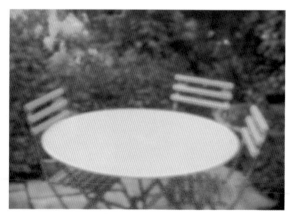

zones. Men such as Mathew Brady, who recorded the American Civil War, were tough and talented people.

Although this technology seems very crude and clumsy compared to the DSLR photography of today, our forefathers produced a great archive of pictures of beauty and extraordinary technical quality. The glass plates and, later, 10 x 8 inch film negatives were capable of recording exquisite detail and tone, but by its very complicated, expensive, bulky and time-consuming nature photography remained something largely beyond the reach of the general public.

The revolution that gave photography to the masses was in 1888, when George Eastman, through his Kodak company, marketed a camera loaded with film to take 100 pictures. When all were exposed the camera was sent back to Kodak for processing and printing. Kodak's slogan 'You take the pictures and we do the rest' was a sensational success. Once colour negative film was invented, the photographic world was transformed and people set about documenting their everyday lives, recording holidays, parties and portraits.

The most recent technological leap has of course been digital photography, which has democratized the medium still further by making it both easier and cheaper. Nonetheless, no matter how far photography evolves, the same principles will apply – it is the confluence of light, a lens and a creative mind that will bring about great images.

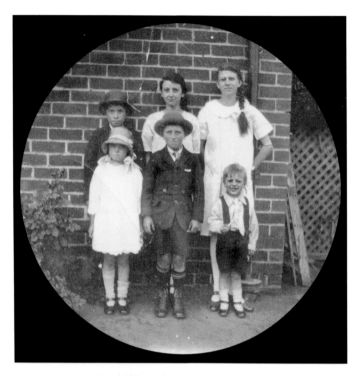

A family portrait from the original Kodak 'you take the pictures and we do the rest' period of mass enthusiasm for photography. Unlike today's rectangular framing, the pictures were the full circle produced by the lens.

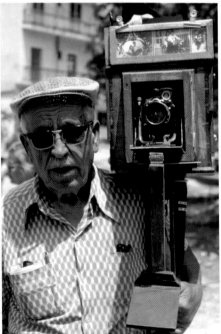

Now everybody takes a camera on holiday, but as recently as 25 years ago this gentleman would set up his great wooden plate camera in front of all the great historic sites in Paris. Tourists would pose for photographs they could take home to remind them of their travels.

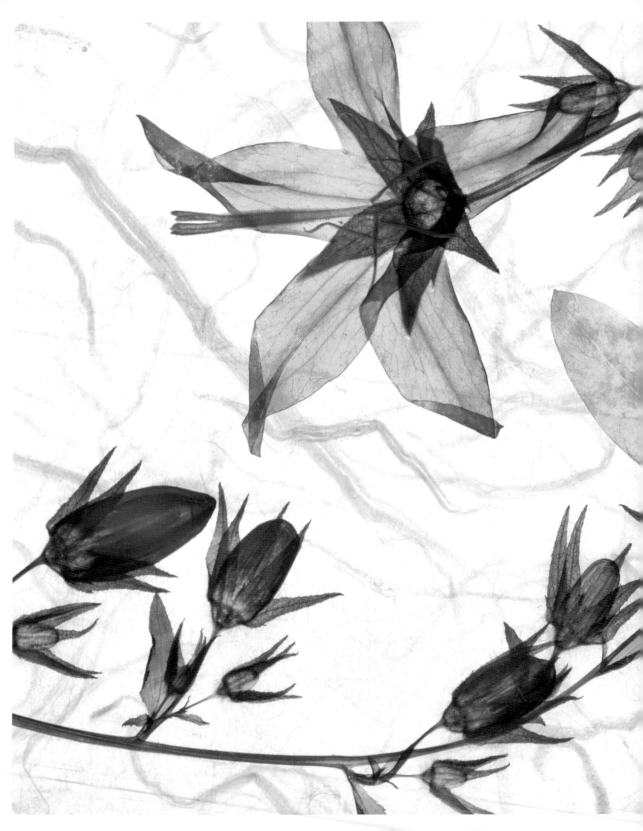

You and your
camera

Camera types

While the following pages are mainly concerned with DSLR cameras, there are many other cameras in use. Although digital technology has galloped ahead of traditional film technology, film is still very much alive and well.

Large-format cameras

Early photographers are associated with peering into giant cameras with black cloths over their heads. However, these cameras are not just of the past – large-format cameras, producing 10 x 8 inch and 5 x 4 inch negatives, were until recently always used for the highest-quality landscape, architectural, food and still life pictures that it was possible to take.

In the commercial world digital cameras have mostly taken over this area, but the large format is increasingly used by art photographers. It's human nature that whenever there is a strong movement forward technologically there will always be a small but determined movement defiantly working with the older technology because it's believed to be more elegant and to give a more aesthetically pleasing result. There are many young art photography students going right back to shooting 10 x 8 inch black and white film in search of the quality of images produced by the old masters of photography such as Edward Weston, Ansel Adams and Minor White and very many more.

Large-format cameras have many camera movements that allow the correction of perspective and the holding of focus from foreground to background on wide apertures. They are the ultimate recorders of tonal values, sharpness and fine detail.

Medium-format cameras

This category of camera includes those producing negatives measuring 6 x 9 cm, 6 x 7 cm, 6 x 6 cm, 6 x 4.5 cm. All use 120 and 220 roll film and the number of frames per film depends upon the format size.

Medium-format cameras have been the professional's workhorses for years and with the digital age they still are, producing the highest-quality digital images possible. Most of the manufacturers make a film camera and a digital equivalent; some, such as Hasselblad, now embrace both film and digital technology in the same cameras, allowing you to attach either a film magazine or a magazine that contains a digital sensor.

Medium-format cameras are more expensive and more difficult to handle than 35mm cameras, but they are very versatile

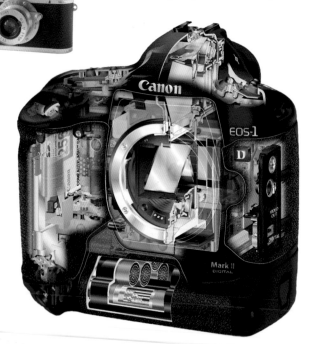

A 1930s 35mm Leica rangefinder camera which incorporated the latest technology of its day and a cut-away of a 21st-century Canon DSLR, showing all its technical complexities.

Seeing the big picture

The double-page photograph on pp.12–13 is of pressed campanula flowers, from a series of images I made of flowers and leaves. I placed a sheet of Japanese paper on top of a lightbox and put the flowers on the paper. The light coming from beneath has passed through them, giving the appearance of an X-ray (see p.121). The textured background behind the flowers comes from the paper. GH

in their use. Most fashion and advertising photography is shot on medium format.

35mm cameras

DSLRs are of course digital versions of the time-honoured 35mm 'miniature' film camera – so-called because when it was developed in the 1920s it was so much smaller, both physically and in the negative size it produced, than the large cameras used at the time. These cameras gave birth to photojournalism and many people still choose to use them rather than DSLRs.

Compact cameras

The film compacts usually called 'point and shoots' have bred the digital compacts. These vary considerably in price according to the quality of the lens and resolution and the sophistication of the controls. The compact camera comes into its own for trekkers, mountaineers and extreme sports fans who are often in spectacularly beautiful places and are keen photographers but can't carry an SLR around with them.

Underwater cameras

These cameras are increasingly in demand as scuba diving becomes more popular. As well as the traditional 35mm film cameras such as the Nikonos (now only available on the secondhand market), there is a large choice of digital underwater cameras available in a range of prices.

Cellphone cameras

The rapid advance of cellphone camera technology has added to the ubiquity of the digital image. The cellphone camera is already beginning to take over from the compact camera as a visual notebook, and it won't be long before they all have zoom lenses and can produce higher-quality prints.

What seems to be the weakness of cellphone cameras is that they are totally automatic and we cannot alter anything. However, this can liberate us from all technical decision-making responsibilities and leave us with just the subject, composition and light to play with.

Remember, most of the great pictures from the past were shot on much less sophisticated cameras than compacts and cellphone cameras. It is still the photographer who takes a great picture, not the camera.

Cellphone camera tips

- Keep the lens clean.
- Shield the lens from the sun when shooting.
- Use the highest-quality setting.
- Fill the frame – don't use digital zoom, since it's poor quality.
- There may be up to half a second shutter delay, so make sure the subject doesn't move.
- Hold the camera very, very still for a sharp picture.

Getting to grips with your DSLR camera

The modern camera is really a computer with a lens attached. Navigating the menu will be familiar to anybody who is used to modern electronic equipment.

It's easy to be daunted by all the clever things your camera can do and just how much information there is in the instruction book about all the various functions. The easiest way to deal with this is to learn on a need-to-know basis. After you've worked out the essentials, tackle the more complex things as you need them.

There are still many photographers, both professional and amateur, who are devoted to film and there will continue to be for a long time. While the emphasis of this chapter is on DSLR cameras, much of the information on aperture, shutter, focus, lenses and so on equally applies to SLR film cameras.

Read the manual

• It cannot be overemphasized how important it is to use your camera manual in conjunction with this book. Every camera model has different controls and methods of accessing its functions, and manufacturers are increasingly using different terms for the same features.

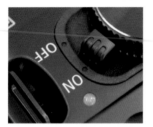

POWER SWITCH The first time you turn your camera on you need to set the language, time and date. Always turn the power off when you are changing lenses, batteries and the memory card.

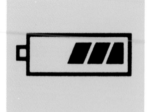

BATTERY The battery will need charging before you use your camera. Keep it charged so you don't run out of power at a critical moment. It's a good idea to keep a spare battery to hand.

SHUTTER BUTTON This releases the shutter and also turns on the lens focusing when pushed down halfway. Gently squeeze (don't jab) the button all the way down to take a picture.

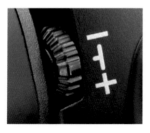

VIEWFINDER FOCUS To adjust the viewfinder to your vision, look through it at a blank wall and adjust the diopter control until the markings on the viewfinder screen come into focus.

COMMAND DIALS OR MAIN CONTROL Depending on your camera model, this control (or controls) sets most of the functions of the camera such as ISO, white balance, aperture and shutter.

MULTI SELECTOR OR SELECTION BUTTON Use for navigating the menu to set functions and to browse photographs in playback. This also varies according to your camera model.

The menu

Many of the functions of your camera are accessed through the menu. The navigational method is much the same as any other computer. Here Nikon screens have been used as illustrations, and although your camera will have the same functions it may display the menus in a slightly different way.

The number of menus that are available on a DSLR are too numerous to explore in detail here. These illustrations will explain briefly what their functions are and for fine detail you will need to turn to your camera manual.

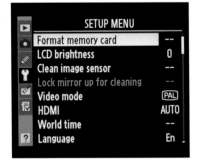

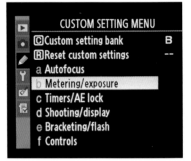

SETUP MENU This contains all the basic functions of your camera. It is the first menu that you need to familiarize yourself with when you are starting out.

SHOOTING MENU All the settings for taking pictures are found inside this menu. Frequent-use functions such as quality, white balance, ISO and exposure compensation can often be accessed by buttons on the camera to simplify matters and save you time.

CUSTOM SETTING MENU You will use these menu banks when you get to the stage of wanting to fine-tune your camera settings to suit you personally and to exploit the full potential of your camera.

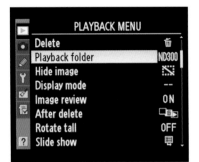

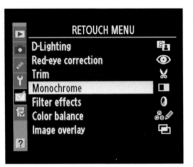

Factory presets

• Don't let all the features worry you – the factory has preset your DSLR to basic settings that will get you started. You will be able to begin shooting as soon as you have charged the battery. Having got the feel of the camera, you can then get down to setting up preferences in the menus as you work your way through the book.

PLAYBACK MENU These are all the tools that are concerned with the viewing and management of pictures already shot and recorded on your memory card.

RETOUCH MENU With this menu, which is only available on some cameras, you can work on the image and make a copy while keeping the original untouched. This means you can print straight from your camera or card without needing a computer.

Exposure modes

Although the majority of cameras have a dial with which you set the exposure mode, some of them incorporate this function in the menu instead. Nevertheless, they all offer you the same choices regarding the type of exposure. These are aperture priority, shutter priority, program mode and manual mode.

M: MANUAL MODE In this mode you take control of both shutter and aperture. You need to use manual if you want long exposures on Bulb setting, or with studio flash where you must set shutter speed and aperture independently.

A OR AV (APERTURE VALUE): APERTURE PRIORITY MODE This is a semi-automatic setting – you set the aperture and the camera automatically chooses the shutter speed for the correct exposure. Use it when the choice of aperture is most important for your photograph.

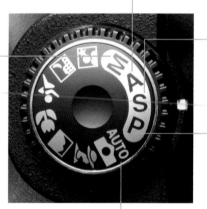

S OR TV (TIME VALUE): SHUTTER PRIORITY MODE Again this is a semi-automatic setting. You choose the shutter speed and the camera automatically sets the aperture for the correct exposure. Use it when the choice of shutter speed is most important for your photograph.

P: PROGRAM MODE The camera sets both the shutter and aperture but you can override it with exposure compensation. This is ideal for snapshots. Some cameras will allow flexible program and auto-exposure bracketing.

AUTO: AUTOMATIC MODE This is the camera in complete control – it is making all the exposure decisions, including when flash is needed. This is the program that is recommended for first-time users.

Holding the camera

• Place one foot half a step in front of the other to maintain good balance. Hold the camera in your right hand with your fingers wrapped around the handgrip. Support the camera with your left hand under the lens. Keep your elbows pressed lightly to your body.

Preset modes

Your DSLR camera is a sophisticated computer and the preset programs are the result of an enormous amount of information that has been programmed into it. These preset modes set up the camera functions to match the subject you have selected, choosing combinations of shutter speed, aperture, flash, colour balance and focus that the camera decides is ideal for each subject.

Preset modes are very useful when you are starting but you can't override the automatics. As your knowledge increases you will probably find this very limiting in creative terms and will want to move on to taking your own decisions.

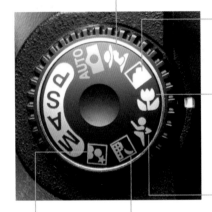

PORTRAIT MODE The portrait mode sets the camera to the largest aperture possible in the lighting conditions on the assumption that you want the subject's face to stand out from the background by making the latter soft focus.

LANDSCAPE MODE This sets the smallest possible aperture that the lighting conditions will allow in order to get as much depth of field as possible.

CLOSE UP MODE To ensure some depth of field to the subject with the background slightly out of focus, this mode sets a medium aperture of around f/8, depending on the available light. It also sets centre focus area. Using a tripod is recommended.

SPORTS MODE This sets the highest shutter speed that the lighting allows in order to freeze motion. Focus is set to continuous while the shutter release button is pressed halfway. The built-in flash is turned off.

NIGHT LANDSCAPE MODE The camera selects slow shutter speeds for night shots; you may need to use a tripod. For speeds slower than 1 full second use noise reduction if your camera has it.

NIGHT PORTRAIT MODE
The camera balances the flash on the subject with the existing light in the background. You have two choices here: keep the camera and subject still to make everything sharp, or move the camera slightly during exposure to blur the background.

Quick tip

• It's all too easy to get carried away and forget to change your preset modes. Always check that you are on the right one for the subject you are shooting or the settings will be unsuitable.

Playback

The ability to see a picture as soon as you have taken it rather than waiting for negatives and prints to come back from a processing lab is one of the most attractive features of digital photography – particularly when you are shooting one-off events such as weddings or competitive sports.

The playback button

This button gives you access to the pictures that are recorded on your card. When you push it, the last picture taken will appear on the monitor.

Image information

By using the multi selector, you can gain a lot of information from playback. All the technical data about the images is recorded and will stay attached to the pictures when they are transferred to the computer – exposure mode, aperture, shutter speed, ISO, exposure compensation, date and time of the exposure, focal length of the lens, flash mode used, white balance setting and histogram.

Playback button

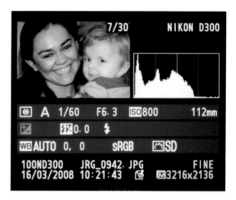

Image information

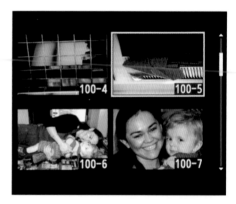

Viewing multi images

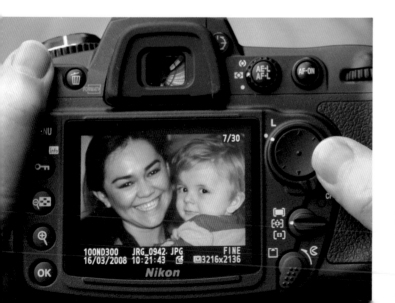

Close up

Viewing multi images

This is the digital equivalent of contact sheets or thumbnails. You can bring four or nine pictures up on the monitor for review, depending on your camera model.

Close up

You can zoom into close up on a portion of the picture in stages using the +magnifier button, and likewise zoom out with the −magnifier button. Using the multi selector, you can also manoeuvre the magnified section of the image around the monitor to check details of your picture for sharpness and colour.

The histogram display

This is a graphic representation of the image exposure; the left side of the graph represents the shadow areas of the image and the right side the highlights. If the peak of the graph is over to the left the image will be underexposed and if it is on the right it will be overexposed. When the peak is in the centre it represents a normal exposure. This graph can be a bit confusing, but it's not something to worry about until you become more experienced.

A problem with digital photography is that it's hard to retain detail in extreme highlights. The histogram is useful to check this. If the graph runs into the right edge of the box (below centre) you'll be losing highlight detail, so you'll need to reduce the exposure.

Protecting images from deletion

Use this button to mark individual images so that they are safely protected from accidental deletion.

Deleting individual images

To delete an unwanted photograph from your memory card, press the delete button. You'll need to confirm this with a second press of the button, or with a different one, depending on your camera.

Don't be too hasty in deleting images at the time of shooting – you may make decisions you'll regret later. Wait until you have the chance to go through them at leisure. Also, time can add significance to a picture; a shot taken on the first day of a holiday can have much more meaning in the context of the holiday as a whole than seemed likely at the time, for example.

Protecting images from deletion button

Deleting individual images button

Playback tips

• Playback is really useful when you are shooting portraits – you can show your subject a picture to give them more confidence in your work.

• Each photograph you shoot has a number, shown on the monitor when you view it. You can record the frame number to link the picture to any notes you are taking at the time.

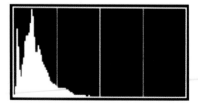

Underexposed

Overexposed

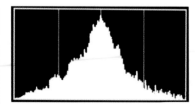

Correctly exposed

Image quality

There's more to a successful photograph than an interesting subject and pleasing composition – the quality of the image must be good.

ISO button

Understanding ISO

Before you make an exposure, you must choose the ISO setting on your camera. The ISO (International Standards Organization) index is a system for calibrating the sensitivity to light of film emulsions and digital sensors. The ISO settings on most cameras go from 100 to approximately 3200, depending on the make of camera, and the higher the ISO number the more sensitive the film or sensor is to light. The ISO rating of digital sensors is based directly on the film ISO, so the 200 ISO setting on a digital camera is the same sensitivity as 200 ISO film.

The practical difference between the ISO setting on a digital camera and the ISO speed of a film is that when using digital the photographer is able to change ISO settings on every frame. In contrast, once you have set the camera's ISO for a film you must leave it on that setting for the whole film as it will be developed for a specific ISO. However, you can raise the ISO rating of a film from the manufacturer's given speed (known as 'pushing') and have it 'push processed' successfully as long as you are consistent with the ISO of that film.

ISO sensitivity

Being able to change the ISO on every frame if you need to has great benefits. If you go from shooting in bright sunlight to low interior light you can increase the ISO from, say, 200 to 1600, thus increasing the light sensitivity of the sensor; the manufacturers call that amplifying the light. With an analogue camera, you would need to change films, which can seem painfully wasteful if you have shot only a few frames of expensive transparency film.

For this comparison of a fine-grained and grainy image, the film grain effect in Photoshop was used. Note that fine detail is lost and the colour is less saturated. The same is true in the case of noise, the digital equivalent of grain.

So why not always use high ISO ratings? The answer is that as a general rule of thumb in both digital and film, the lower the ISO (thus the slower the film) the higher quality the image will be in terms of tonal range, sharpness and colour; the higher the ISO the grainier (in film) or noisier (in digital) the image will be. A digital picture shot on 200 ISO will be sharper and smoother (with no noise) and have more colour saturation. In the case of film, a 50 ISO black and white film will be almost grainless, very sharp and of higher contrast than a 1000 ISO film.

A question of taste

However, we now arrive at an old chestnut – what is good quality? Depending on the subject, a grainy picture may well convey more to the the viewer about the subject than a smoothly fine-grained one. Indeed, you will see that there are a number of deliberately grainy pictures in this book. To some, the smoothness of digital images looks plastic and unreal, and they choose to add film grain effect in Photoshop.

In both film emulsions and digital sensors, the manufacturers have succeeded in

pushing the speed of ISO with improved picture quality further and further; some 400 ISO films now have little more grain than the older 100 ISO films, while top of the range digital cameras can go beyond an astonishing 25600 ISO.

Guide for your ISO settings

• **50–200 ISO** For very bright sunny days or when you want the ultimate in smooth, sharp images.

• **400 ISO** A good all-round setting, suitable for overcast skies or when you need a fast shutter speed.

• **800 ISO** For interiors, low-light outdoor subjects or action photography when you don't want to use flash.

• **1600 ISO** For night shooting or indoor low available light, or with very long lenses. Grain/noise may be a problem. Try using your noise reduction setting.

• **3200 ISO** Much the same as 1600 but with more grain/noise. The grainy effect of fast film can look great with black and white subjects.

The picture of the horse (below left) is a small section of a 16 x 12 inch print. Shot on Ilford FP4 125 ISO film, it has little evidence of grain. The ballet photograph (below) is a similar section of a 16 x 12 inch print, in this case shot on Kodak TMAX 3200 ISO film. Here the grain is very obvious.

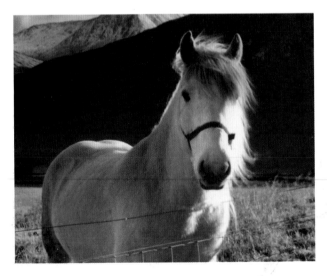

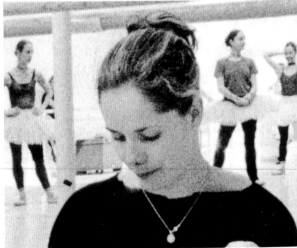

Digital quality

Digital cameras use three different file formats to store the images on the memory card: JPEG, TIFF and RAW.

The file format that you choose has a big influence on the final quality of your pictures and also on the amount of pictures you can store on the memory card.

Memory cards are very delicate and shouldn't be dropped or subjected to extreme temperatures. Protect them in a padded carry case.

JPEG format

This type of file is processed by the camera's computer, which applies all the settings that you have selected, such as colour balance, contrast and sharpening, to form the digital image. It then compresses the image to the file size and quality (fine, normal or basic) you have chosen.

Although the large size and fine setting takes up more space on the memory card, it's best to select it because you may want to do a bigger print in the future. Even if you think you are only aiming for postcard-size prints, there may be some shots you are so pleased with that you want to print them poster-size, and if you have used a smaller file size you have ruled out that option.

Fine (less compressed) JPEG files produce high-quality images and are used by many professional photographers.

RAW format

If you save your file in RAW format, you are storing all the image information that is received by the camera. It's the digital equivalent of the analogue camera's negative. Every detail is in the file for the photographer to download onto the computer and make adjustments to later; just like the film photographer will take his or her negative into the darkroom and use the information on it to make a print, so the digital photographer will open up a RAW file in Photoshop and process the image to

make a final interpretation. This is then saved as a separate file, and the RAW file is kept untouched ready for future use.

The disadvantages of RAW files are that because they are not compressed by the camera they take up more space on the memory card, and the camera also has to pause more frequently to write them to the card. While professional cameras can do this fast enough not to cause a problem, keeping up with the action at a sports event, for example, isn't practicable with many consumer-level cameras.

The CD provided with your camera should include software to enable you to process the RAW files. If not, you may have to buy a program or download a free one.

Some cameras have the facility to shoot RAW and JPEG at the same time. Many professionals use the JPEGs as a digital equivalent of a darkroom contact sheet from which to choose the best pictures then get to work on the RAW images.

TIFF format

In terms of quality, TIFF files lie between JPEG and RAW files. They are compressed,

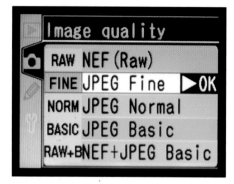

You have a choice of file formats. Shooting high image quality and large file size will allow you to do large prints if you ever need them. Use RAW if you plan to do extensive retouching on your pictures in Photoshop.

but not as much as JPEGs; they lose no detail, but take up much more space than a JPEG, though less than a RAW file.

So, your choice of file type depends on how many pictures you want to get on the card and on the quality you are after. However, not all cameras offer TIFF as an option for storage.

Memory cards

In the digital camera, the memory card replaces the function of film in terms of recording the images. The cards are available in different memory capacities; which you decide to buy will depend on the number of images you want them to hold, and their size. They also have different transfer speeds – the faster they record, the faster you can shoot.

Make sure you turn your camera off before you insert or remove a card. Before you use a card for the first time, you must format it in the camera. Reformatting a card which contains images will permanently erase them, so make sure you have copied them first.

It's a good idea to have several smaller capacity cards instead of one large one, especially when you go on holidays. That eliminates the possibility of losing all your pictures if you damage or lose a card.

Downloading

There are different ways of downloading the pictures from your memory card. You can download directly from your camera to your computer using the USB cable supplied, but it's quicker to download via a separate card reader. As a precaution, many photographers download their images onto a portable storage device or laptop computer while on location. Some printers have card readers built in and you can print directly from your card without needing a computer.

Sharpening

• This function gives your pictures an appearance of greater sharpness by emphasizing the borders between light and dark areas. Whether and how much you sharpen in the camera is a matter of personal taste and also the subject matter. Sharpening is more suited to architecture than baby pictures, for example, though you can choose different degrees of sharpness.

If you plan to work on the images in Photoshop later, it's best not to sharpen in the camera but to leave it as the last step after you have retouched and resized the image.

Using a card reader is a quick way of transferring your pictures from the memory card to your computer.

Downloading the images from your card into a portable storage device such as this makes a secure back-up copy and is a way of managing your pictures on location.

Film quality

It's a mistake to write off film as a dying technology – in fact there is probably a greater variety of films available than ever before. While digital technology has been motoring on, film emulsions have been improving too. New films have been launched and some old discontinued films have been revived; at the same time the current favourites are still being improved.

The processing chemistry that goes with black and white film has been improved also and there are several small manufacturers making traditional formulae that have not been seen for years. This revival is directed toward the art photography movement.

Some photographers working in both colour and black and white prefer to shoot film and then go digital by scanning the negative into the computer and fine-tuning the image there, combining traditional and modern technology.

Black and white film

The actual speed of black and white films is dependent on the amount of development they receive – for example, a film that has a manufacturer's rating of 400 ISO can have a working speed of 1600 ISO if the development time is increased sufficiently. Longer development times increase grain size and contrast. There are films available designed specifically for uprating, known as push films.

Black and white films are available in the following categories:

Slow-speed films: 20 to 50 ISO This group of slow films produces the ultimate in photographic technical excellence, giving very fine grain and high resolution (sharpness) and contrast. Use them for any subject that would be especially enhanced by those qualities, such as architecture and still life. Ilford, Adox and Rollei make films in this category which are superb when matched with the manufacturers' recommended developers.

Medium-speed films: 100 to 200 ISO Films in this versatile group offer most of the qualities of the slow films in terms of fine grain and high resolution but are not as contrasty. This enables them to produce more shadow detail, which is useful for subjects such as landscapes and portraits. Ilford, Kodak, Fuji, Lucky, Adox, Foma and Rollei all have films in this range.

High-speed films: 400 ISO This group is the most versatile of all, and the manufacturers have been improving their films continually over the years. Ilford's 400 ISO film started its life as HP3 in the 1950s, became HP4 then HP5, and has now graduated to HP5+, its latest manifestation in a long and distinguished career.

Today, all the 400 ISO films can be pushed up to 1600 ISO and beyond. At 400 ISO they reproduce a huge tonal range and can be used for almost any subject, which has made them the universal choice for photojournalists for many years and has also made them popular for landscapes on medium- and large-format cameras. As well as Ilford, Kodak, Fuji, Foma and Rollei all have films in this range.

Ultra high-speed films: 1600 to 3200 ISO These are all push films which can be rated at anything from 200 to 50,000 ISO, according to development time. The more you push them the grainier they become, with increased contrast. Use them for available light pictures and for when you want grain for graphic effect. Ilford, Kodak and Fuji produce them.

Film effects

• If you want a digital image to look as if it has been shot on a particular film you can use software that will mimic the appearance of any film available now and even some obsolescent ones. Films such as Fuji Velvia, Kodak TriX, Ilford Delta and many more can be reproduced in Photoshop using software programs.

Chromogenic films Designed to be processed in C41 colour chemicals, these films have the advantage that they can be quickly processed with colour negative film in a mini lab. Although the negative looks different, they produce a normal black and white print. They are made by Ilford, Kodak and Fuji.

Infra-red films These films are like normal black and white films except that they have an extended red sensitivity. Foliage and faces become pure white when infra-red film is used with a deep red filter – to get the greatest effect, use an 87 or 88 Wratten filter to cut off all visible light relative to the infra-red. Exposure readings are difficult, and you will need to do a wide bracket (see p.32). Ilford, Rollei and Adox make infra-red films.

Digital transfer film This is a transparent film with a surface to accept inkjet printing, allowing you to make larger negatives. Makers include Permajet and Pictorico.

Colour film

Transparency films Colour transparency or slide film has been the traditional colour film for both the professional as well as the family slideshow evening. It has been preferred for the highest quality commercial printing. Most of the big transparency processing labs have now changed over to digital work, but transparency film still has many devotees.

Kodak films start from Kodachrome 64 ISO, the sharpest 35mm fine-grain colour film available. Their Ektachrome range starts from 64 ISO and goes to 400 ISO in steps of 100, 200 and 400 ISO. Kodak also make 64T film, a 64 ISO film which is balanced for use with tungsten light.

Fuji's slowest colour transparency film is Velvia 50 ISO, which is highly saturated and

Kodak 200 ISO transparency film (left) and Fuji 400 ISO colour negative film.

has fine grain. Velvia is also available at 100 ISO, along with Astia and Provia 100; the latter also comes at 400 ISO. The Velvia films have a warm colour balance, while Asti and Provia are more neutral. Fuji also provide a tungsten-balanced 64 ISO film.

Colour negative films There have been great improvements in colour negative films over the last ten years; the colour is more accurate, and the grain is smaller and sharper. Most photographers still shooting colour film are using colour negative, which has the advantage that a print can be made in the darkroom or it can be scanned and used digitally.

Kodak make a range of Portra professional colour negative films at 160, 400 and 800 ISO. These are available with a neutral colour balance (NC) or with more vibrant colour (VC). They also have a large range of amateur films from 200 to 400 ISO.

The Fuji Superia range covers 100, 200, 400, 800 and 1600 ISO. These films are warmer in colour and sharper than the rest of their range. The Pro range, from 160 to 400 and 800 ISO, is good for a general range of subjects, while Reala 100 ISO has finer grain and lower contrast.

Lenses

The primary function of a lens is to focus the image onto the film or sensor. It also controls the angle of view and houses the aperture diaphragm.

Lenses come with fixed focal lengths (known as prime lenses) or as zoom lenses. The latter are designed to provide many focal lengths in one lens, which reduces the amount of equipment that a photographer has to carry on location.

The advantage of prime lenses is that they have the largest apertures, allowing you to work in lower light levels without a tripod and to choose a shallower depth of field, which is useful in selective focus imagery. They are also still the best in terms of sharpness and minimum distortion.

Within these two categories there is a further choice between digital (D) and analogue lenses. The former are dedicated to digital cameras and will not work with film cameras; however, the latter can be used with both film and digital cameras, which means that if you are changing from film to digital you won't have to go to the expense of buying new lenses.

Focal lengths

While the sensors of DSLR cameras vary, they are approximately two-thirds the size of a 35mm film frame. This means that lenses are effectively increased in focal length by 1.5x, so that, for example, a 50mm lens will become a 75mm lens on a digital camera and a 200mm lens has the effect that a 300mm lens would have on film.

This means that there is an advantage at the telephoto end of focal lengths but a disadvantage in wide-angle lenses because a 24mm lens on a film camera is only about 36mm on a digital camera. To get a really wide-angle effect you need a 12mm or 14mm lens for digital, of which there are now plenty available.

Lenses range from an 8mm fisheye right up to 2000mm. There are also some very specialized lenses such as the perspective control lens and macro lens. Today, zoom lenses are used almost universally by most photographers, although some still prefer to work with fixed focal lengths.

You'll find that just two lenses, a wide-angle zoom and a medium to telephoto zoom, will cover most situations. Indeed, the majority of people never use anything other than a zoom because cameras are usually sold with a zoom lens included, and they are also the easiest, lightest way to go. However, if you are interested in close-up

Perspective correction lenses are used for eliminating the distortion that occurs when you photograph a tall building from a low viewpoint. The front of the lens can be moved up, down and sideways while the camera remains on the same plane. These lenses are mainly used by photographers specializing in architecture.

Macro lenses are the sharpest you can buy. Most are about 55–60mm focal length, used with film; their focal length is effectively increased by 50 per cent on a digital camera. They are relatively inexpensive and you will probably be able to find a secondhand one at a good price on eBay.

Reflex telephoto lenses have an internal mirror system and fixed aperture. Their creative characteristic is that they turn out-of-focus highlights into doughnut-like shapes.

A recent addition to some lenses is vibration reduction (VR), which allows you to shoot with lower shutter speeds and still get a sharp image. VR may be incorporated in the camera body instead of the lens.

photography you may want to consider using a fixed focal length macro lens as the quality is superior to that of the macro setting on the zoom lens.

Photographers keep to their favourite lenses over many years. It is often not so much that there is anything particularly special about that lens, but that it suits the way they see the world and the type of work they like to do.

Good-quality lenses, especially those with large apertures, can be very expensive. However, independent lens manufacturers such Sigma and Tamron make high-quality lenses for most DSLRs at about half the price of the camera manufacturers' lenses.

Focusing modes

Your lens is focused via three modes that are selected from a switch on the camera body: S, C and M.

• **S** Single auto will automatically focus on the object that you point the camera at when you push the shutter button halfway down. It will fix that focus until you release the button or take a picture.

• **C** In continuous auto, the camera will follow focus on a moving object when you keep your finger halfway down on the shutter button.

• **M** In manual mode the camera is focused by using the focusing ring on the lens. The focus indicator dot will light up when you are in focus.

Most DSLRs give you a choice of where to place your point of focus in the viewfinder. This could be a single point that you can move around the viewfinder and place where your subject is. Alternatively, you can group a number of the points together to cover a larger focus area in the viewfinder. This varies with different camera models.

Focus lock

You will also have a focus lock on the camera. This may be a question of pressing the shutter release button halfway down, or there may be a separate button.

Focusing modes

Exposure

The two devices that the camera uses to make an exposure are the aperture and shutter. Working in tandem, they determine the amount of light that creates the image when you release the shutter.

Shooting modes

All these aperture and shutter combinations have produced the same exposure for this picture. If either element of the combinations were to be changed the image would be brighter or darker.

The aperture

A camera lens contains an iris diaphragm, based on the functioning of the iris in an eye. It is constructed of metal leaves that open and close, making a bigger or smaller aperture in the lens through which light enters the camera. The aperture thus controls the volume of light that's allowed to reach the film or sensor.

The size of the aperture is calculated in f-stops. Confusingly, the smallest number on your lens, such as f/2, is the largest aperture, and the highest number, perhaps f/16, is the smallest. The reason for this is that these numbers are actually fractions, representing the focal length of the lens divided by the diameter measurement of the aperture.

The shutter

Located in the camera just in front of the film or sensor, the shutter controls the length of time that either is exposed to the light entering through the aperture.

The main shutter speed settings are in steps, each of which halves or doubles the length of the exposure; for example, 1/250 second allows half the amount of light through the lens as 1/125 second, while 1/60 second allows twice as much.

Modern cameras have a large range of exposure time settings, from 30 full seconds to 1/8000 second. There is also a setting called either B or Bulb, which keeps the shutter open for as long as the shutter release button is held down (you will need a cable release or remote control to keep the shutter open for an extended period). Shutter speeds on the dial are in fractions of a second until they reach 1" second, the symbol " denoting full seconds.

Your camera has different shooting modes: S (single), which takes a single frame each time you press the shutter release and C (continuous), which is a built-in motor drive that can take up to 6 frames per second (depending on your shutter speed) while the shutter button is held down or

1/250 second at f/4

1/125 second at f/5.6

1/60 second at f/8

1/30 second at f/11

1/15 second at f/16

until the film is finished or the card is full. This continuous mode can be great to use when you are panning or trying to capture a fast-moving subject. Some cameras offer the option of low and high speed continuous shooting (CL and CH respectively).

The aperture and shutter function in relationship to each other, because in order to maintain what you or your meter calculate to be accurate exposure, both the volume of light entering through the aperture and the length of time the film or sensor is exposed to that light must be adjusted. If you increase the volume of light by enlarging the aperture, to maintain the same exposure you have to shorten the shutter speed.

Exposure meters

The exposure is calculated by your DSLR or SLR camera's built-in exposure meter. When you compose a picture in your viewfinder, the meter analyses the light reflected off the subject and calculates what it considers to be a correct exposure of that subject.

When you are using the P, S and A modes at least part of the exposure is automatically made by the camera. In the case of M (manual), you have to set both the aperture and shutter yourself. Whether or not your photograph will be correctly exposed at the settings you have chosen is shown in the display in the viewfinder's control panel so that you can adjust them if need be.

Although built-in meters in good-quality cameras are now very efficient, some photographers still prefer to use a separate handheld exposure meter. These use two methods of analysing the light and making exposure readings: like the camera's meter, they measure the light reflecting off the subject, or they can measure the light falling on it, which is called an incident light reading.

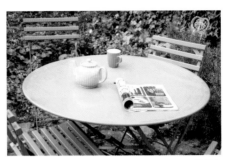

Overexposed

M 3o F8

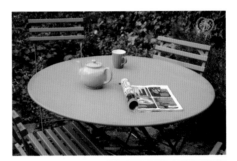

Normal

M 6o F8

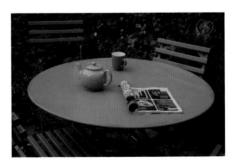

Underexposed

M 125 F8

When you are working with the exposure in M (manual) mode the exposure display in the control panel of the viewfinder shows if your picture is correctly exposed and, if not, whether you need to allow more or less light.

Meter modes

Exposure compensation

Auto exposure lock

Self timer

Handheld incident meters are used to take readings when studio flash units are providing the lighting. Handheld spot meters, which measure the light on a small area, are seldom used by the DSLR or SLR user now because most camera meters offer that facility.

Meter modes

Most cameras provide you with three exposure modes which evaluate the light reflecting off different areas of the picture.

Matrix mode (Nikon) or evaluative metering (Canon) averages the exposure over the whole viewfinder frame. It is recommended by camera manufacturers for all-round situations but does not work well with exposure compensation or on exposure lock.

Centre-weighted mode meters the whole frame but makes the centre of the frame (as marked in your viewfinder) the most critical. It is ideal for portraits and is also recommended when using strong filtration.

Spot meter mode (Nikon) or partial metering (Canon) takes a reading off a small centre circle (only about 2 per cent of the frame). It is ideal if you have a small but critical area in your frame that you want to be sure is well exposed. This is often much brighter or darker than the rest of the picture, but you can spot meter it and let the rest of the frame take care of itself.

Exposure compensation

When you are shooting in P, S or A modes the camera automatically calculates the exposure. If you want to override its reading, use exposure compensation. By pressing the button and rotating the control wheel you have a choice of making the pictures

brighter or darker (shown on the camera as + or - respectively).

This can be useful when you have a light subject in front of a dark background, for instance, when you may need to give less exposure than the camera has calculated because it is trying to record detail in the dark background and will make your lighter subject in the foreground too bright. Conversely, if you have a dark subject in front of a bright background you may want to give more exposure.

Auto exposure lock (AE AF)

If your subject is off-centre in the viewfinder the exposure could be incorrect. The answer is to select centre-weighted or spot metering, put the subject in the centre of the viewfinder and hold the shutter button halfway down to set the focus and exposure. Use the auto exposure lock, recompose your picture and take the photograph.

Self timer

The self timer delays the shutter release, giving you time to push the button then run around to include yourself in the shot. If you don't have a cable release or remote control to fire the camera on long exposures, use the self timer to avoid camera shake.

Quick tip

• Taking several shots of the subject at different exposures each side of normal exposure (bracketing) ensures that one will be correct. Some cameras can be set to do this automatically. You can select the number of steps you want to bracket. Keep shooting until the number of brackets you selected is finished.

Flash

Having flash at your disposal can be invaluable on many occasions, and modern automatic systems make it easier than ever to use.

Most cameras now have a built-in flash, but it's something to use with care. Set onto auto, the camera will be popping a flash into just about everything, trying to produce a uniformly 'normal' picture every time, and that's not the way forward for a creative photographer. However, the 'fill-in' flash works well in automatic to supplement ambient (existing) light. If you practise and study your camera manual you will be able to use it imaginatively as well as usefully.

Flashguns

As well as the built-in flashlight, the manufacturers all make separate dedicated flashguns. 'Dedicated' means that when they are connected to the hot shoe on the camera they can be controlled from it and work with the through-the-lens (TTL) automatic exposure. Check your manual for the maximum recommended shutter speed that will synchronize with your flash; you can use slower speeds, but if you exceed the maximum speed you will not get an image.

Flashguns have a very short flash duration which is so fast it will freeze almost any moving subject. They have more power than the built-in flash, and because they have their own battery power, they don't drain the batteries of the camera. The swivel head can be angled to bounce light off walls or ceilings, which makes a lovely soft light – but be careful that the surface you are bouncing off is neutral, preferably white, or your flash will pick up the colours and cast them onto your subject.

There are many accessories such as diffusers, reflectors and colour filters

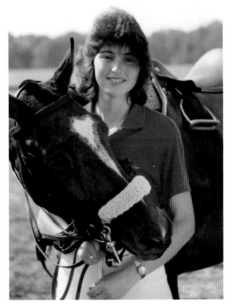

This young horsewoman was too strongly side-lit by the sun. I set the camera to P (program) and the camera did a perfect fill-in flash. JG

Flash button

Hot shoe

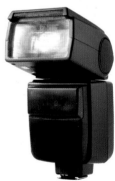

Flashgun

available for flashguns. They become a really versatile and creative light source when you add an off-camera cable which connects the flashgun and the camera hot shoe, enabling you to light your subject from almost any direction (see pp.116–17), with the flash still dedicated to your camera's automatic exposure.

To calculate the correct exposure for flash when using manual mode, you will need to get the guide number from the instruction manual for your particular flashgun and follow the instructions on how to calculate the f-number.

White balance

On a digital camera, white balance solves the problem of colour casts without the need for the filters that are used with film.

The white balance button is used to set the colour according to the light.

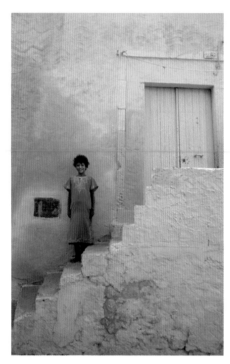

I made this portrait of a child in a Moroccan bazaar. I like the way the shade light has made the dirty white walls blue, which has blended with the colour of the child's clothes. If I had used the shade setting on white balance this subtle blending of colours would have been lost. JG

There is no such thing as a pure white in the outside world. A building that is painted white, for instance, will change colour during the day as the colour of the light bouncing off it changes; if blue light is hitting it, the wall will photograph as blue.

White balance, or WB, gives you options for correcting colour balance for a number of different light sources. Once the camera has established a neutral white all the colours in your picture will fall into place, and the colour cast that has been taken out of the white will also be removed from the colours. Many of the new camera models also include the facility to fine-tune the colour balance in the camera after you have taken the shot, which can also be done in Photoshop.

However, this book is not intended just to help you take technically correct pictures, but to show you how to make exciting ones. The danger of digital photography is that it always attempts to make things uniform, and this is most evident on the white balance mode; WB technology has been developed to make every colour picture you shoot look as if you have taken it in direct sunlight.

The end result of this is that you could end up with blandly normal pictures that lack the excitement that all the amazingly variable light sources provide us with.

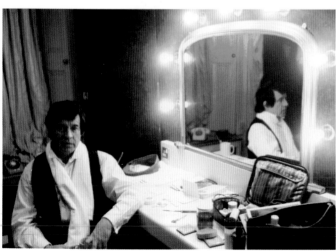

This portrait of the actor Alan Bates in his dressing room would have been drained of its warm glow if I had shot it on incandescent mode or auto as it would have been corrected to neutral colour balance. JG

Although it's important to understand the white balance mode and its functions, don't allow it to commandeer your own assessment of light.

Auto
This automatically sets your camera to suit any lighting conditions, giving a fairly good neutral colour balance. However, if you just leave white balance set to auto all the time you are in danger of missing out on capturing the subtle beauty of different light conditions. When shooting in daylight, for example, try setting the white balance to the direct sunlight setting so you can capture the different light qualities that change throughout the day.

Incandescent
An ordinary household tungsten bulb gives incandescent light. It is much warmer (yellow/orange) than daylight and requires the camera to add blue to balance it back to neutral. The incandescent setting provides a more neutral colour balance than auto, which tends to be warmer.

Fluorescent
Use this setting when you are shooting in fluorescent light; it will achieve a much better colour balance than auto white balance succeeds in doing.

Direct sunlight
Like daylight-balanced colour film, this setting gives a natural colour balance in direct sunlight in the middle of the day.

Flash
Flash tends to be slightly cooler than daylight; this setting warms it up a little.

Cloudy
On overcast days the light is cooler. This setting warms it to match direct sunlight.

Shade
Light in the shade is much cooler than bright sunlight because it mainly comes from indirect blue sky light. This setting warms the light to match direct sunlight.

Preset
You can manually set the white balance to correct any light source to neutral. This is accomplished by photographing a grey or white surface in the light in which you are working. You can also set the colour balance to a pre-selected photograph of your choice. Refer to your manual for instructions.

This landscape was shot on a very overcast day. I liked the composition but not the colour, which was boringly grey. By setting the white balance to incandescent I was able to get a blue cast which gave it an early-morning feel. I then tried a shot on shade setting and that warmed it to look like evening light. GH

Essentials

This is a list of essential items that you will find invaluable – in fact, sometimes they can be as important as your camera.

Compass and torch

Carrying a compass is a great idea as it helps you to plan ahead as to where the sun will rise and set when you are shooting landscapes. You can also work out which way buildings are facing to choose the best time of day to take a photograph. A torch is handy to find things in your gadget bag and to see camera controls at night. It can also be useful as a small light source for shooting portraits or still life.

Cleaning equipment

Your camera is a precision instrument. Take care to protect it from dirt, water, and particularly sand, which is a sure killer of unprotected cameras. Keep a plastic bag with you for emergencies.

A dirty lens covered in fingerprints and grime will act as a diffuser and degrade your images. Keep the lens clean, first by trying not to let it get dirty to start with. Ideally, use a UV filter to protect the lens as it will be much cheaper to replace than a new front lens element – it won't affect your exposure values and its only function is to reduce haze.

To clean a lens, use a blower brush first to remove any dust and grit then carefully clean it with a microfibre lens cloth and lens cleaning solution if needed. Don't scrub it – use gentle strokes or you will risk scratches on the surface.

The image sensor in a DSLR is particularly vulnerable to dust spots. When you are changing lenses, make sure the camera is turned off and don't allow dust to enter the camera. You can get specialized sensor-cleaning equipment or have your camera manufacturer's service department do it.

Camera bag

The selection of a camera bag is most important. Buy the best quality bag you can afford to protect that expensive camera. Hard cases that protect camera gear in the worst conditions are heavy to carry about, but some now have built-in wheels. Soft

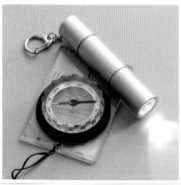

Compass and torch

Cleaning equipment

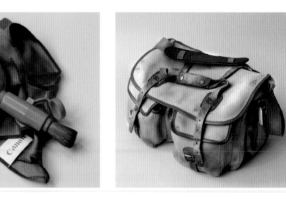

Camera bag

bags in a variety of materials and a huge range of styles are now available. Backpacks are great for hiking and are also useful in urban situations as they aren't easily identifiable as containing valuables, but shoulder bags are much quicker and more convenient to work from.

When buying a bag, take your equipment to the shop to make sure that it will fit in and the bag will suit your way of working. A good bag will last a very long time; the Billingham one pictured here has been working hard for 30 years.

Flashgun

A separate flashgun has great creative advantages over the built-in flash you may have on your camera. As well as the dedicated flashguns described on p.33 there are also manual and automatic flashguns available; the manual ones have a fixed light output and you find the aperture you need from a table on the flashgun, while on the automatics you set your camera aperture to match the flashgun and it controls the exposure.

Most flashguns allow you to rotate the flash so you can bounce it off walls or ceilings to get indirect light. The most creative way to use the flashgun is to attach it to an off-camera cable (see pp.116–17), so you will probably want to buy one of these too.

Laptop

An increasing number of photographers take their laptop computer out and about with them, and you may think it a good idea to do the same. You can download your pictures on the spot, check the shots on the larger screen, save the images to the hard drive and also output to a CD if you want to be sure the pictures are safe. With the right software and cable you can also shoot with your camera tethered to the computer – the image appears on the screen when you make the exposure.

If you prefer to travel lighter you will need to have some other way of making records of locations and so on. Take a notebook, or something more technological such as a Blackberry, depending on your taste.

Fold-up reflector

Reflectors bounce light back onto your subject, almost as if they are an extra light. They are usually white or silver, or gold to add a warm glow. This type pictured below is convenient as it has a handle and packs into a pouch for easy carrying. There are

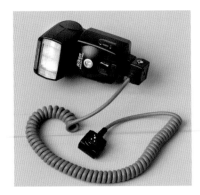

Flashgun

Laptop

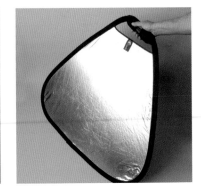

Fold-up reflector

Tripod

Camera support

Multipurpose tool

many sizes and types available, but you can also use a variety of materials such as card, paper, cloth, kitchen foil and so on.

When you use a reflector remember that it bounces the main light back, so position it for maximum effect. For a portrait, for example, placing it below and in front of the subject will lighten the eye-socket shadows. For still life, use pieces of card, foil or small mirrors to add sparkle and soften shadows.

Tripod

This is an invaluable piece of equipment when you are using slow shutter speeds as it prevents camera movement during exposure. While modern lenses with vibration reduction have helped the photographer handhold the camera at slower speeds than previously, for long exposures a tripod is still needed.

A tripod is also a great help for shooting a still life. You can set up and compose your subject, then lock the camera onto the shot. This allows you to move lights and reflectors and adjust the subject without having to recompose each time.

When choosing a tripod you have to consider weight, height and ease of use. The higher, more stable ones are superior but are difficult to carry around for long.

A cable release or remote control is generally used in conjunction with a tripod to minimize camera movement when the shutter is released. In the absence of one of these, use your self-timer to fire the shutter.

Camera support

Some photographers carry a bean bag with them. This is nothing more complicated than a small bag half-full of beans, rice, polystyrene beads and so on. It suffices as a camera support when you don't have a tripod or are in too difficult a position to use one. Alternatively, anything to snuggle the camera into will do, placed on something handy such as a wall or bench; the picture above shows a sweater. This allows you to do long exposures without the camera moving. Again, use a cable release, remote control or self-timer to fire the shutter.

Multipurpose tool

This is an indispensable tool that can rescue you from a wide range of small problems. Where there is any well-used equipment things will inevitably go wrong, and this gadget may get you out of trouble. It is invaluable for everything from repairing a broken fingernail to removing a wine cork when celebrating a great shoot.

Review

In this section of the book, you have discovered the basics about the equipment you need and some extra items you may like to acquire.

Always remember, though, that the possession of a range of technology and gadgets isn't the most important factor in whether you are a good photographer or not. Too many people concentrate more on equipment than on their images, constantly poring over the reviews of new products in magazines rather than thinking about the content of their photographs.

The range of sophisticated equipment available is indeed vast and it's amazing how much the price of cameras has dropped in recent years; relative to inflation, the Leica of 30 years ago would cost about £8,000 today. Although most of us can be quite excited by the technology, it's not the camera that takes the picture and it still needs a great eye and imagination to achieve a stunning shot.

Improving as a photographer doesn't come from buying a new camera – it's all down to getting experience and the way to do that is to start shooting lots of pictures, learning from your mistakes. Start working your way through the projects in the following pages and you'll soon see results. Most importantly, have fun and enjoy making pictures.

Pre-shoot checklist

It makes sense to refer to a checklist of equipment and settings before you go out. This one should cover most eventualities.

- A fully charged battery, and a spare too if possible.
- Formatted memory cards, or film of your chosen type and speeds.
- File type and image size selected.
- ISO set to your chosen speed.
- White balance set to auto or the light source that you will be shooting in.
- Exposure compensation set to 0.
- Shooting mode, focus mode, exposure mode and meter mode selected.
- Lenses, cleaned and set to auto or manual. VR set to on or off.

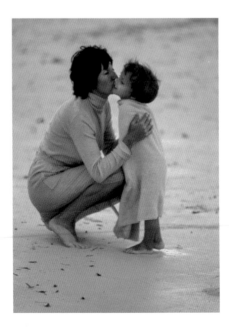

This picture was shot in late afternoon in shade. The light was very blue and I was tempted to warm it up, but decided that the cold light was sympathetic to the mood and that the yellow dress was so saturated it would survive the blue cast. It made a warm shape to comfort the cold little boy. JG

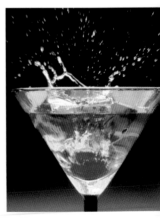

This was lit from below by a flashgun under a sheet of opal Perspex. The fast flash has frozen the splash made by the cherry dropping into the cocktail. GH

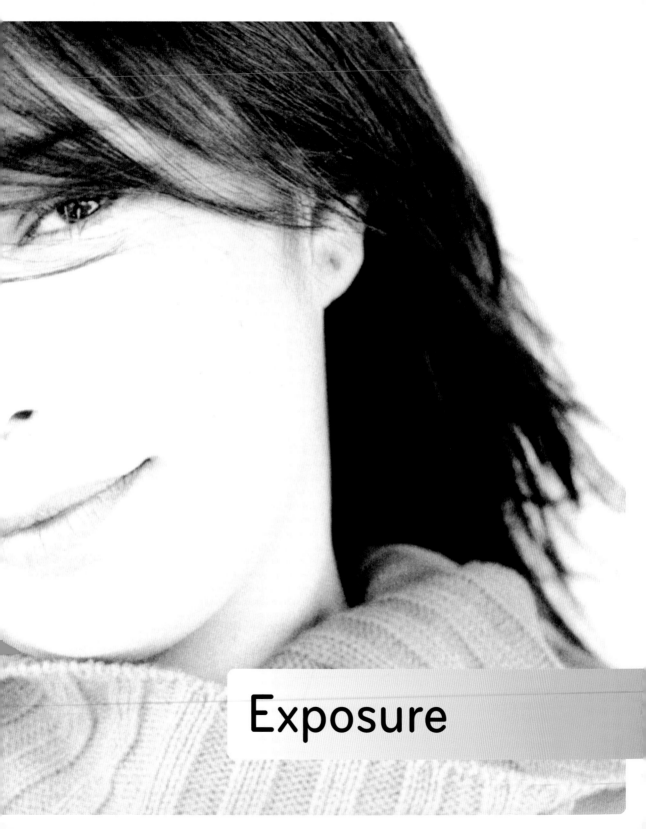

Exposure

Capturing the light

This lesson will take you forward from the basic facts you learnt about exposure on pp.30–31. In the following pages you will discover how you can take control and use exposure in an imaginative way.

When we take a photograph we are basically trying to reproduce our subject onto the film or digital sensor by means of translating light into an image. Louis Daguerre, after making his first photographic image in the 1830s, reportedly exclaimed, 'Eureka! I have seized the light. I have arrested its flight. The sun itself in future shall draw my pictures!'

It's said that Daguerre's discovery was an accidental one that resulted from leaving an exposed glass plate in a cupboard where there were spilt drops of mercury which gave off vapour. No one today would recommend some of the more hazardous dabbling with chemicals the pioneers of photography indulged in during their attempts to find ways of advancing the techniques of this new medium, but the principle remains the same: the photographic image stems from the capturing of light.

Creative exposure

After framing the subject and focusing the lens to provide a sharp image, the photographer – or the automatic mode on the camera – then sets the combination of the aperture and shutter to control the amount of light reaching the film or sensor to obtain a correct exposure.

However, this exposure is defined by what the equipment manufacturers believe will

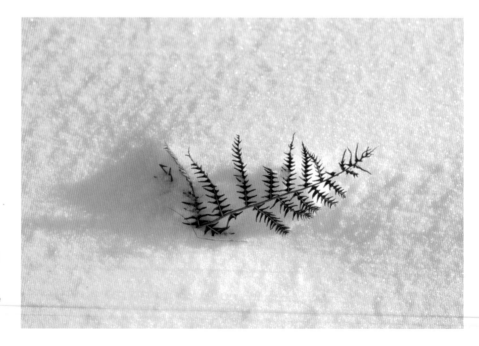

The snow was lit by early-morning sunlight and the blue sky filled in the shadows. I needed to keep the snow light but retain the texture. I added +1 stop exposure compensation to the normal exposure. GH

give the maximum amount of colour and tonal reproduction that is faithful to the subject. In fact, as you will discover in this lesson, the correct exposure is a highly subjective matter.

Exposure is not merely a technical equation – it is one of the most creative decisions you can make when you are taking a photograph. While a basic average exposure may record how the subject appears to the eye, it may not express how you as a person responded to the subject at the time. Perhaps a darker or lighter image would better capture the mood you were feeling when you took the picture.

The personal response

In spite of the incredible sophistication that manufacturers have built into the modern camera, they have not yet managed to incorporate a human heart, aesthetic taste or sense of humour into their machines. That is still down to the photographer's

Seeing the big picture
The double-page picture on pp.40–41 is a high-key portrait achieved by using soft front light and a red filter over the lens. I gave it + ⅔ exposure compensation because I wanted to produce a thick (dark) negative from which it is easier to make a light print. Once I had developed and fixed the print I gave it a one-minute immersion in selenium toner to give it a sparkle and warm tone. JG

input – but to be able to express your creative feelings you need to understand what the camera is doing, and how to use all this amazing technology to help you take more imaginative pictures. This lesson will help you to explore the possibilities that are open to you and encourage you to depart from what the technology tells you.

This was an exercise in 'Old Master' lighting – a diffused window without a reflector. I wanted to keep the image low key and moody. I took a spot reading off the highlight areas and shot at f/11 for a good depth of field. GH

Choosing the exposure

You will see the term 'correct exposure' used often, but the pictures here show that there is a wide range of exposures that may be right for the occasion.

All the pictures in this series, which is a bracket (see tip, p.32), have merit in their own way and could be described as correctly exposed – yet they vary from the lightest image to the darkest by 2½ stops.

The darkest one (bottom right), at -1¼ stops from 'correct' exposure, has turned the model into a near silhouette which is a very effective use of the body shape. The lightest (top left), at +1¼ stops, is also attractive because it looks soft and romantic. The shots in between are quite usable also. It's a perfect example of how the right exposure is often a matter of personal taste, and depends on what you want your pictures to achieve.

These photographs were all shot with window light and a white reflector at 1/125 second and 200 ISO.

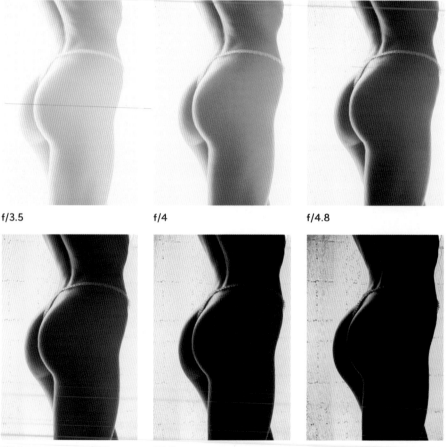

f/3.5 f/4 f/4.8

f/5.6 f/6.7 f/8

Bracketing

Bracketing your exposures is the safe way of achieving the density that captures the atmosphere that you are after.

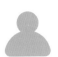

Bracketing (see tip, p.32) is more critical for film users than digital photographers, because with a digital camera you can check the exposure on your monitor. However, bracketing is still valid for the digital photographer because it produces unexpected results that can prove to be more exciting than those the chosen exposure has given.

For this project, choose three different subjects such as a landscape, a portrait and a still life – bracketing isn't suitable for reportage and action photography because of course the best action may be on the wrong exposure.

Bracket the exposures on each shot and see if a lighter or darker frame works better than the one the meter chooses. Don't be tempted to delete what appear to be unsuccessful exposures – keep them so you can reassess them on the computer later.

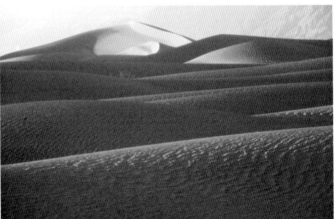

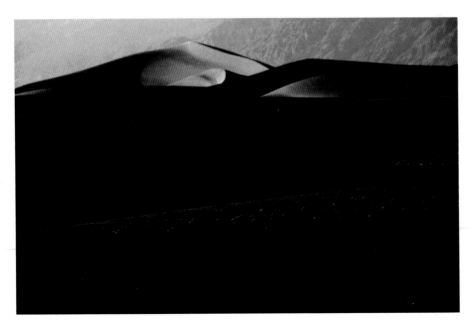

These two photographs were shot one hour before sunset in the dunes of Death Valley in the American southwest. With the camera on a tripod, I made a big bracket of exposures from −2½ stops to +1½ stops as I couldn't decide on the exposure I wanted. I received a pleasant surprise when the picture at −2 stops was more interesting and dramatic than the normal exposure. JG

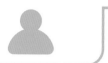

PROJECT 2

High-key photography

The high-key approach is ideal for subjects where a soft, dreamy look is wanted, for example in plants, nudes and portraits of children.

The photograph on pp.40–41 is a classic example of a traditional high-key portrait. Note how little highlight detail has been kept, with the result that the sitter's skin is very pale and the viewer's attention fixes on her eyes and mouth.

The old maxim for high-key photography is to expose for the shadows and let the highlights take care of themselves. The subject matter needs to be one that benefits from being light, not just in the sense that

there needs to be pale tones present but also that it should suit the atmosphere that high key gives.

What you are after for this project is lighting as close to shadowless as you can get. It's a good idea to have small areas of black in the picture to contrast with the overall light tones, such as the stems in the picture below. Bracket your exposures, starting on the normal exposure and overexposing in ½ stop steps up to +2 stops.

When honesty (Lunaria) pods dry they turn translucent white like tracing paper. This shot was made using back light, with a white reflector to fill the front. It is almost a silhouette, but the light coming through the pods has lit them up. A normal exposure reading would have turned the whole picture medium grey, so I overexposed by +1½ stops to keep it light. GH

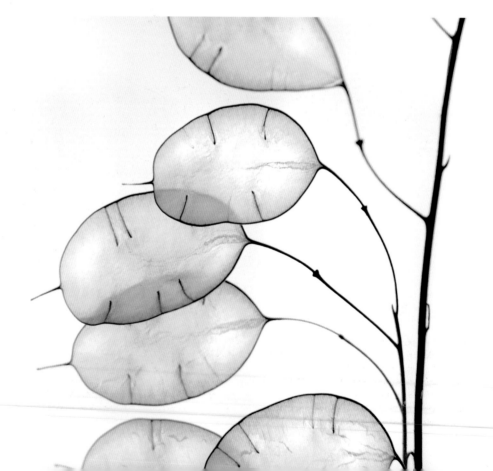

Most objects in this picture are predominantly white. The light was bounced off a large white reflector on the front left, with a white reflector on the right side to fill in and soften any shadows. I then overexposed by +2 stops from normal to get the high-key effect. GH

This intimate subject required a high-key approach. One light hidden behind the subjects illuminated the white sheet I used for the background. A large white reflector was placed each side of the camera to act as a soft front light. I used a warm-up filter and overexposed by +1 stop to give the light, delicate feel. GH

This portrait was taken in front of the Carlton Hotel during the Cannes Film Festival. The subject, who looked like a still from a 1920s movie, was completely front-lit by a bright but overcast day. The conditions were perfect for me to overexpose by +1 stop in order to emphasize her high-key make-up. JG

PROJECT 3

Low-key photography

A low-key picture is predominantly dark in tone, which gives a dramatic effect suitable for a range of subjects from atmospheric landscapes and interiors to urban scenes with an air of menace.

On a stormy day in the English Lake District this shaft of light hit the lake for a brief moment. I was shooting on infra-red black and white film, which has provided grain and high contrast. I took a highlight reading off the bright clouds and printed the picture dark and moody so the light on the water would be the focal point. JG

For a successful low-key picture the critical elements are the choice of subject matter, the light and the exposure. When all these come together successfully you will find you have taken exciting shots that convey a strong sense of atmosphere to the viewer.

Choose a subject that will benefit from looking dark and moody and look for light that is throwing deep shadows with little or no reflection. The exposure needs to be less than normal in order to keep the highlights and mid-tones rich and dark.

In contrast to high-key pictures, this time you expose for the highlights and let the shadows take care of themselves. To do this, use your spot meter mode to take a reading off the highlight area of your subject. The result is that the rest of the picture will be underexposed and low key.

An alternative way to achieve low-key exposures is to bracket on the minus side using exposure compensation, for example -1 stop, -2 stops, -3 stops, which will give you a range of density to choose from.

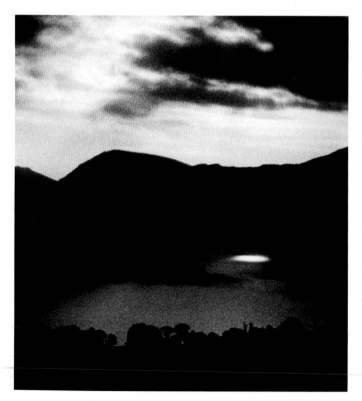

This shot of the little boy was exposed for dramatic effect. In reality, the scene looked much lighter to the eye. The low-key effect has come from underexposing by 2 stops. I achieved this by bracketing and chose the darkest picture. JG

Sunrise and sunset

There can be few photographers, professional or amateur, who haven't felt impelled to photograph the stunning sight of the sun rising or setting in a sky glowing with pink and purple.

When you are photographing a sunrise or sunset it's very tempting to point the camera directly at the sun. If you accept the camera's metering of this the sun will appear in your photograph as an intense red ball but everything else will be underexposed. If you want to hold some other surrounding detail you need to add +2 stops exposure (see right).

An alternative approach is to keep the sun to the side in the viewfinder, take a reading, then recompose and take the picture with that exposure. This will give you a more average exposure without the direct brightness of the sun fooling the meter into underexposing.

Shooting the sun

For this project, shoot a sunrise or sunset using the ball of the sun as the focal point and include some other interesting feature. The ball of sun never looks as big in the picture as you expect it to be, so use the longest lens you have.

Experiment with exposure compensation until you reach a good compromise between strong colour and detail in the rest of the frame. It's advisable to bracket to make sure of getting some good shots. There are no prizes for getting the picture in one exposure – a beautiful picture is the prize.

The second part of the project is to turn your back to the sunset and take advantage of the warm light to shoot romantic landscapes or even portraits. If the colour is too pale in your photographs, use a warming filter or warm up the white balance.

This dark picture was taken with the normal reading selected by the camera meter.

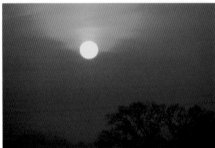

Given +2 stops exposure, the camera has included the detail.

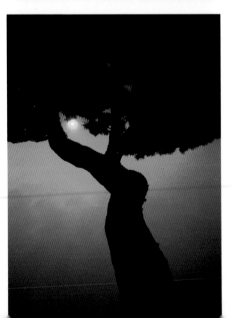

Here the sun is used as the focal point of a pattern. Knowing the tree would be silhouetted in such strong back-light, I took readings of the sun and the bottom left and top of the frame, arrived at an average and set the exposure on manual. GH

PROJECT 5

Silhouettes

The cutting of profiles from black paper originated in Europe in the early 1700s and became extremely popular. It was not only fashionable but also a much cheaper way of having your portrait made than commissioning a painting.

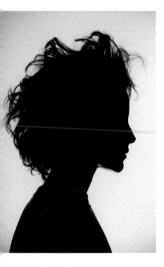

This silhouette is a straight imitation of the original cut-out look. I used a flash gun on an extension cable hidden behind her head, pointed to bounce off the white background and create the silhouette. I bracketed the exposures to make sure I got a white background and no detail in her face. JG

When photography was invented, shooting silhouettes was an easy technique to master and it has remained popular with photographers. A simple way to make a silhouette is to hang a piece of tracing paper or a thin white sheet inside a window on a bright sunny day. To get the correct exposure, set the camera to manual mode, take a reading of the sheet, then add +2 stops to the normal reading to ensure the sheet will be white.

Place your model about 2m (6½ft) in front of the sheet and make sure the room lights are turned off so your model will be in relative darkness. A wide aperture is best to keep the sheet out of focus, and if you are on a slow shutter speed you will need a tripod. You will get a sharper edge to the portrait if you use a low ISO setting. You may have trouble focusing on the dark face, in which case focus on the edge where the face meets the background. Compose your portrait and shoot.

The assignments here are first to make a silhouette against a window as described, or use the flash technique shown left. Secondly, make one outside, remembering that the light behind your subject has to be at least 3 stops brighter than the light falling on it.

The girl's silhouette against the dramatic flames makes an unusual Bonfire Night image. I framed the picture and waited until she turned her head so I could see her profile. I took a direct centre-weighted reading and added +1 stop exposure compensation so the flames wouldn't be too dark. GH

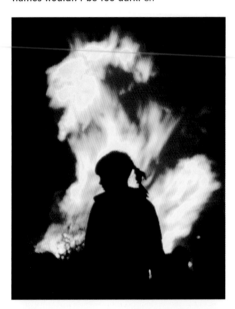

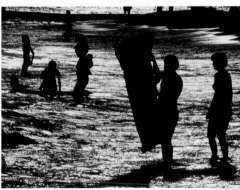

Early morning and late afternoon are silhouette times of day; any subject caught between the low-angled light and the camera will appear in silhouette. In this shot, made at about 4pm, the sun has kicked off the sea and sent all the bathers into silhouette. The exposure was +½ a stop. JG

Multiple exposures

Two or more exposures mixed with each other can produce some unusual and interesting results. Once you have got to grips with the technique you may find you want to experiment with more complicated moving subjects.

Multiple exposures can of course be done in Photoshop, but the degree of control you have on the computer means that often the results lack spontaneity. The fun of trying it in-camera is that it is a more random, hit-and-miss method. Accidents often produce very creative images that, even if they don't entirely please you, can send you off on new paths of exploration. Film shooters will find it even more experimental as the results can't be seen until the film is processed.

Mixing images

The more images you mix together the more complicated the picture becomes. For this project it's best to start with just two images. You will need to use a camera with a multiple-exposure facility – or one where the film is wound on by hand in traditional fashion.

Choose your main subject first then look for a background. The best results generally come from overexposing the main shot at normal or +½ stop then underexposing the background, which allows the main shot to stand out. If each exposure is the same, one image tends to mix with the other and you can end up with an abstract pattern – it depends on the subjects you choose.

Try making a double portrait, too. For this you need to make both exposures normal as the two shots will not be overlapping.

To get this double portrait of John, I had him wear a black sweater, then put up a black backdrop to stop any background details showing through his face. I set the camera to multi-exposure and selected 2 shots. I shot his profile first, leaving space to the right of the shadowed side of his face to add the second shot. I then recomposed with John facing me and made the second exposure. GH

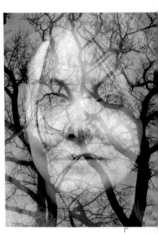

I took the portrait first, underexposing by −½ stop, then shot the trees at −1 stop to get the sky dark enough. It took three attempts to get it right. I think the glow of the face against the tree pattern looks satisfyingly spooky. GH

This tree abstract was done by shooting bare branches against the sky. I did the first exposure with the camera horizontal and the second vertical, keeping both exposures the same. The 90-degree criss-cross pattern has given an effect like reflections in a pond. GH

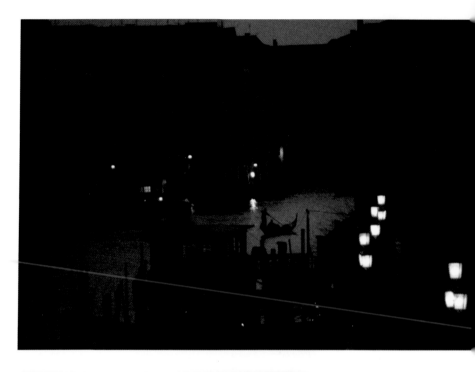

I chose this photograph out of a bracket of exposures. There was still some daylight left to add to the light of the lamps and I used centre-weighted, aperture-priority exposure. I couldn't decide how I wanted this to look, but it turned out that the darkest exposure gave me the atmosphere of Venice at dusk. JG

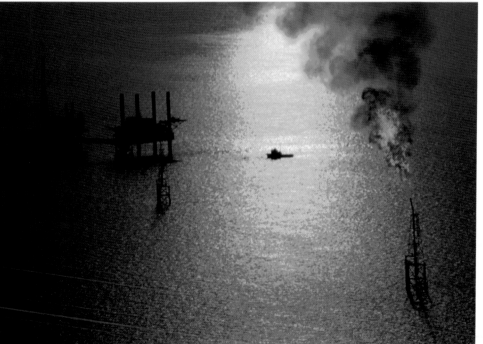

This shot of an oil rig in the Arabian Gulf was taken at sunset but I used only the light trail of the sun and its hot colours to compose my picture. There are many ways of shooting a sunset, and the usual one of pointing the camera at the ball of the sun can sometimes be boring. JG

Ian was wearing a camouflage jacket and hood, and the idea was to double-expose dry leaves over his face to add to the camouflage effect. In my first try both exposures were the same but his face was too obscured. I then underexposed the leaves by -1 stop and used normal exposure for his face, giving a great result. GH

Exposure review

- **There are more ways of getting the exposure right than simply accepting the camera's version of correct exposure.**
- **Choosing high-key or low-key lighting, silhouettes and multiple exposures gives you the chance to add atmosphere to your pictures and exercise your creativity.**

Project 1 Bracketing

You should have seen from the project how density (light or dark) affects colour, tone and the mood of your photograph. Bracketing is a great way to learn this.

Project 2 High-key photography

If you didn't achieve a satisfactory result, you may have chosen the wrong subject with too much shadow – rethink your subject matter and lighting. If the picture was too bleached out you possibly overexposed too much. Next time, try reducing the exposure.

Project 3 Low-key photography

If your pictures didn't have the right mood, maybe you chose a subject that lacked enough shadow; in the case of a portrait, perhaps your model didn't wear sufficiently dark clothing. If the exposure was wrong, study the exposure brackets as they will help you to see how to get your exposure right next time.

Project 4 Sunrise and sunset

One problem you may have had is missing the right moment, which is quickly over. You cannot chase a sunrise or sunset – you need to plan ahead, set up and wait. A compass reading can be very helpful to establish where you should be. If you don't have a really long lens, you may be disappointed at how small the sun ball appeared in your picture. Instead, try excluding the sun and make beautiful pictures with the colours.

Project 5 Silhouettes

You may have found that the exposure difference between the background and the subject wasn't enough. If you had too much detail in the subject, perhaps your flash fired an automatic fill-in – check that it is turned off.

Project 6 Multiple exposure

If you were disappointed with the result, it's probably because you chose subjects that weren't sympathetic to each other, or the exposures were too similar. Try again, making one of the exposures darker than the other. If that fails, change one of the subjects or start from scratch.

A double portrait with details of the first showing through the second means that you didn't achieve a sufficiently dark shadow area on the first. Take a look at John's profile on p.51 and aim for a similar effect.

Aperture

Using aperture creatively

The ability to control the depth of field in a photograph offers you the chance to convey mood, draw the viewer's attention to a particular point of interest in the composition and influence colour and tone.

You have learnt about the functions of the aperture and shutter as the mechanisms that control the exposure; now it's time to discover the use of the aperture as a creative tool.

The aperture controls the depth of field in the photograph – that is, the distance in front of and behind the point of focus that is held sharp. Many photographers keep their cameras almost permanently set to aperture priority, choosing to make the depth of field a major part of their creative decision about how their shots will look.

Handling colour and tone

The ability to decide upon the depth of field you want gives you considerable control over colour and tone. When colours are out of focus they merge together; when they are sharp they become hard-edged, each colour separated from its neighbours. To be able to change the relationship of

I shot these back-lit poppy buds on a 300mm lens at full aperture (f/4.5). The combination of the long lens and wide aperture has isolated the buds against swirls of orange colour. GH

I wanted the tramlines of Melbourne to be in sharp focus from front to back, which I achieved by stopping down to f/22. Using a 300mm lens compressed the perspective. I underexposed the background by -2½ stops to make the tramlines stand out against the darkness. JG

colours and tonal range by enlarging or reducing the aperture is very exciting.

Influencing emphasis

Your chosen aperture also affects the emphasis that you place on the subject matter. For instance, if you want to isolate your sitter in a portrait shot and make the viewer study the face without being distracted by the background, you would shoot with the aperture wide open; the face would be sharp but everything in the foreground and background would be out of focus. On the other hand, if you decide that the sitter's environment is important to the story – for example, an artist in the atmosphere of her studio – you would then choose to stop down to a smaller aperture to keep the surroundings and any foreground more sharply in focus.

Checking your settings

You can check the depth of field by using your depth of field preview button if your camera has one, or digital photographers can check it on the LCD screen. However, you must take careful note of the shutter speed that your camera has set. Stopping down to a smaller aperture to obtain greater depth of field may have necessitated a slower shutter speed that requires a tripod or an increase in the ISO setting.

Seeing the big picture

Just before I took the double-page photograph that opens this lesson I was packing my equipment away in the car. The man and his dog appeared from the side of the road and, spotting a good shot, I rushed to get the camera out again. I zoomed the lens to 200mm and shot at full aperture of f/4.5 to throw the background out of focus. GH

Depth of field

For creative photography, making a positive decision about what the depth of field will be is equally important across all genres from still life to sports.

Some students of photography find depth of field a difficult technique to understand, but it's really quite simple and it's important to grasp it because it is such a potentially exciting creative tool.

The still life and portrait photographs shown here use aperture in exactly the same way, though this might not be immediately obvious because the subject matter is so different.

Still life

This guitar makes a good subject for a still life because you can easily see the effect the choice of aperture has. The left-hand picture was shot at f/1.8 on a 50mm lens; note just how limited the depth of field is. The right-hand shot was taken at f/22 and the guitar is now sharp right through from front to back. You can use this variable depth of field to place the visual emphasis wherever you

Using a very wide aperture of f/1.8 has left only a minimum area of the guitar in focus at the far end of the fretboard.

Even though the guitar is angled directly away from the camera, an aperture of f/22 has succeeded in recording it all in focus.

choose. With the aperture wide open you can make the viewer concentrate on the only part of the object in focus; by stopping it down, you can be more descriptive by keeping everything in focus. A tripod was used here to make sure the positioning of the guitar was the same in both pictures and that there was no camera movement.

Portrait

This portrait of Ines was set up with a foreground, middle ground and background. The lens was a zoom, set at 80mm, and the first shot was taken with the aperture wide open on f/2.8. Both the flowers and the street scene behind are completely out of focus. This has placed the full emphasis of the picture on Ines, as the eye is not distracted by any other detail.

For the second shot the aperture was stopped right down to f/22. Now the flowers are sharp and a street scene has become visible behind Ines. You can see the obvious application of the aperture here; the first picture is solely a portrait of Ines, while the second picture is a portrait of Ines at the street café.

A tripod was used because in aperture priority the camera automatically slowed the shutter speed down to 1/2 second to maintain the same light value when the aperture was stopped down to f/22.

With the aperture wide open on f/2.8, there is nothing in this picture for the viewer's eye to fasten on except Ines herself.

Stopping the aperture down to f/22 has placed Ines in an urban scene, giving the viewer information about her surroundings.

Shooting with a wide-open aperture

The purpose of this project is to practise using the aperture wide open (maximum aperture). If you have always allowed the camera to decide the aperture, you will find it a revelation to take control of your backgrounds.

With the camera focused on a foreground subject, you can throw the background out of focus by setting the aperture to its widest opening. The longer the focal length of the lens or zoom setting, the shallower the depth of field will be and therefore the more dramatic the effect.

Remember to consider the background in terms of colour rather than information and if possible place your subject so that the background colour works well with the part of the picture that is in focus – for example, a complementary colour or one that echoes even a small patch of colour on the subject will provide a coherent picture that pleases the eye. An unrelated colour won't add to your picture, and if it is strident too it will distract attention from your subject.

This photograph was shot on a zoom setting of 135mm at f/3.5. Throwing the background to the fern out of focus draws attention to the beautiful structure of the plant and loses the confusing detail of the background foliage. I used the shade setting in white balance to add extra warmth. GH

This is a typical long-lens wide-aperture portrait, albeit of a bird. It was shot in Kenya from a jeep, using a 400mm lens at f/3.5. The camera was supported by a bean bag. The straggly bushes behind have been converted into a lovely green background that zings the bird forward to the eye. JG

Using selective focus

Choosing a very shallow depth of field to place emphasis on the point of interest is known as selective focus. It enables you to achieve dramatic shots and to draw the viewer's eye to your subject.

The first project in this lesson explored the effects of using full aperture and throwing the background out of focus. In the second project this idea is taken a step further to include an out-of-focus foreground as well. How unsharp the foreground will be depends upon the length of the lens, the size of the aperture and, very importantly, the distances between the lens, foreground and subject. This technique is often seen when the photographer wants to create a soft, romantic mood in a picture.

Practicalities

Sometimes your subject falls perfectly into place, but you may often find that you have a perfect background but nothing in the foreground to work with. If you can't achieve what you need by repositioning your subject a little, try to add your own foreground object, for example a branch, some flowers or even a scarf.

If you want both the background and subject sharp and the foreground out of focus, you need to keep the subject and background as close together as possible, with the foreground still close to the lens.

You will probably find this project trickier than the first. To make it easier, take your subject with you – a patient friend who will move back and forth while you experiment. Taking a range of shots with varying apertures such as f/2.8, f/4 and f/5.6 will help you to learn how to achieve different effects; sometimes you may want backgrounds or foregrounds to be slightly unsharp rather than completely out of focus.

This shot of a lemon was the result of playing around with some kitchen objects. I used a 80mm lens and stopped down to f/5.6, which kept the cutlery out of focus but made it still recognizable. Rather than this being just a straightforward photograph of a lemon the cooking process is now implied. GH

I spotted this family through the trees at sunset. The out-of-focus foreground adds an atmosphere of this being a secret place where they are in their own private world. I waited until the group made an interesting shape; the boy pointing at something adds an element of mystery. This was shot on a zoom set to 200mm with a wide-open aperture of f/3.5. JG

PROJECT 3

Stopping down

Sometimes you will want everything in your photograph to be in focus. Unlike shallow depth of field, where you have to make choices as to how much or how little, this is an absolute which depends only on the capacity of your lens.

It was essential that this shot of the Wrigley Field Baseball Park in Chicago was sharp from foreground to background; I needed to hold detail in the city skyline as well as in the fans below my vantage point. Shooting on a 24mm lens at f/16, I did just that – the picture works well. JG

The two main reasons for stopping down to hold focus through from foreground to background are the need to be descriptive about a place or event and the desire for a hard-edged, graphic composition.

When you are shooting stopped down you will get most effect by using a wide-angle lens or a wide-angle setting on a zoom. As stopping down to small apertures means increasing the amount of time that the film or sensor is exposed to light, remember to keep an eye on the shutter speed as you will need to use a tripod if the shutter speeds are getting long enough to risk camera shake. A rough guide is to use a tripod if the

shutter speed, in fractions of a second, is less than the length of your lens or zoom setting – for example, a speed of 1/60 with a l05mm lens will require camera support.

As objects in the background will be sharp, you will need to search the viewfinder very carefully to make sure there are no distracting objects that will spoil your picture, such as the old classic of a telegraph pole growing out of the top of your subject's head. If you are shooting on a digital camera you can also take a shot and check again on the LCD screen. If it's not possible to move the subject or unwanted object, editing it out in Photoshop is the modern option.

Zion National Park is noted for its rock formations, which look as if they were formed by the stirring spoon of a giant. To describe them best the picture needed to be sharp from front to back. A 24mm lens at f/16 has done the trick, with a polarizing filter to take the shine off the rocks and intensify the blue sky. JG

These 'kettles' are used in the distillation of Cognac. I wanted my composition using the round and oval shapes to be as clear and sharp as possible. By shooting on a wide-angle 20mm lens and stopping down to f/11, I have maintained sharpness from front to back. The shutter speed was 1/8 second, with a tripod. JG

Quick tip

• The best way to maximize depth of field is to focus on a point one-third of the way into your composition, then stop the lens down to a small aperture, such as f/16. Lenses maintain two-thirds of their depth of field past the point of focus and one-third in front. This point of focus is known as the hyperfocal distance.

The Madagascan spice market would look pretty shot at any aperture. I decided to hold it all in focus to make sure the colours and the round shapes of the bags would be well separated. I used a zoom lens at a wide-angle setting, stopped down to f/11. JG

REVIEW

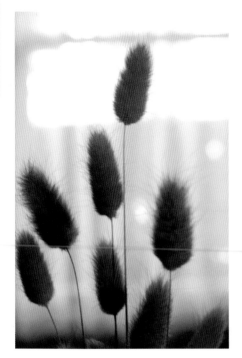

I back-lit these seedheads by placing them in front of a window with a white net curtain. I used a desk lamp as a warm front light on the seedheads and shot on a 150mm lens at f/5.6. The out-of-focus background makes a pleasing pattern without being too conspicuous. GH

This photograph was for an annual report and I wanted it to be descriptive rather than arty. The whisky barrels needed to look close together and sharp all the way through, so I used a 75mm lens setting on my zoom and stopped down to f/16 with a warming filter. It was shot outside in the storage yard in sunlight. JG

By using a wide aperture of f/4 on a 105mm macro lens I was able to isolate the trumpet of the daffodil. The out-of-focus foreground and background has added a soft, romantic feeling to the picture. GH

Aperture review

- Setting your camera to aperture priority allows you to take creative decisions about how much of your photograph you want to be in sharp focus.
- A shallow depth of field gives you the chance not only to guide the viewer's eye but also to influence colour and tone.

Project 1 Shooting with a wide-open aperture

This should have been the easiest of the three projects because in principle, once you have set your aperture wide open and focused on your subject, the background will be out of focus. If it wasn't sufficiently out of focus, you may have had your zoom set to a wide angle, which gives a greater depth of field than a telephoto lens. Alternatively, your subject may have been too close to the background.

Did you remember to consider the colours in the background? You are in effect washing the colours together to create an attractive background that doesn't distract from the subject.

Project 2 Using selective focus

If your foreground was not as soft as you expected it to be, you may not have set a large enough aperture or you may have been using too short a focal length on your lens. Other things to consider are that the foreground was too close to your main subject, or not close enough to your lens. Selective focus works best when the foreground detail is very soft.

Did the out-of-focus foreground colours work well with your main subject? With selective focus, you need to consider both foreground and background colour.

Project 3 Stopping down

If your image was unsharp all over this was probably caused by camera movement because your shutter speed was too slow for you to handhold the camera. Always check your shutter speed and if need be use a tripod.

If you didn't maintain sharpness throughout the picture you may have been inadvertently using the telephoto setting on your zoom. Longer lenses do not have the inherent depth of field of wide-angle lenses even when they are at minimum aperture.

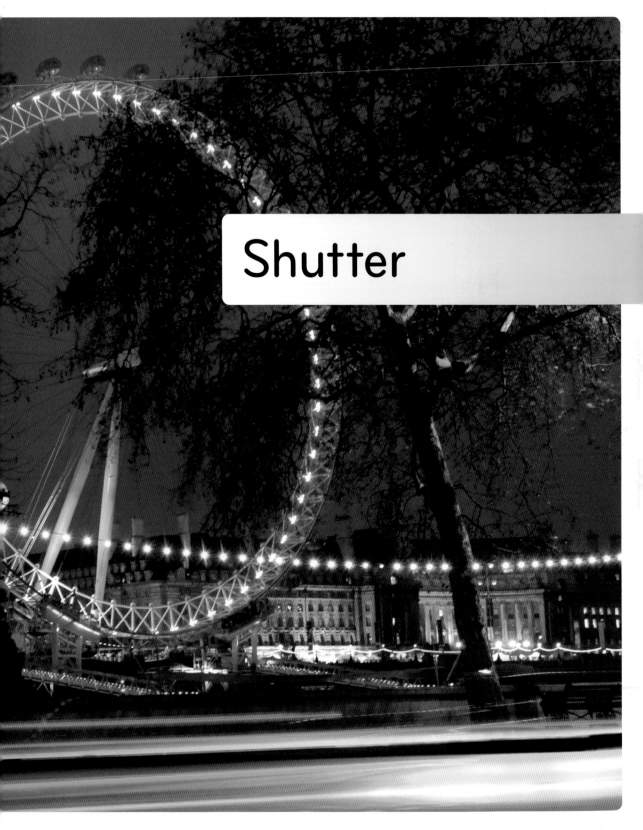

Shutter

Exploring shutter speeds

Shutter speed, the other half of the exposure equation, is just as important as the choice of aperture to the creative photographer.

The shutter's job of controlling movement in the photograph enables us to determine the way colours are separated in the picture. Changing shutter speed means that colour composition and relationships will be entirely different, and that of course applies equally to the tonal management of black and white.

In the case of sports photographers, the interpretation of movement is their stock in trade. More often than not their editors are looking for a frozen moment; the newspaper or magazine readers usually want to see the expressions on the faces of their mud-spattered heroes. This requires a fast shutter speed to produce sharp, hard-edged shapes that are crystal clear.

However, speed can also be elegantly interpreted with a slow shutter setting that blurs the shape of the moving subject, describing the movement in a poetically visual way. It can be interesting for the study of movement and also for its painterly quality; the effect can look almost like brush strokes.

Extended exposures

You also have the choice of using very long exposures - up to 30" seconds timed or, if you want still longer exposures, you can use the Bulb setting. These extreme shutter speeds are generally used for very low light levels, such as night and even moonlight pictures. Shutter speeds at such extremes allow us to see the frenetic world around us in a way that is not possible for the human eye, which makes this use of camera technology very interesting.

You will need a tripod for these long exposures. Alternatively, you can handhold the camera and move it around during the exposure as if you were painting with light.

Shutter priority

When you are working on shutter priority, remember that the camera is altering the aperture as you change the shutter speeds in order to maintain correct exposure. Keep an eye on the aperture when you are using speeds of 1/1000 second or more, as the camera may need to set maximum aperture, reducing depth of field; digital users have the choice of changing the ISO speed to retain the preferred aperture, while film users will have to load a higher ISO film.

Have a go at the assignments in this lesson and see the difference you can make by taking control of the shutter in manual or shutter priority mode rather than leaving the camera to make the decisions.

Seeing the big picture

The double-page shot of the London Eye that opens this lesson was taken from the Thames Embankment on the opposite side of the river. My zoom lens was set to 27mm. I used a shutter speed of 2" seconds, long enough to allow the traffic to leave light trails in the foreground. The aperture was f/11 and the ISO 400. GH

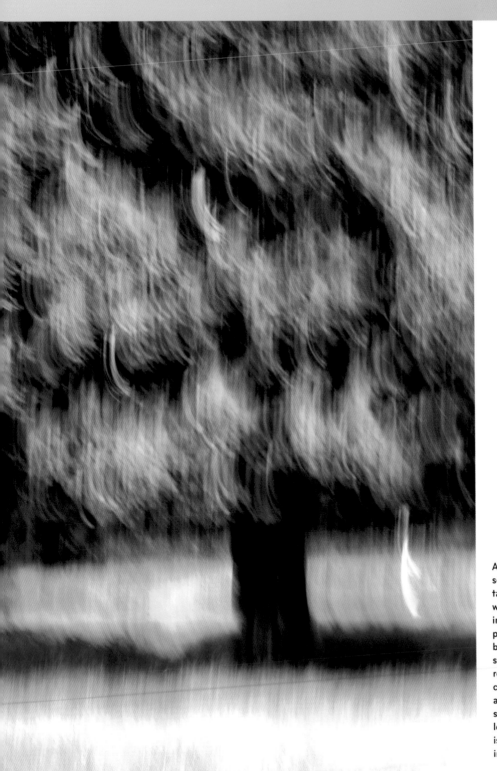

A shutter speed of 1/8 second, combined with taking the shot as I walked, gave this an impressionistic feel. I perfected the technique by using different shutter speeds and checking the results on my digital camera. The blue streaks are blurred areas of sky showing through the leaves and the white one is highlights from a lake in the background. GH

Shutter speeds and movement

Exposure time in relation to movement can take a lot of experimentation to get right, not least because the speed of the moving subject may vary.

The photographs below demonstrate shutter speeds in relation to subject movement. They show you not only the choices you have in interpreting movement, but also what can be achieved graphically – that is, the influence of the shutter speed on the colour separation and tonal management of the picture. Note the change in the depth of field in the top two pictures; the aperture has compensated for a slower shutter speed.

Quick tip

• If you don't have enough light for a fast shutter speed, increase the ISO setting. Changing from 200 ISO to 800 ISO, for example, would enable you to reduce a shutter speed from 1/250 to 1/1000 second – a big difference.

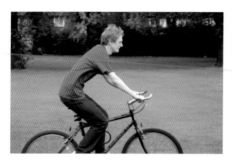

The cyclist rode past the stationary camera, which was on a tripod. Exposure of 1/500 second has almost frozen his movement.

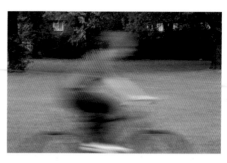

As the cyclist rode past the stationary camera for a second time at the same speed the exposure was 1/15 second, blurring his action.

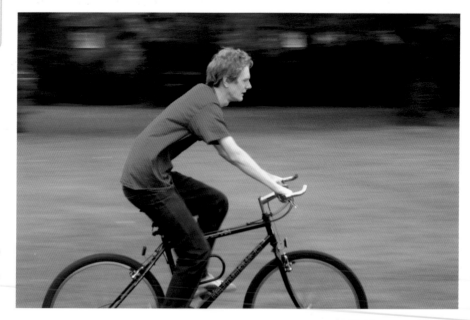

Here the camera panned with the cyclist as he rode past. With an exposure of 1/15 second, the cyclist is sharp and the background is blurred.

The peak action

Capturing action at its peak allows you to freeze graceful shapes where the subject often seems to hang in the air forever.

There is a point in many movements in sports, dance or play where the subject has finished the upward trajectory and has not yet started on the downward journey. In this moment, which often lasts for only a fraction of a second, the subject is actually stationary. It has traditionally been called the peak action.

The early experimenters in action photography exploited this moment largely because they did not have the luxury of fast shutter speeds that could freeze motion. Today, the top sports photographers are expert at anticipating the peak action. There is an old sports photographer's saying, 'If you see the great shot in the camera, it is already too late.' In other words, you need to anticipate peak action and be pushing the button as it is peaking.

The peak action is often where the most dramatic and poetic movement pictures can be made. Catching it requires a combination of fierce concentration and fast reflexes.

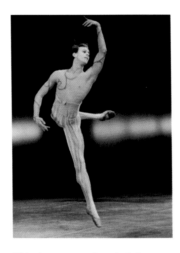

This dancer was almost stationary, caught between going up and coming down. I needed to get him at the peak because in low light I could not shoot faster than 1/125 second, which would have blurred him earlier or later in the leap. JG

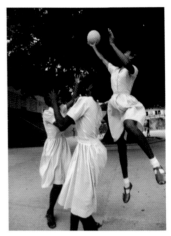

These schoolgirls playing netball are caught at the peak of their action. The court was in shadow so I could only manage 1/125 second; in bright light I would choose to shoot 1/500 second or faster to be sure of freezing the movement. JG

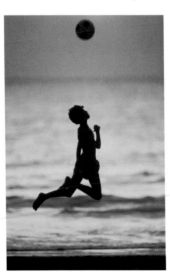

The young boy heading the football on the beach in the Seychelles has struck a beautiful pose at the top of his jump. This was shot at 1/250 second, but I could have caught him sharp in this position even at 1/60 second. However, the ball would have been blurred. JG

I caught the boy on the trampoline at 1/250 second though, as he was at the top of his bounce, I could have frozen him at 1/60. This is a good peak action exercise, because you can repeat the bounce until you learn to consistently catch the action at its peak. GH

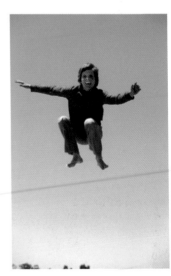

PROJECT 1

Fast shutter speed

A photograph can freeze movements that to our eye are just a blur, capturing shapes and actions we would otherwise never see.

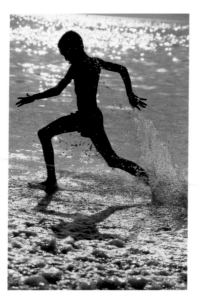

When I saw this picture I was pleasantly surprised. I hadn't spotted the shape the hair and water had made in the viewfinder, although I knew that they would be frozen with a shutter speed of 1/2000 second. JG

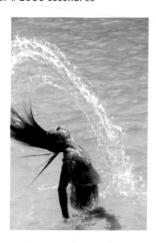

This was an ideal subject for a shutter speed of 1/2000 second because you can see the beautiful shape the boy has made and the individual drops of water he is kicking up. JG

To use your shutter creatively, you first need to understand how the shutter controls movement at different speeds.

The first exercise is to freeze a moving subject. Asking a friend to bicycle past you repeatedly at the same distance from the camera, keeping to the same speed, is a convenient way to experiment with this. Set your camera on a tripod to keep it stationary and try shutter speeds of 1/125, 1/250, 1/500 and 1/1000 second. It's likely that you'll have to take a number of shots before you get the framing right. You'll see how your subject becomes progressively sharper as the length of the exposure diminishes.

High-speed shots

Once you have mastered this, try shooting faster-moving subjects such as racehorses or, for the ultimate challenge, racing cars. Obviously you won't have any degree of control over what they do individually, but an afternoon at a race track will give you plenty of opportunity. Start at 1/500 second and go on to 1/1000, 1/2000, 1/4000 and 1/8000. Framing your subject in a way that is compositionally strong will be even more of a challenge with subjects travelling at high speed but, as with catching the peak action, learning to anticipate the moment is the key.

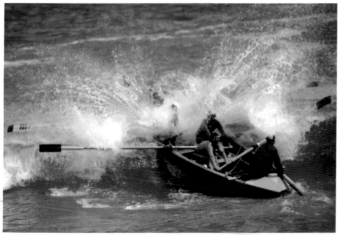

This surfboat in the waves was caught on 1/1500 second. Even at that speed the water is not completely sharp, but the impact of the boat hitting the wave has been well caught and shows the drama of the sport. JG

Slow shutter speed

As far as deliberately blurring a moving object goes, slow shutter speed is a relative term that depends upon the speed of the action.

For this project you will need to consider your shutter speed in relation to your subject. For example, 1/125 second can be a slow shutter speed for a car driving past the camera, giving you considerable blur. However, it would be a fast shutter speed to use for a garden snail and would freeze its movement.

The aim of the project is to use shutter speeds slow enough to allow the subject to blur across the picture. Think of it as a way of freeing you up to look for abstract images that have the appearance of an Impressionist painting rather than a photographic image.

Creative blur

Find a subject that is moving, preferably one with bright colours because the blurred colour will give a pretty result. Secure the camera to a tripod or hold it as still as possible and set a slow shutter speed – start at 1/30 second and slow down to 1/15, 1/8, 1/4 and 1/2 second.

Once you have got the hang of making your subject blur across the frame to give a flow of movement, vary the shutter speed to give a range of effects. The slower the speed the more abstract the subject will become.

If you are a film user you won't see any of the results until after the shoot, of course – it's crucial to make a note of the shutter speed for each shot or you won't know how to repeat effects you like another time. If you are shooting digitally, you have the big advantage of seeing the pictures immediately and the details are automatically recorded by the camera.

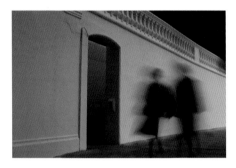

This wall had a good graphic shape so I used a wide-angle lens to exaggerate the perspective. I then waited for a subject to move into the space. I shot at 1/4 second and f/8. The slow shutter speed has blurred the people into a ghostly image which is effective against the very sharp background. GH

I photographed this lion on Westminster Bridge in London as a bus went past, using a shutter speed of 1/8 second with the camera on a tripod. This combination of a fixed subject and blurred foreground could be pushed further with an object moving in the background as well. JG

The long exposure I used here made the water look milky, which contrasts well with the sharp autumn leaves. This is a classic technique to use with moving water. I used a tripod and an exposure of 1" second. Adding a warm-up filter enhanced the autumn tones. GH

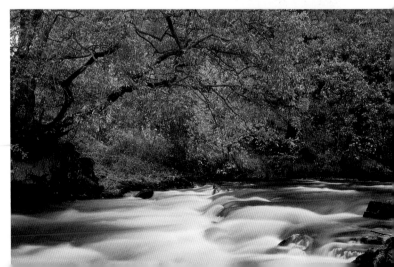

Panning

Panning is a favourite technique with all action photographers, who use it to keep a moving subject sharper against a blurred stationary background.

This is the classic use of panning in sports photography, keeping the subject sharp while blurring the background. With a 100mm zoom set to 1/125 second at f/5.6, I used continuous exposure at 5 frames per second. GH

Panning means following the subject with the camera as it approaches you and releasing the shutter as it goes past. It's very important to keep the camera moving smoothly during and after the exposure – think of it like the follow through in a golf swing. You should also try to frame the shot with some space in front of the subject so that it is not running into the edge of the picture, which you may find tricky at first.

At faster shutter speeds panning can reverse the effect given by a slow shutter speed on a stationary camera, creating a blurred background with the subject sharp against it. However, you can also use slower shutter speeds that will blur the moving subject and blur the background still further.

There are so many variables with panning, such as different shutter and subject speeds and the distance of the camera from the subject, that you will need quite a bit of practice to discover what combination of these variables works for you and how you can perfect the technique. Make sure you do your practice before an important event, not during it! Local football games and other amateur sports are ideal for this, giving you plenty of opportunity for multiple shots.

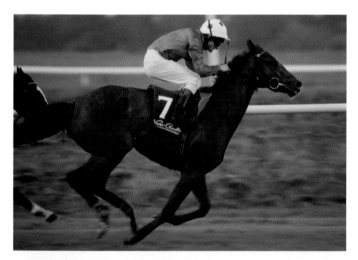

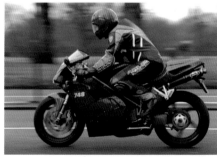

The motorbike was travelling at 60mph and I shot it with a fast pan at 1/250 second. Longer exposure would have given more speed blur but the bike would have been less sharp. GH

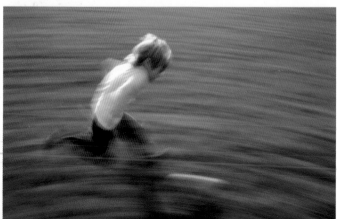

Using a 28mm lens and 1/4 second shutter speed, I panned the camera as Jon ran around me kicking the football. He remains recognizably sharp and the technique has given a great feeling of speed. GH

Movement to camera

Freezing the movement of a subject approaching the camera is more difficult as the focus changes rapidly, but modern technology has made it easier.

Focusing on a subject moving towards the camera used to be tricky as the photographer had to follow focus manually or pre-focus on a spot ahead of the subject and press the shutter when it reached that point. However, with fast auto-focus you should have no problem. You can use a much slower shutter speed than you would need for a subject going across the camera – 1/125 second as opposed to 1/1000 second, for example. Make sure your auto-focus is set on C (see p.29). Children are good to practise on since you don't have to worry about your safety as you would with, say, a herd of horses.

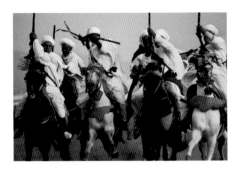

I shot this picture of the Fantasia horsemen of Morocco on 1/125 second on a 200mm lens. The image is not absolutely sharp but I like the slight movement as it emphasizes the speed at which they are charging. JG

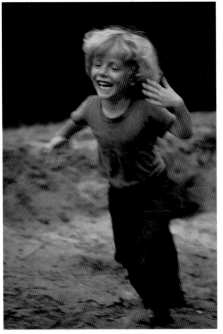

This shot of Nick running towards me was taken at only 1/60 second. It is not necessary to completely freeze all action shots – sometimes a little bit of blur in the picture looks attractive, as it does here. JG

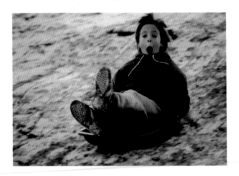

Here Matt is travelling at considerable speed. If he had been going past instead of towards me I would have needed 1/1000 to freeze him but even in the low winter light I was able to freeze the movement on 1/125 second. JG

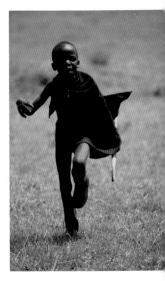

This Maasai boy in Kenya was trying to scare me by running at me swinging his spear. The auto focus on C has done its job and kept him sharp. The picture was shot at about 1/200 to 1/500 second, using the zoom wider and wider to keep the boy framed as I wanted. JG

PROJECT 5

Camera movement

Moving the camera during a long exposure allows you to use it like a paintbrush, but with unpredictable results. The blurred colours and abstract shapes you will get can make exciting and original images.

The splashes of pink amid the blue and green attracted me to this picture. I shot it first with the camera still, but on seeing the result I felt some movement would give an impressionistic look. I moved the camera in various directions, with a shutter speed of 1/15 second and 200 ISO; this diagonal one was best. GH

In this project you are going to treat your camera as an artist's medium to make patterns rather than shoot a literal representation of a scene.

Shutter speed and ISO

Start the project by using an exposure of 1" second. The results you get will depend on how fast you move the camera and whether the subject is moving or not. You can work in daylight or at night, and in colour or black and white. A low ISO setting will give you smoother, more saturated pictures, while a high ISO will give a more impressionistic look because of the larger grain or noise.

The fun of this project is that each picture you take will be unique. The examples here are just a starting point – it is for you to pick up the camera and paint your own pictures. You are sure to create some images that will make great posters for your wall.

I took this shot of Manhattan from the Staten Island ferry in the early evening. My shutter speed was about 2" seconds and the ferry was heaving about on the choppy water. JG

Here I panned in a diagonal with the traffic and jiggled the camera at the same time, with the exposure set to 1" second at f/3.5. I particularly like the light streak patterns. GH

Time exposure

Extended shutter opening is known as time exposure, defined here as 1" second to many hours. You can use it to discover unexpected patterns, even in your absence, or choose to make your own.

Most modern cameras will give time exposures up to 30" seconds. After that, the Bulb setting will allow you to expose for as long as the shutter release is held open with a cable release or remote control. You will of course need a tripod or something reliably solid to support the camera then, once you have opened the shutter, you can leave the camera to its own devices unless you want to take an active hand in the imagery.

Night shots using the lights of the moving traffic to streak red and white stripes across the picture are often striking, but try some more unusual things too. Using a torch with coloured gels to draw shapes in the air is fun and can produce interesting pictures.

You can also shoot during the day, but you will need the lowest ISO setting, the smallest aperture and probably a dull day as well to get a sufficiently slow shutter speed.

I shot this in a dark room at night, using a torch to create the light. I decided on 200 ISO and 10" seconds exposure at f/5.6 – I needed enough time to move into shot, turn the torch on, point it at the camera and make a drawing. A single image looked uninteresting, so I used multi-exposure (see p. 51) and made three exposures, each with a different colour over the torch. GH

This night sky was shot with 200 ISO film and the camera on a tripod. I locked the shutter open with a cable release on Bulb for 3 hours, setting the aperture to f/5.6. The rotation of the earth has caused the stars to draw arcs across the dark sky. The picture was a bit colourless, so I manipulated it in Photoshop using the three different colour channels in Levels. JG

The highlight behind this autumn tree was a perfect position to place my subject. I put the camera on a tripod, set an aperture of f/8 and asked her to run back and forth while I tried shutter speeds from 1/60 to 1/2 second. The one with a small amount of movement – 1/30 second – worked the best. GH

This diver was photographed in the Seychelles on a sunny day. There was so much light I was able to shoot on 1/2000 second stopped down to f/8, using 100 ISO film. At that shutter speed and aperture, sharpness was assured. JG

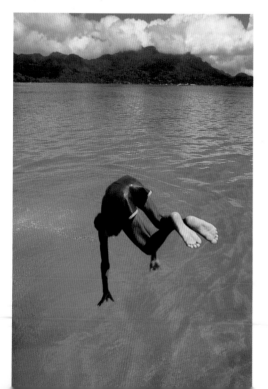

The shutter speed here was about 1/250 second – the moving hoop is sharp but there is slight movement in the running foot. The exposure is -1 stop, giving the rich brown colours. JG

Shutter review

- **A creative use of shutter speed can bring a variety of interesting and unexpected results – don't always stop at what seems 'right' for a shot.**
- **You may have to do a lot of experimenting before you can anticipate with some certainty what your picture will be like, but every shot is a learning process.**

Project 1 Fast shutter speed

The fast shutter speed of a camera shows us things that are invisible to the human eye. Did your pictures do that for you? If you couldn't achieve high enough shutter speeds you may need to increase your 1SO rating to around 1000 ISO or, if you are using film, load a faster film (800 or 1600 ISO).

If you had trouble capturing action, try less ambitious projects where the action is slower and then, once you find success, work up to faster-moving subjects. You will find your motor drive very helpful for action pictures.

Freezing water is something that many photographers like to do, but if you have tried and failed to freeze really turbulent water such as a waterfall the problem may have been that you didn't shoot on a bright enough day with plenty of light – you will need shutter speeds of 1/2000 to 1/4000 second to freeze fast-running water.

Project 2 Slow shutter speed

Did this project give you some unexpected and even magical results? If the answer is no, you haven't really experimented enough. The joy of slow shutter speed photography is that the camera shows us a world that is surprising and different. If you are a bit disappointed with the results, maybe the colours in the pictures weren't vivid enough or the subject wasn't suitable.

Project 3 Panning

If you have had trouble getting the subject in the middle of the frame you need more practice – you haven't got your rhythm right yet. If the subject is too blurred or not blurred enough for your liking, change shutter speeds. For a really stunning pan, the colours and shapes in the background are important as they determine the colour of the streaks behind the subject.

Project 4 Movement to camera

If the subject wasn't sharp you may not have had your camera set on C in the auto-focus mode; if it was on S the auto-focus would have kept to the focus it set when you pressed the shutter button halfway down rather than refocusing as the subject moved.

A helpful tip if you are having trouble with holding sharpness is not to let the action get too close to you. Shoot from further away on a telephoto zoom setting – it is easier to hold focus.

If you are zooming during the movement you will probably have problems keeping the framing accurate throughout the zoom. With practice this will come to you.

Project 5 Camera movement

Technically speaking there is nothing that can go wrong with this project because it is purely subjective – it is simply a matter of whether you found the results pleasing. If not, they probably stimulated ideas for adaptations in future projects.

Project 6 Time exposure

If you tried the torch project, there are a few things that you may have had trouble with. Was the background too light? Maybe the room wasn't dark enough, or the torchlight spilled on the background. If you can see yourself in the picture, maybe the torch illuminated you or your clothing was too light. If you actually want to include yourself in the picture, shine the torch on your face during part of the exposure.

If you tried photographing the night sky, did you include the moon? Even a crescent moon may have dominated the stars too much. If the picture wasn't sharp, maybe the camera moved during the exposure – check your tripod and beware of shooting on windy nights.

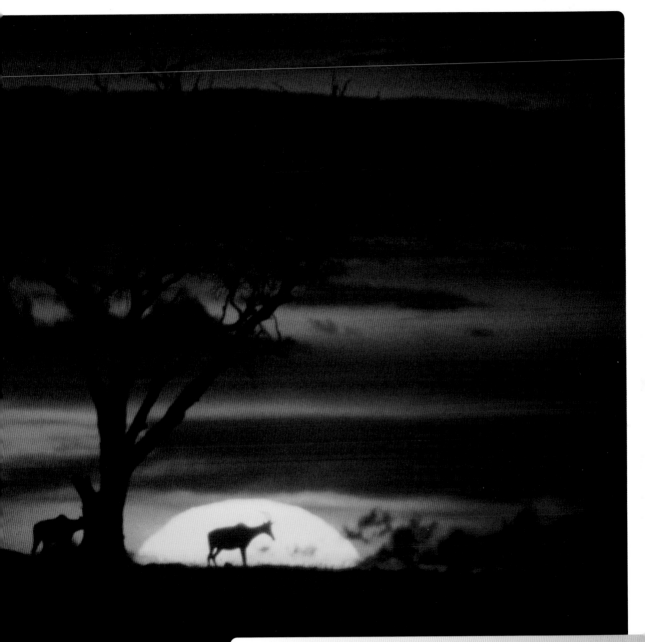

Lenses

The creative lens

Modern lenses range from wide-angle to super telephoto and can create images of extreme sharpness, coupled with the latest auto-focus technology that has produced photographs impossible to achieve with manual focus.

The angle of view of a 35mm focal length lens on a digital SLR camera is based on the angle of view of the human eye, and it is therefore referred to as a standard lens; the equivalent lens on a similar film camera is 50mm. However, we have many more choices available to us than just the standard lens length. Indeed, most digital SLRs are bought with a zoom lens included, which takes you from wide angle through normal to telephoto length.

Exaggerating perspective

You will know that a wide-angle lens includes more of a scene while a telephoto lens brings you closer to the subject, but those are not the most interesting properties of lenses. The photographer's creative decision as to which focal length setting to use is based mainly on the ability of the lens to control perspective.

The longer the focal length of the lens, the more it condenses perspective, making the foreground and background appear closer together than they do to the human eye. Conversely, the wider the angle of the lens the more it exaggerates the perspective, so that the distance between foreground and background expands.

The old adage 'the camera never lies' has become increasingly wide of the mark in these days of digital manipulation but, as far as perspective goes, the lens has always been capable of considerable exaggeration.

In this lesson you'll find some projects that will encourage you to explore the ability of the lens to distort perspective for

compositional effect – but let's not forget that some of the greatest pictures ever made were taken with standard lenses. Indeed, several of the photographic legends used the standard lens for most of their careers, most famously Henri Cartier-Bresson and Ralph Gibson.

The focal length you choose also has considerable influence on the depth of field; telephoto lenses have less depth of field than wide-angle lenses. Here again the camera can produce images that are not familiar to the human eye.

The wide-angle 24mm lens has distorted Chris's face dramatically, elongating and narrowing it. By exaggerating the perspective it has enlarged the appearance of his nose and his ears have almost disappeared.

Lens length in portraiture

The portraits below of the actor Chris Knowles show how important it is to choose the right focal length when making portraits. They demonstrate how, by changing the focal length of a lens, you can actually change the shape of a face.

Many inexperienced photographers take portraits using the wide-angle setting on their lens which, as you can see, is very unflattering. However, there are times when you may want to use the distortions of the wide-angle lens for effect – for instance, if you were shooting a clown and wanted to exaggerate the size of his nose.

A fresh view

Auto-focus technology has made focusing so fast and accurate that it has enabled photographers to take shots that were once beyond capture; the speed at which the lens can follow fast-moving subjects has produced innovative images. Zooming during exposure can also bring a dynamic effect, even with a stationary subject.

Seeing the bigger picture

Sunrise in Kenya's Maasai Mara is magical. Photographs of sunset and sunrise can be disappointing because the sun looks so much smaller in the composition than expected, but the double-page shot that opens this lesson was taken with a 600mm lens that has 'pulled up' the sun behind the animals. To fill the frame with the ball of the sun would require a 2000mm lens. JG

This photograph was taken with a standard 50mm lens and there is still some distortion in a close-up such as this. Taken from further back, with slightly with more space around his head, his facial proportions would look natural.

The telephoto 120mm lens is more flattering because it has eliminated the distortion of his features. This is faithful to how Chris looks in life. You can see why the medium telephoto lens is favoured by portrait photographers.

The angle of view

Modern zooms have a wide range of focal lengths in one lens, allowing you versatility without having to carry around a heavy load of equipment.

18mm

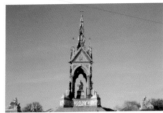

24mm

Manufacturers make a range of lenses from the widest 6mm fisheye, which covers more than 220°, right up to super telephotos of 2000mm with a 2° angle of view. Lenses at the farther ends of the range are mainly used for specialist purposes and the demonstration of the angles of view here was done with an 18–200mm digital zoom lens, since that is the most popular range of focal lengths.

You can of course get fixed focal length (prime) lenses for all these lengths as well. They have larger maximum apertures and, from a perfectionist's point of view, are sharper and have less distortions.

These pictures were all taken from exactly the same place, using the zoom to increase the magnification.

35mm

50mm

70mm

110mm

200mm

Control of perspective

The main creative contribution that lenses can make to photography is the ability to alter perspective, reassembling spatial relationships in a scene.

While the angle of view and magnification associated with different focal length settings on the zoom is immediately obvious, the more important property of lenses is their control of perspective.

Once you have understood the principles of this you will be able to manage perspective in your photographs as you choose. The demonstration here, again using a 18–200mm digital zoom, shows you how the choice of focal length will affect your images. On the following pages you'll find projects suggesting ways to explore this principle in practice.

At the 18mm setting the camera is 1.5m (5ft) from Antonio in order for him to fill the frame. He has been distorted by the wide-angle lens, and the memorial appears to be pushed further away than it does to the eye as a result of the wide-angle lens's ability to stretch perspective.

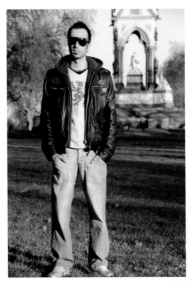

To keep Antonio the same size in the frame on the 35mm setting, the camera position was moved to 3m (10ft) away. The memorial has been pulled closer to Antonio – the perspective our eyes see.

On the 80mm setting, the camera was moved back to 9m (30ft) from Antonio to keep his size roughly the same. The perspective has been compressed by the longer lens and the memorial now appears closer than it does to the eye.

At a lens length of 200mm, the camera was moved 20m (66ft) away from Antonio. You can see only a portion of the memorial now and he appears to be standing within a few metres (yards) of it.

PROJECT 1

Wide-angle lenses

The wide-angle lens is a wonderfully creative tool, allowing you to stretch the effect of perspective. This has obvious use in landscapes, but it can also add interest to architectural and close-up shots.

Exaggerated perspective has many applications and you can use it to add drama to your pictures across all genres. Unless you are shooting open landscapes, a wide-angle lens also makes you get in close to your subject, giving the feeling that you – and therefore the viewer too – are part of the scene. This proximity to the subject also means that when you are working in crowded places, you can avoid including people in the foreground.

A wide-angle lens has greater depth of field than longer lenses, so use this to your advantage if the subject needs to be sharp from front to back. A wide-angle lens stopped down to its minimum aperture will give you maximum depth of field.

Try some shots using subjects where the perspective lines already exist, such as buildings, roads or lines of trees – and don't forget to shoot some still-life subjects too.

A 20mm lens has enabled me to get in close to see the score but also the perspective exaggeration has made it an interesting composition. I added to the effect by burning in around the edges to remove distracting detail on the desk and background. JG

The dawn light reflecting off the road into Death Valley inspired this picture. I used a 24mm lens on my film camera (the equivalent of 16mm on digital) to make the road dominate the picture. The lens has stretched the perspective, pushing the background further away and making the road look as if it goes on forever. JG

The drama of this composition was created by aiming a 18mm lens up at the building. The converging lines of perspective made an interesting design, with the building and sky almost becoming one. GH

This market shot is typical of how I use wide-angle lenses. The 12mm lens has enabled me to get in close and look right down into the baskets of vegetables. The perspective has been stretched by making the baskets big, with everything else diminishing into the background. JG

PROJECT 2

Telephoto lenses

This project concentrates on the ability of the telephoto lens to compress the composition, allowing you to play with perspective, and also to bring you closer to subjects that you cannot approach directly.

The longer your lens the more dramatic will be the compression of perspective so, for this project, you should ideally use a lens of at least 200mm for a film camera and 150mm for digital rather than a medium telephoto of only about 75mm. You are looking for the effect of foreground, middle ground and background looking almost pasted together.

Practically speaking, your telephoto lens can also be used for bringing the subject towards you. Telephotos are the everyday tools of sports photographers because they can get them closer to the action, which

might be at the far side of a football field, for example. If you are a fan of sports, try photographing your favourites.

Another area where the telephoto lens is a must is in wildlife photography. Whether you are out in the wild or at your local zoo, a long lens will give you close-ups of creatures that are either too shy or too dangerous for you to get near to.

If neither sports nor wildlife appeal to you, other good subjects to try include city streets, portraits with out-of-focus backgrounds, or landscapes with a prominent foreground and background.

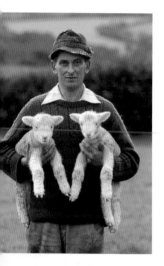

This sheep farmer was photographed with a 180mm lens at f/2.8. The compression of the perspective has the effect of pressing the lambs in tighter to him and pulling up a soft green out-of-focus background behind him. JG

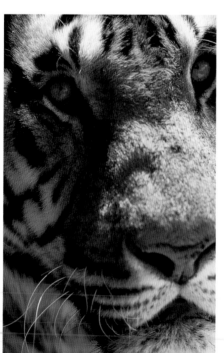

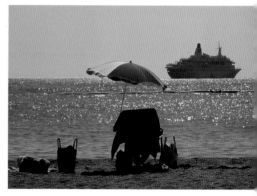

Here a 300mm lens has brought the ship closer. It was about 4.8km (3 miles) out to sea, and shot on a standard lens would have looked about a quarter of this size. JG

I didn't want to get too close to this chap for obvious reasons. The 200mm setting on the zoom has taken me through the bars at the zoo and right into his face, eliminating a messy background. JG

Perspective in portraiture

This project reinforces the creative possibilities of perspective management by showing you the results you can get from using both a wide-angle and a telephoto lens on a familiar subject.

In these two portraits, taken with 18mm and 75mm focal lengths, you can clearly see that the 18mm wide-angle lens has stretched the perspective. Diego's hands appear enormous and his head small. In the second portrait, the longer lens has compressed the perspective and his hands are now in correct proportion to his head.

Ask friends to pose for you and try using a range of lens lengths to see how their features and the settings you have chosen are affected by perspective. Clearly the photograph below right is the most naturalistic, but you may wish to emphasize aspects of your model's life by enlarging salient features – the grimy, roughened hands of a gardener or the hands of someone knitting, for example.

Wide-angle distortion of the human body was favoured by Surrealist photographers. You may enjoy experimenting with extreme wide-angle for abstract effects.

Here the perspective given by the wide-angle lens has placed the emphasis on the drink that Diego is holding.

The longer focal length of the 75mm lens has now attracted the viewer's eye to Diego's face and his drink has become incidental.

Quick tip

• When shooting an environmental portrait using a wide-angle setting to exaggerate the perspective, be careful that the face doesn't fill more than 20 per cent of the frame as it may become distorted.

Zoom movement

You can have great fun with your zoom lens by zooming it during the exposure, giving a dynamic and explosive feeling of movement to a subject even if it is stationary throughout.

This is an example of the pause, zoom, pause method. I set the camera on 1" second shutter speed and the 35–105mm zoom to 35mm. I paused the zoom at 35mm for about 1/4 second to create the small figure then zoomed out to 105mm and paused again, producing the foreground figure and blur. The tennis player kept still throughout. JG

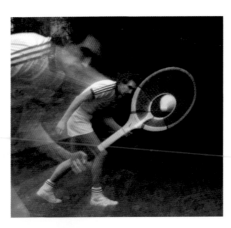

I made a continuous zoom throughout the whole exposure for this shot of daffodils. I composed the picture using the telephoto setting, then with a 1/4 second shutter speed zoomed to wide-angle as soon as I pressed the shutter button, gaining an abstract effect. GH

For this purpose you will have to set a slow shutter speed to give the lens time to get through its zoom, so you will usually need to use a tripod.

First compose your subject using the telephoto setting on the lens, then zoom to wide-angle during the exposure. Practise a few times to get the idea before you commit to film; if you shoot digital you can check immediately to see if you got it right. Next, reverse this by composing with the wide-angle setting and zooming to telephoto.

By varying the shutter speed, the speed of the zooming and the movement of the subject an infinite number of effects is attainable. You will of course need to keep notes on your exposures and methods so you can repeat effects you like.

Pause and zoom

To get a multi-stepped effect, try adding pauses of about 1/4 second between your zoom movements. You will need to keep the point of interest in the centre of the viewfinder because the zoom effect fans out around the middle of the picture. If you want the point of interest off-centre you will have to crop the picture later, as was done with the tennis player above.

The picture here is a result of the pause and zoom technique. I set the shutter speed to 1/2 second, paused for 1/4 second at the 35mm zoom setting, then zoomed to 105mm throughout the last 1/4 second. This has resulted in a recognizable face for the boy then a wild zoom. JG

Close-up photography

The pleasure of close-up photography is that you can reveal details and textures you're not usually aware of. What's more, you don't need models, suitable weather or a great deal of space to practise it.

PROJECT 5

If you don't have a macro facility on your camera, you can buy a close-up filter for the front of your lens or extension tubes that fit between the camera and lens. Neither solution is expensive. Take your camera and lens to a photography shop and try out some attachments to see which gives you the magnification you want.

You will also need to support your camera on a sturdy tripod and use a cable release to minimize any vibration. If you don't have a cable release use the self-timer, which will allow the camera to settle down before the shutter releases.

Finding a subject

First choose some everyday objects that you take for granted, such as scissors, pencils or CDs, and clean them carefully – any dirt or fingerprints will ruin your pictures. Place them on a plain background to start with so the basic graphic shape will be apparent and try a range of compositions.

Next, photograph a flower, selecting a detail such as a petal or stamen to focus on. The closer you are to it the shallower the depth of field will be; with the lens set at full aperture, any background details will go completely out of focus, isolating the point of interest. With the aperture stopped down, background details will be sharper but the extra detail could be quite distracting.

This was shot with the macro setting on my zoom at f/13. I lit it with a 60 watt desk lamp, with a white reflector to hold detail in the shadows. Using Photoshop, I changed it to Grayscale and toned it blue. GH

I used a 55mm macro lens at f/8 for this shot of a peacock feather, placed on a piece of paper that picks up and echoes some of its colours. It is lit with window light only. JG

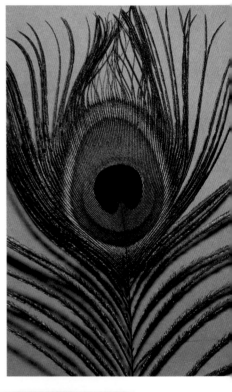

I focused on the top of these rose petals and shot on the macro setting of my zoom at a setting of f/4 to keep the background petals out of focus, creating a soft, dreamy look. GH

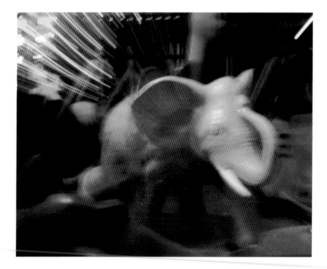

The idea here was to make the fairground elephant look as if it was lumbering out of the frame. As it happened, the lights in the background make it seem as if it's being chased by a swarm of angry neon bees. Zooming can be a hit or miss technique, but the odd lucky accident can be great fun. GH

I placed a parsley stem in front of the camera, using some adhesive tape to keep it in position. I added the snail and, when it reached the right position, focused the 55mm macro lens and exposed it at f/11. GH

As a cricket fan, I shot this from the stands, using a 300mm lens plus a 1.4 teleconverter to take it to 460mm. When using a telephoto lens for sports it is best to shoot from a high angle like this to gain a clear foreground and background. JG

Lenses review

- Good-quality modern zoom lenses give you the ability to use a range of lens lengths without having to carry a bag full of equipment.
- The creative use of lens lengths allows you to control perspective, while zoom movement and the use of macro photography offer a new look at the world.

Project 1 Wide-angle lenses
Do your photographs give the effect of the foreground stretching towards you? If not, maybe your lens wasn't wide enough. If parallel lines stretching into the distance don't appear to converge it's likely you weren't angling the camera down enough.

Project 2 Telephoto lenses
Your photographs should show the compression of distance that comes from a telephoto lens. If this isn't obvious, try again and check the length on your zoom – the telephoto effect becomes obvious at about 120mm on a digital camera or 180mm on film.

If your background is too sharp and distracting even at full aperture, your subject was probably too close to the background.

Project 3 Perspective in portraiture
If your wide-angle lens did not sufficiently exaggerate the scale between the hands and face, ask your model to

push his or her hands further from the body and closer to the camera. To appreciate the difference in perspective, make sure the hands are in the same place for the telephoto lens shot.

Project 4 Zoom movement
If you are having trouble with this technique, don't give up – it takes quite a bit of practice to get a smooth zoom throughout an exposure. Try a longer shutter speed to give you time to get through the zoom action.

Project 5 Close-up photography
If you failed to clean the subject well enough before you photographed it, that's something to chalk up as a lesson that never needs to be relearned – it's very disappointing to put a lot of work into pictures only to find dust or a fingerprint on the final image!

If your picture was spoiled by subject movement, for example in the case of a flower in the breeze, have another go but this time use flash to freeze it.

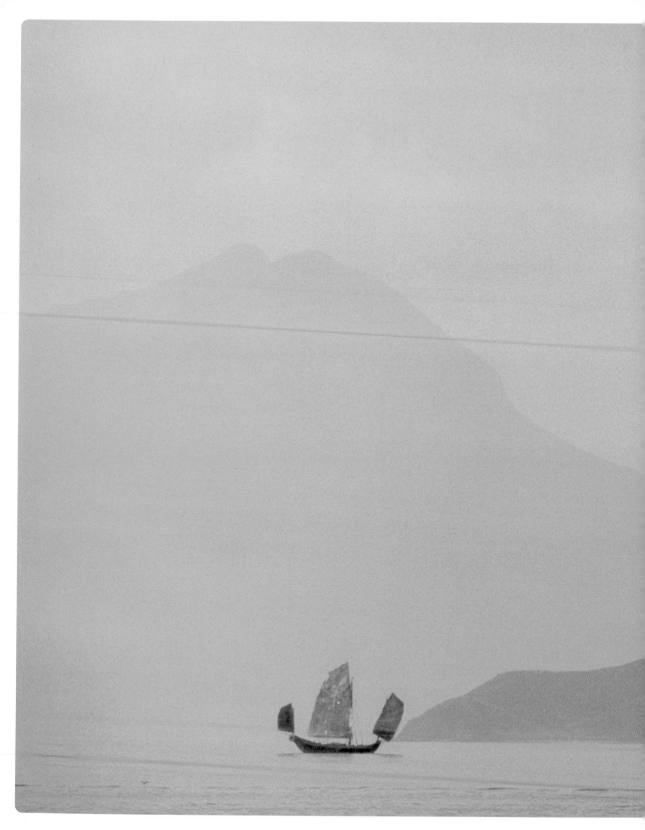

Composition

The leap from a snapshot to a photograph

There have been many learned and often rather intimidating books written on composition. The temptation is to avoid wrestling with the subject altogether when you embark on a photography course, with the idea that you would prefer to learn the technical stuff first and then deal with the 'arty' stuff later.

However, composition isn't a difficult concept to understand and it's what accounts for the difference between a mediocre picture and a great one.

There are a few basic rules of composition that have been passed down to us by the classical painters. Some of these rules were arrived at by the Old Masters using trial and error to craft their methods, while others drew on theories from the architecture of Ancient Greece. Over the centuries artists formulated ways of presenting their subjects in the most direct and accessible form.

Many of the early photographers were in fact artists who at first used this new high-tech medium to provide reference material. Originally, photography looked to painting for inspiration, but as photographic optics developed, wide-angle and telephoto lenses resulted in new perspectives and by the 1920s photography started to influence the compositional ideas of artists.

Composition today

Unlike artists, traditional photographers haven't been able to omit objects that spoil a composition - a pole apparently growing out of the top of someone's head, an ugly litter bin and so forth. With the arrival of digital, this has become possible to remedy

For this temple in Sri Lanka a symmetrical composition felt right, because a composition such as this is low on tension and high on harmony. A stopped-down wide-angle lens has exaggerated the foreground curves that sweep the eye into the group of worshippers. JG

My environmental portrait of a Maasai warrior places him far right in the picture plane. While his position in the foreground keeps him large against the landscape, the emptiness of the rest of the picture, shot with a shallow depth of field, emphasizes the vastness of the savannah stretching into the distance behind him. JG

in post-production but it's time-consuming and often requires a great deal of skill to do successfully. Even in these digital days, one of the most important things a photographer still needs to learn is to scan the viewfinder for what should be left out of the picture – it's as important as what's included.

Today, we live in a highly visual culture. It's possible to learn a great deal about images not only by visiting art galleries but also by looking at beautifully illustrated books and the internet. Even magazines and television can provide plenty of information on different ways in which you can use composition to improve your photographs.

To set you on the right path, this lesson demonstrates the principles of composition and gives tips for you to follow when you shoot your projects. Composition is all about practice, so don't be discouraged if you find it hard at first – you'll soon be surprised at the improvement in your pictures.

Seeing the big picture

The double-page picture that opens this lesson is an exercise in scale; the tiny red sails are set against the huge blue shapes of the mountains. I chose a viewpoint and made a few photographs as the junk sailed by - here it is in the classic 'rule of thirds' position. I was helped by the misty light which removed the detail in the background, giving the feel of a watercolour painting. GH

The strong silhouetted shape of the pier at Sanabel Island, Florida, determined the composition of this photograph. It was shot on a compact camera using panoramic format, though I could have shot on normal format and cropped it later. JG

PROJECT 1

Horizontal or vertical format

The simplest way of experimenting with the composition of a shot is to try a different format – but it's amazing how easy it is to forget that you can totally change the look of the picture just by rotating the camera 90 degrees.

The majority of photographs are taken with the camera held in the horizontal position. It's not difficult to see why – the camera is designed to be held that way and is consequently more comfortable to handle.

However, the aim of this project is to encourage you to be conscious of a vertical format as an alternative. The subjects to shoot are landscapes and portraits, chosen because a landscape is usually shot horizontally and a portrait vertically. In fact, most people dealing with images refer to horizontal pictures as landscape format and vertical pictures as portrait format.

The exercise here is to shoot these two subjects both horizontally and vertically. To make both shapes work effectively you will have to find ways of dealing with the extra space you will discover in the viewfinder.

Exploring shapes and spaces
In your horizontal portrait you may decide to include some appropriate background such as symbols of the life your subject leads - for example, a motor car or a garden. Remember this space needs to add to your portrait, not detract attention from it.

For the landscape vertical you could look for something to use in the foreground to lead the eye into the picture. Alternatively, if you are lucky enough to find a dramatic sky, you could visualize the landscape

Venice is one of the most poetic cities in the world for a photographer, and here it is seen at sunset. I took the horizontal shot first, then searched in vain for an angle I was more pleased with. Returning to my original position, I tried a vertical shot and by moving a little to the left found the scene fitted perfectly and made a stronger composition. JG

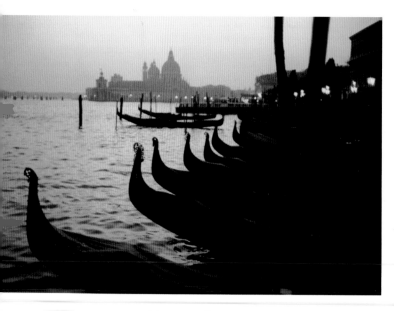

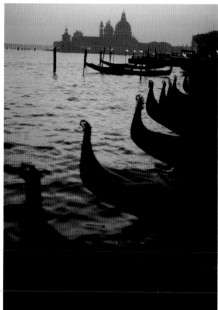

By changing to horizontal and moving the camera to a different angle, I was able to include some of subject's surroundings, thus turning what was a straightfoward head shot into an environmental portrait. GH

differently and lower the horizon to make the sky a major part of the composition.

If in doubt as to the best way to tackle the subject, try shooting both ways. You may be surprised to find that the one you liked least at the time becomes your favourite when you study the photos later. Making instant decisions about a subject is, of course, quite difficult, especially if your subject is a person or situation that is changing quickly.

This is where experience counts, and the more you practise the better you'll get. Try to take as many pictures as you can – you will learn from each one, and often the ones that aren't successful teach you the most.

Quick tip

• One of the bonuses of a digital camera is that you can shoot as much as you like without your expenses adding up. Be careful, though, that you don't get into the habit of shooting without analysing first – sifting through dozens of aimless pictures is a waste of time.

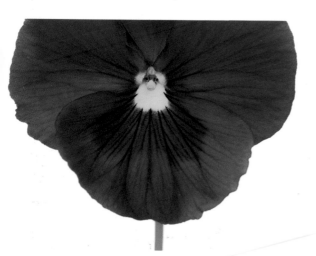

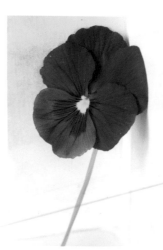

Something as simple as a single flower can be given a different look by changing the orientation of the frame. My vertical shot of a pansy has a softer, poetic feel, while the horizontal one is much more bold and descriptive. GH

PROJECT 2

Filling the frame

One of the main reasons why many photographs lack immediate impact is that the subject is not occupying a large enough area of the frame. You need to get straight to the point with a big, bold statement.

This exercise more than any other is the one that can give your shots the punch that you need to get the message across. By getting in closer you will improve your photographs immediately.

Out of the comfort zone

When you start this project, try going closer to the subject than feels comfortable. If a person is the subject this can be quite hard to do initially, especially if you have a reticent personality, but like everything it gets easier with practice.

When you see your pictures you may be surprised to find that you were not nearly as close as you thought. That's why it's important to scan the viewfinder to see how big your subject is within it – photographers often become so engrossed in looking at the subject that they fail to notice that there is much more space around it than they want. It's essential to decide on the main point of interest in your composition and then fill the frame with it – even if this means screwing up your courage at first!

Quick tips

You have a choice of four different ways of filling the frame:
• Move closer to the subject.
• Move the subject closer to you.
• Zoom in to fill the frame.
• Crop the final picture on the computer or in the darkroom.

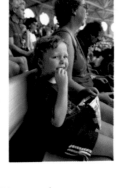

This young boy was watching a performance at an aqua park. I took the first shot to show him in his surrounding area but had second thoughts. I decided to zoom in to get rid of the background, concentrating on his cheeky face. JG

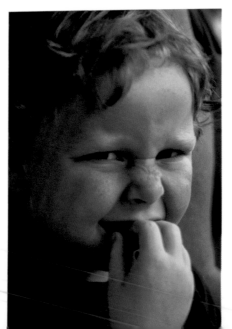

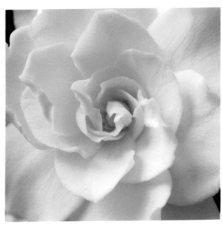

Getting in close to this flower has made for maximum impact. The viewer's attention is concentrated solely upon the tactile quality of its petals. GH

Changing your viewpoint

One of the easiest and yet still one of the most effective methods to dramatically change your composition is to change your camera angle. Considering a different viewpoint often pays dividends.

Most of the pictures we take tend to be from our own eye-level. However, with a bit more thought and experiment the subject can be given more importance by photographing it from another viewpoint.

Not only does a change of camera angle alter the graphic design of a photograph, it also changes the story that the photograph is trying to tell. You may achieve a more descriptive image of the subject than you would with the eye-level viewpoint that you habitually use.

High and low viewpoints
For a 'bird's-eye' view, try standing on a chair or a wall, for instance. Conversely, to get that 'worm's-eye' view try crouching down – you may even have to lie down to get the camera to ground level. To gain the most dramatic effect of this change of camera angle, use a wide-angle lens.

For this project, start with a shot at eye-level before you explore from a higher and lower angle. Look at the shot from an unusual viewpoint and find its true potential. By analysing your subject you'll be forced into trying something different. You could transform an average shot into a remarkable one.

In the round
Don't forget you can also circle around your subject and maybe find a more nteresting image than at first seemed possible. Even a portrait from behind may make a great image in its own right, and it's surprising how characteristic a back view can be.

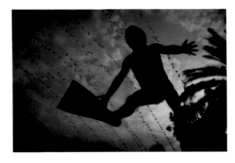

Even experienced photographers need to remind themselves to look at things from a different point of view. I started off shooting from the poolside and then had a second look from water level. This one is far more interesting than my first visualization. JG

You can often introduce an element of humour into your pictures by changing your viewpoint. This picture of a man sitting in a park eating his lunch is quite unexpected; a normal, everyday sight becomes unusual by looking at it from a different angle. GH

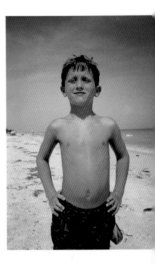

This is an example of how a lower angle rather than the usual one of looking down from an adult's point of view can give a child a more dignified, even arrogant look. JG

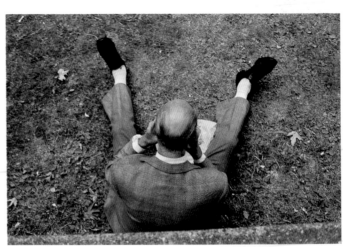

PROJECT 4

Perspective

Everything we look at is affected by perspective. Objects that are closer to us appear larger than ones of the same size that are further away.

I shot this cityscape of Istanbul from a long way off, using an 800mm lens. The bridge in the foreground is actually about 1.6km (1 mile) from the city behind it, but because the telephoto lens has condensed the perspective it appears to be right in front of it, almost like a theatre backdrop. JG

Artists have always had to work with perspective to make their pictures convincing. However, photographers have the advantage that they can easily create exciting graphic compositions just by changing the focal length of the lens and thus exaggerating or compressing perspective (see p.85).

For this project, start by using your standard lens (see p.82) and your powers of observation to isolate an image where perspective dominates the composition. This might be, for example, a line of terraced houses, a row of cars or a queue of people.

Wide-angle and telephoto lenses

Having observed perspective as your eyes see it (that is, with your standard lens), now use your wide-angle lens. You will have to move closer to the nearest object in order to fill the frame. Note how the wide angle stretches the foreground objects toward you and away from the background, exaggerating the perspective.

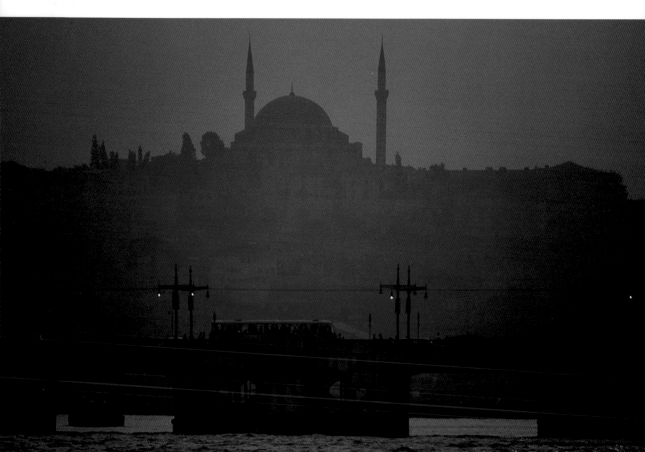

Having seen the creative possibilities of the wide-angle lens, now try using your telephoto lens. This will compress the perspective, appearing to squash the objects in the picture closer together. To fit the whole subject in your viewfinder you'll have to move further away from it – just how far depends upon the focal length of the lens you are using.

Close to home

We get so used to our everyday environment that we often fail to spot the possibilities around us. You probably won't have to go far for this project – just have a fresh look around with your zoom set to different focal lengths. You will find you can often transform the mundane into the remarkable.

These three pictures are examples of using perspective with different subjects. To exaggerate perspective, the beach huts were shot with a 28mm lens, the building with a 20mm lens and the spanners with a 24mm lens. GH

To give the tree a feeling of soaring into the heavens, I put a 24mm lens on the camera and got close to the trunk. By stopping the lens down to a small aperture I was able to keep the whole tree in focus. GH

PROJECT 5

Focal points

Every picture should have a focal point. Even the most beautiful landscape, photographed with care for the correct exposure and pleasing light, won't grab the viewer's attention without a point of interest.

I had just driven down from the mountains of Colorado onto the high plains of New Mexico. The mountains and the cloud formation looked quite impressive but the farmhouse provided the focal point that has made this landscape really work. It has added scale that has emphasized the grandeur of the Rockies. JG

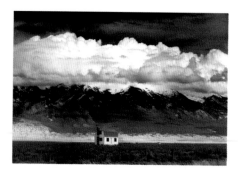

So many pictures are almost great, but fail to make the first rank because they lack a focal point. A landscape without an eye-catching feature, such as a little farmhouse, a solitary tree or an animal, becomes just a record of a place rather than a definitive landscape photograph; a still life may appear to be just a jumble of accumulated objects rather than a cohesive composition.

There are several ways in which to establish a focal point that will draw the viewer's eye into a photograph. For this project, shoot some pictures using each of the following techniques.

Finding focal points

The classical way is to find a subject that includes a focal point and compose using it to your advantage. For example, in an urban scene this might be a human figure, a bicycle, or a statue; in a harbour, a particular boat; and in a landscape, any sign of human activity will always attract the eye.

A second method, favoured by reportage photographers, is to pre-compose your picture in the viewfinder leaving space for a focal point to move into, such as a person, boat or animal. The great Henri Cartier-Bresson was a master of this technique.

Putting in your own focal point is a ploy used by most still-life photographers, although it's equally valid in a larger scene. After pre-composing the photograph in the viewfinder, add in a point of interest, from a fallen petal in a flower photograph to a bicycle against a tree. You can also move the objects around in a still-life picture, rethinking their arrangement until you create a composition with a strong point of interest.

To get this shot I waited until the fisherman moved across into the reflection of the sun in the water. JG

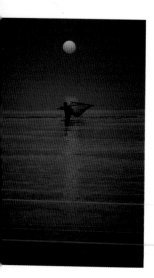

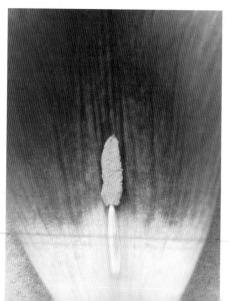

I laid a tulip petal on a contrasting blue background then added the little stamen to create a point of interest. As well as making a pleasing symmetrical composition, I also wanted to imply that the stamen was a small paintbrush used to paint the picture. GH

The rule of thirds

One of the most classic laws of composition is the rule of thirds, in which the focal point of a picture is placed approximately on one of the intersections of horizontal and vertical lines dividing the area into thirds.

This is a good project for developing your visual perception. You won't be able to get every subject to fit on one of these intersections but it's good fun to choose a random subject and have a go at it.

Your project is to find three subjects that you can compose using the rule of thirds. Keeping the main subject on or near one of the four intersections will be a great lesson in isolating the subject and simplifying your compositions.

One of the difficulties you may have is that there may be strong shapes in other parts of the frame and these will fight for attention with your intended point of interest. Changing your viewpoint to simplify the details may solve this problem.

For an unusual use of the rule of thirds, try going in really close on a subject – for example, make a portrait and place the person's eye on one of the intersections. You could find you have produced an unusual and powerful image.

Taking a hand in composition

The rule of thirds usually works best if you have an object contrasted against a larger area of colour or tone. Remember that if the situation allows you can add another object to the composition and art direct the picture yourself. For example, the large field of red tulips containing a single yellow one (above right) was a lucky find. However, had the yellow tulip not been there, it could have been added separately just at the point where it was needed to fall on the intersection of thirds.

Place your focal point at an imaginary intersection of two horizontal and two vertical equidistant lines.

By placing the yellow tulip near the intersection of the thirds I was able to give it greater emphasis – you can't help but look at that spot of yellow. JG

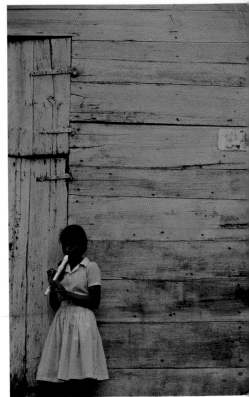

By placing the girl on the intersection of the thirds I was able to allow plenty of space in the rest of the frame and still keep her face and flute as the main focus. The colour contrast between her yellow dress and the blue-green wall in the background lends extra weight to the bottom left and helps to balance the large area of blue-green at the top and right. JG

I was immediately attracted to this shot by the circular shapes in the composition. The old car tyre hanging in a children's playground formed a perfect frame within a frame for Jonathan's round face. His arms inadvertently formed another circle as well, which helps to reinforce all the other circular shapes in the picture. GH

It's possible to suggest emotion in a picture just by contrasting the relative size of one object against another. Here I placed the small shell in front of the larger one and went down low and in close, using a wide aperture to throw the large shell slightly out of focus. I think the scale suggests an element of protection – like a big brother looking after his sibling. GH

This leopard in a zoo was very aggressive and the extreme composition was not the result of lengthy creative thought – it was because there was a bar in the way and it was the only option available to me. He looks as if he's cornered in the edge of the frame and a cornered animal is famously more dangerous – so my lucky composition has added to the tension in the picture. JG

Composition review

- **Composition is the way we organize and manage all the visual information in the viewfinder.**
- **Your choice of subject, lens, film, lighting and composition all combine and will in time become your unique style.**

Project 1 Horizontal or vertical format
Most subjects will fit either a horizontal or vertical shape. Now you have seen how effective a change of format can be, always keep it in mind when starting a shoot.

Project 2 Filling the frame
If you weren't brave enough to get in really close, shoot your standard framing first then force yourself to move up to your subject. Compare your pictures to see the huge impact that close framing can have and you'll see it's worth getting to grips with.

Project 3 Changing your viewpoint
Did this project change your way of composing pictures? You should now be aware that there's always another way of looking at your subject.

Project 4 Perspective
Remember it's not just finding a suitable subject but also the focal length that you choose that's vital to using perspective for effect.

Project 5 Focal points
This project should have helped to simplify your compositions. You'll have learnt to include one focal point that the eye is attracted to instead of wandering aimlessly across the picture.

Project 6 The rule of thirds
The classical rule of thirds is another way of keeping your compositions uncluttered. This is a tough assignment, but keep trying and you'll find that locating your focal point on the intersection of thirds becomes second nature.

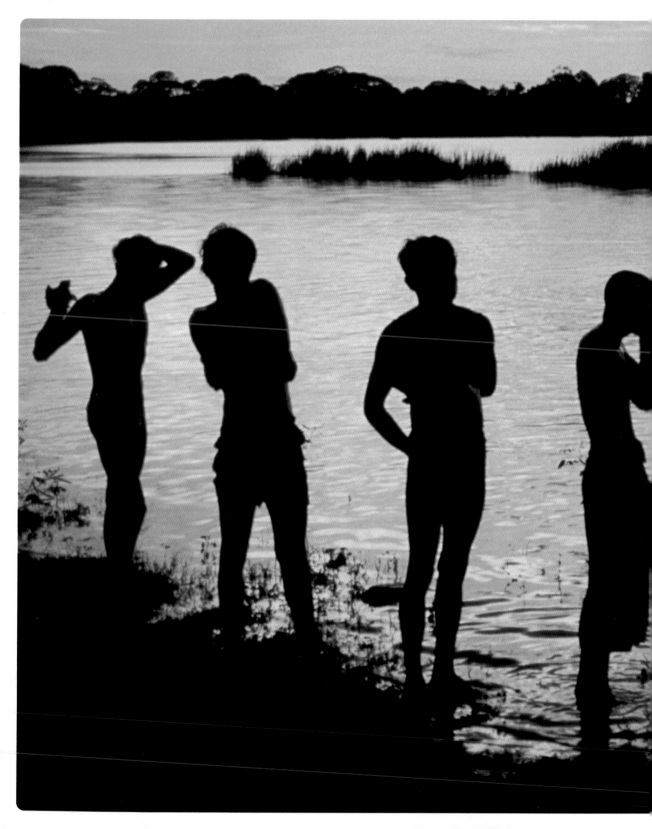

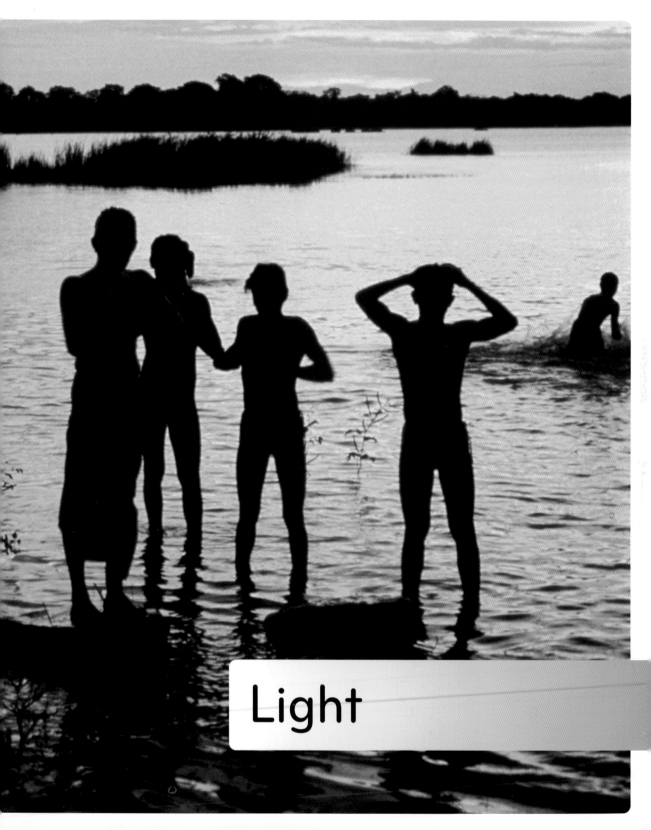

Light

The magic ingredient

Light has been described as the magic ingredient of photography, and indeed the quality of beautiful light does have something magical about it. However, light is of course more than a matter of aesthetics – it is the very essence of photography, making the creation of the image possible.

Painters have always been obsessed with light, and their preference for a certain light quality usually defines their style; think of Rembrandt and his love of the window-lit portrait and Turner for his early dawns and sunset skies. The artist has his or her palette and brushes to interpret the light, while we photographers have our camera with the light as our palette. For inspiration, have a look at the work of notable photographers such as the legendary Ansel Adams, Edward Weston and Irving Penn, just three of the great interpreters of light.

The quality of light

The colour of natural light changes throughout the day, affecting the colour and form of every object it falls on. We can manipulate the colour of light by using filters or by changing the white balance on our digital cameras, but often it is hard to improve on what natural conditions offer; a setting sun can turn the greyest and drabbest street into gold, offering pictures that would have seemed inconceivable just an hour earlier.

Remember too that the description 'bad light' or 'good light' is relative: while a dull, overcast day may be unsuitable for a Utah landscape, for example, it may be perfect for photographs of Utah citizens, since harsh shadows make for unsatisfactory portraits.

Light affects not only colour but also texture, tonal balance, mood and even the apparent shape of everything in our world. Not only can we take advantage of the light

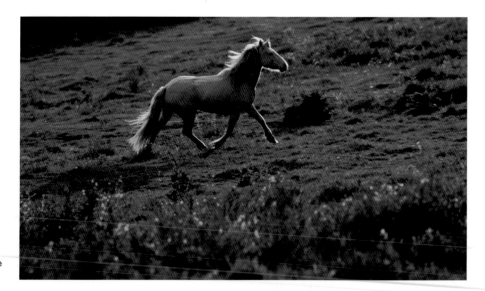

This shot would not have been worth taking if the horse had not been beautifully back-lit by the late afternoon sun. JG

we find, both indoors and out, we can nearly always take control by introducing our own incandescent and flash lights, diffusers and reflectors, working with the light already present or shutting ourselves in a dark room and building light from scratch.

The ability to read light in photographic terms is not a skill learned easily in the classroom – it is gained from observation and is really a lifetime study. During your day-to-day travels, get into the habit of observing the quality of light around you and try to understand the moods it is creating. The projects on the following pages will also help you to understand the many different qualities of light.

Seeing the big picture

In the picture on pp.108–9, the soft glow of light preceding the sunrise was bright enough to silhouette these Buddhist monks in Sri Lanka against the water. The dawn light was the main attraction; the composition was a matter of waiting until the figures formed this pattern where one leads you to the next in a gentle curve. It was shot with a 35mm lens. JG

A reward for early rising – the dawn light filtering through the mist was the reason for taking the picture. GH

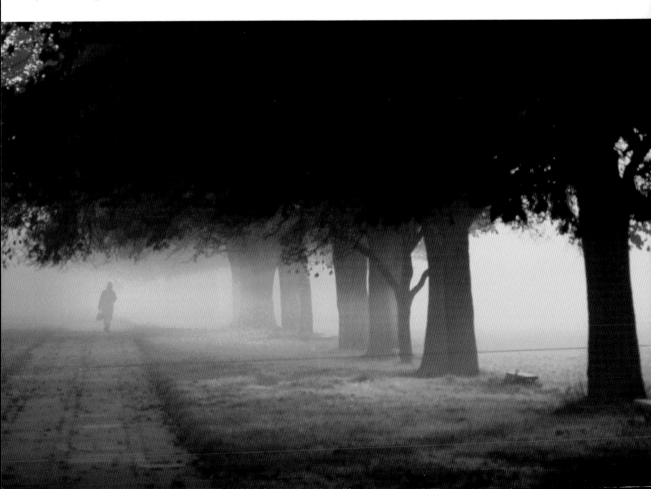

Time of day

Here are some examples of how the quality of light changes during the day and the effect those changes have on your photographs. Note how both the angle and the colour of the light are transformed.

This is the eerie, colourful light that occurs just before the sun rises. There is not yet any dust in the atmosphere so the light is clean and sharp.

In this shot, taken not long after dawn, the sun burned through the branches and back-lit the mist, accentuating the blue of the atmosphere.

Here, early morning in Stockholm gave sharp northern light, perfect for high-definition architecture. The sun was high enough for the sky to be blue.

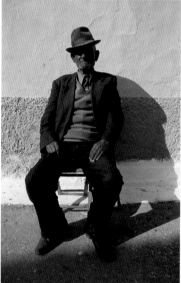

Midday sun directly overhead is tricky for portraits as shadows are very black but good for graphic compositions.

Dusk can provide some beautiful soft glowing light. Try photographing every couple of minutes until it gets dark.

Quick tips

• Black and white photographs are equally affected by the change of angle and intensity of the sun throughout the day.

• The time of day particularly dominates the tonal composition of subjects such as landscape and architecture.

Mid afternoon, when the sun is getting lower in the sky again, provides a combination of detail and shade and offers you a choice to expose for either highlights or shadows according to what you wish to show.

A sunset can be the focal point of a composition, or you can turn your back on it and use the very warm light for portraits – or indeed almost anything.

Weather

As you can see below, the weather can have an enormous influence on light quality. Some great pictures have been taken in extreme weather conditions when everybody but the photographer was keeping warm and dry indoors.

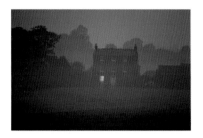

Mist acts like a thin translucent veil over a picture. It softens and subdues detail, allowing you to compose with blocks of tone and colour.

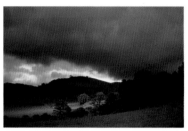

Some of the best landscape light happens during and after storms. With patience you might get this spotlight effect illuminating your subject.

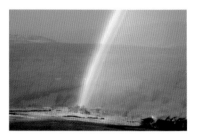

It's impossible to plan a shot of a rainbow; you need to react quickly as it can be gone in seconds. This one is particularly bright and saturated.

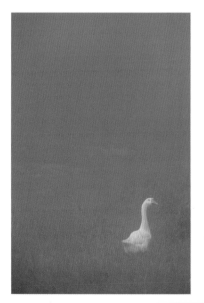

Much denser than mist, fog can give a ghostly look. You can use it to simplify the picture by isolating the subject and masking out background detail.

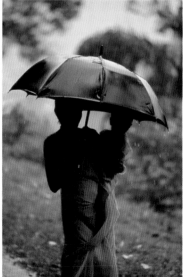

Wet surfaces make lovely shiny highlights and colours tend to pick up a glow from all the reflected light bouncing around.

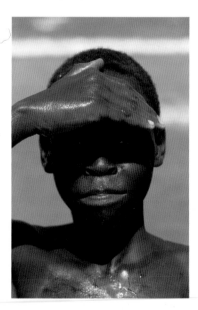

Bright sun can make for difficult lighting conditions; it's too harsh for many subjects, but is ideal for texture and strong shadows.

Single light source

The apparent shape of any object is dependent on the angle and intensity of the light falling on it. The exercise here, using a single light source, shows how the shape of the sitter's face appears to alter with each shift of the light.

An important point of this exercise is that learning about lighting is not enough – you also need to study the geography of each face that comes in front of your camera. Your first priority is to look at the structure of the face and from your observations you can then light it to its best potential – for instance, it wouldn't be a good idea to front-light a round face from above the camera as it would make it look rounder still.

Placed immediately above the camera, the light has flattened Christine's face and made it appear wider than it really is.

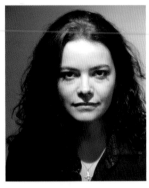
With the light still from the front but now 1m (3¼ ft) above head height, her face appears narrower and longer.

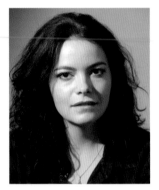
The light is now 45° from the camera and 1m (3¼ ft) above head height – the classic portrait light.

Quick tips

• As you can see, you can produce a great variety of light effects with just one light and a reflector. There's no need to buy a set of lights.

• You could also achieve the same results using a hand flash with an extension cord (see pp.116-117).

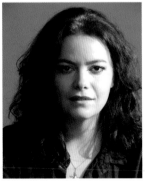
Here the light is side on to Christine's face. Side light narrows the face as it leaves one side in shadow.

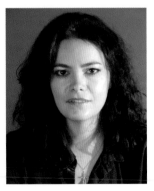
Side light, plus a reflector placed next to her face on the shadow side, makes the face appear much wider again.

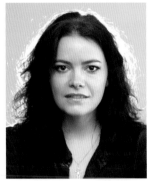
The light is now behind her head. A reflector held above and in front has bounced the back light onto her face.

Window light

If you have a window and a white card for a reflector you don't need artificial light. Even on a sombre winter's day the light may be low but it will still be good quality – you will just need a tripod so you can use a slow shutter speed.

This set of portraits was shot on a digital camera with the white balance set to auto. This wasn't a good decision – the colour balance is very inconsistent because of the changing camera angles, but it has provided a useful lesson. If you are taking a series of window-light shots, set the white balance to daylight so that the pictures will have a consistent colour balance, thus avoiding the need to fix them later on the computer.

Quick tips

• When shooting black and white film by window light be generous with the exposure – set +½ or +⅔ stop to make sure you maintain shadow detail.

• For modern masters of window light, look at the work of Irving Penn and Jane Bown.

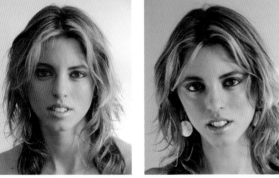

Yamila side-lit by the window. The shadow side has some detail because the white room offers some reflection.

Side light but with a reflector added to fill in the shadows – the face appears broader than in the first picture.

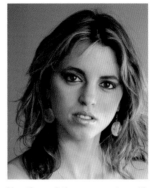

Yamila and the camera turned 45° towards the window – the classic portrait light, a good mix of light and shade.

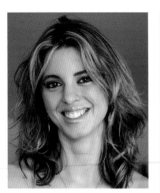

Yamila is now looking directly towards the light, with the window behind the camera. Her face is evenly lit.

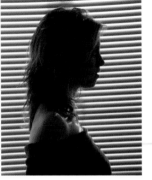

This is a back-lit silhouette with a difference. Shot against the venetian blind, it has made an interesting picture.

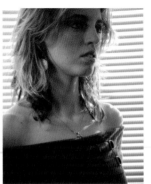

Here the same back light is coming through the blind, with a gold reflector added to find some detail in her face.

With Yamila turned just a few more degrees towards the window than directly side-lit, the light has just caught her right eye, adding sparkle.

Making the most of flash

From small units built into cameras to large studio packs, flash is a way of providing portable bright white light whenever you need it.

Most cameras have a built-in flash that can be a very useful light source, but if you use it as a matter of course you risk ruining the beauty of natural light. In situations with strong back-light, indoor available light and extreme high-contrast light and shadow, the flash will automatically turn on, possibly spoiling any atmosphere the subject may have. On the plus side is the extremely short flash duration (up to 1/30,000 of a second)

even a built-in flash has, allowing you to freeze rapid subject movement.

A more creative way to use flash is with a dedicated flashgun that fits onto the camera's hot shoe. Better still, by attaching it to a cable so that you can hold it away from the camera (known as off-camera flash) you can light the subject from any angle and still maintain the flash's auto connection to the camera.

This is a direct flash shot using the flash as the main light. In aperture priority, I set the camera and flash to f/8. The camera balanced the background exposure. GH

Here on-camera flash is combined with a slow shutter speed. The fast flash has frozen the boy kicking the leaves and because I panned the camera a little to follow his movement the 1/15 second shutter speed has blurred the background. JG

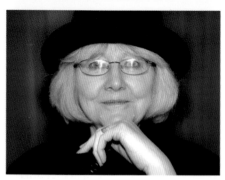

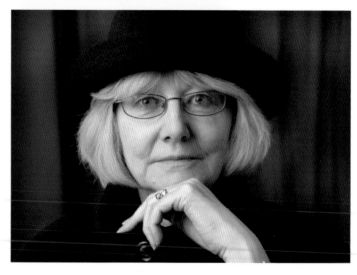

Direct flash (above) can be rather harsh and in this picture it has caused highlight reflections in Margaret's glasses, hiding her eyes. In the shot shown right I have rotated the flash to bounce off a white wall, making a softer, more pleasing light. GH

This shot was taken using natural overcast light in early evening. The aperture was f/5.6 and the shutter speed 1/30 second. The sculpture looks flat and blends into the background.

Adding fill-in flash from the built-in camera flash has made matters worse by diluting most of the shadow.

With a manual setting of aperture f/5.6, shutter speed of 1/250 and off-camera flash set to auto, held 1m (3¼ft) above head height, the background is much darker as the daylight is underexposed.

Here the exposure settings are the same as the shot shown top right but the off-camera flash is held at a three-quarter angle to the sculpture and 50cm (20in) below head height.

Again with the same settings, the off-camera flash is at a three-quarter angle and 50cm (20in) above head height. It has created a more dramatic picture and isolated the figure from the background.

Quick tip

• If you feel you'd like to take the off-camera flash technique further, you can buy a wireless remote flash-triggering device that frees you from the restriction of cable lengths. These are quite expensive, but they're very effective.

PROJECT 1

Flash in daylight

This project teaches you how to use flash as a main light source in daylight – valuable when light levels are low or for dramatic effect.

It will help you to carry out this project successfully if you think of the flash and daylight as two different light sources. The aperture will control the flash exposure and the shutter speed will determine the density of the background.

Your choice of aperture will depend on the depth of field you require. You will find this technique easier if you set the camera to aperture priority mode rather than manual.

Set the flash to auto, then the camera and flash to your required aperture. Use the exposure compensation to reduce the background density – the examples here are a guide to how to achieve the density you would like. The camera will alter the shutter speed accordingly. Remember not to exceed your flash synchronization shutter speed – this is usually 1/250 second but on the newest cameras can be higher.

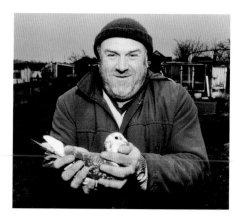

I used flash as the main light because the daylight was very low, leaving the man's eyes in shadow. The flash was on an extension cord, 1m (3¼ft) above the camera. I set the camera exposure compensation at -1 stop and the flash on auto. The effect was to make him stand out from the background while still holding some atmospheric background detail. JG

I used off-camera flash and hid a second small flash on a stand behind the subject's head. I underexposed the background by setting the camera to -1½ stops. At normal exposure the sky would have looked like a sunny day. JG

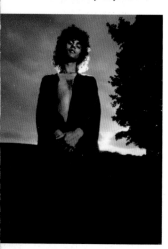

For this shot I used a flash gun mounted on the camera. The flash was on auto and the camera was set at -2 stops exposure compensation. Matt looks as if he is pasted on to the underexposed dark background. The short duration of the flash has frozen the movement. JG

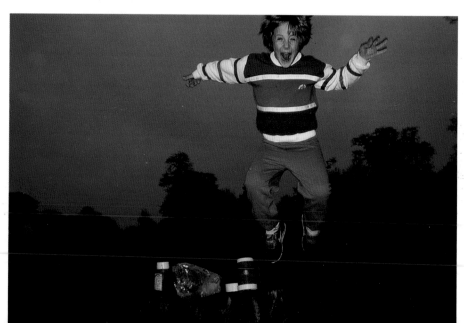

Night photography

Night-time opens up a whole new world for you to photograph. Urban scenes offer a wide range of light, often in exhilarating colours.

Apart from photographs taken at dusk, in moonlight or during a lightning storm, all night photography relies on the presence of some form of artificial lighting. This may consist of streetlights, illuminated arcades and fairgrounds or floodlit buildings. The subject may be the whole scene, perhaps with dramatic shadows, or the pattern made by the lights themselves.

To make the most of what light there is, you could look for scenes in which there are light-reflecting surfaces – buildings, foliage, vehicles and so forth. The highlights in the picture can be doubled by choosing a rainy night – preferably just after a shower – when they are reflected in the wet pavement. It is often possible to make use of the surface of a river or lake in the same way.

Moving objects, such as cars or boats, can leave light trails across your picture if you select a slow shutter speed. High viewpoints will help to spread the objects apart and allow space for them to move about. They will have to be travelling at an angle to you – if they are moving in a direct line away from you they will be a single point of light. With a bit of practice, you'll find it possible to create striking patterns of light and colour.

Quick tips

- Use a tripod or find a support such as a wall to keep the camera steady.
- Use a cable release or remote release to open the shutter (alternatively, you can use the self-timer).
- If you are shooting on film, take a notebook and pen to jot down down your exposures.
- A torch is handy to help you to see the camera controls.
- In bad weather you will need warm clothing, an umbrella, and a plastic bag to go over the camera.

Sitting at a café opposite the Duomo in Siracusa, Sicily, I supported my camera on my folded jacket on the table. I set the camera to 800 ISO and program mode with matrix metering. Digital cameras handle this kind of exposure problem very well – I just checked my exposures on the screen after each shot. This picture was +½ on the exposure compensation. JG

Photographing St Paul's Cathedral across the Thames, I used a 200mm lens to make it look closer. I set the aperture to f/4 to let the lights in the foreground go out of focus, forming a frame around the cathedral. GH

This was taken in central London, just before dark. The camera was on a tripod, and the exposure was 1" second at f/5.6. Two cars and a white van went by during the exposure; the ghost of the van has lightened the top half of the frame. GH

PROJECT 3

Candlelight

While candles give light that is soft, warm and flattering, you may not have thought of them as a photographic light source because they don't appear to be sufficiently bright. However, a few can create a surprising amount of light.

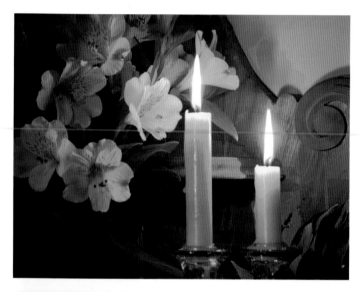

Here candles are the main light source. The blue light coming from the left is from a torch with a blue filter. The white balance was set to incandescent. GH

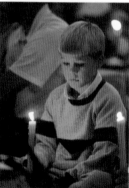

This picture was shot at a Carols by Candlelight event. Candles throw more light than you might think – I simply set a large aperture of f/1.2 on a 50mm lens. Using flash would have spoilt the picture. JG

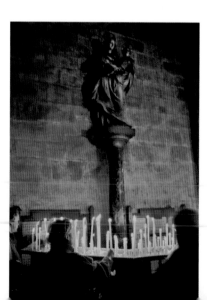

This was taken on daylight balanced film, which has made the candlelight orange. There was also an incandescent light on the right side. I didn't have a blue filter with me to cool it down, but as it turned out I like the very warm colour; it adds more emotion. GH

As you can see from the photographs here the colour of the light is very orange, though it appears to be more neutral to the eye. Setting your white balance to incandescent is a good starting point – you need to keep at least some of the warm colour or it will simply look like ordinary white light. Film users will need a blue correction filter, or no filter at all.

Candles flicker, and in doing so bathe the subject in light rather than hitting a particular spot. That is why they create a glow on subjects when you use a long exposure (1/8 second or more). The colour combined with the flicker tends to smooth the complexion, making flattering portraits. In black and white it has the same effect as shooting with an orange filter.

Avoiding camera shake

If you set a low ISO speed you will probably need to use a tripod in order to avoid camera shake at slow shutter speeds. Try a high ISO speed such as 1600 too – this may allow you to handhold the camera, making the pictures more spontaneous in the case of portraits. The pictures will be grainier (or noisier in the case of digital) but that can add to the candlelight effect. It is especially pleasing in black and white.

Photographing on a lightbox

Lightboxes are generally used for viewing negatives and transparencies but are a great light source. This is an exciting project and you will produce some beautiful images. They can look great in black and white too.

If you don't have a lightbox you can produce the same effect by placing a light beneath a sheet of opal Perspex, or a sheet of glass with tracing paper laid on top. The light may be flash, incandescent or fluorescent. When translucent items such as flowers, leaves or feathers are placed on top, the light shines through them and gives an X-ray effect.

You will need to use close-up (macro) focus and don't forget to set your white balance (or use a filter for film) to match the light source you are using. It is a good idea to bracket your exposures, as the back-light may cause your meter to underexpose. You can use a reflector to add some top light – if silver foil is too bright, try white card instead. If possible use a tripod so the camera can be kept in position, allowing you to move the subject around without having to recompose with the camera each time.

Translucency and texture

Pressed flowers and leaves have beautiful translucency and texture. To press them, place them between sheets of blotting paper

I went in very close to this pressed fern frond to isolate the shapes. I cropped it square then toned it blue in Photoshop to resemble a Dutch Delft tile. GH

and put a heavy weight on top. In about a week they will be pressed and dried, with great shapes perfect for lightbox subjects. Try experimenting with unpressed items too.

Shooting on a lightbox will usually produce a white background around the objects you are working with. To get some texture into the background, try adding a piece of paper to the lightbox. Tissue paper works well, and you can use colours too.

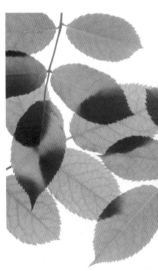

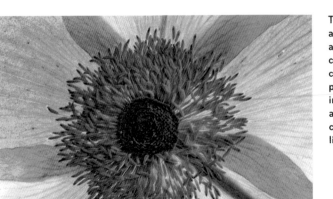

This pressed mauve anemone flower has a glow to it which is caused by the light coming through the petals. I composed the image with the carpel and stamens in the centre, making it look like an eye. GH

Here I laid two fresh rose stems over each other and created a pattern. Where the leaves cross over a darker shape is created, giving a three-dimensional effect. GH

REVIEW

I took the pictures shown right and below for the jacket of a murder novel set in Dover, Kent. This one was shot at 8.30am, looking into the early-morning sunlight. The light has back-lit the famous white cliffs, making them look very sombre and foreboding. The publisher chose this one of the two because it better illustrated the dark theme of the novel. JG

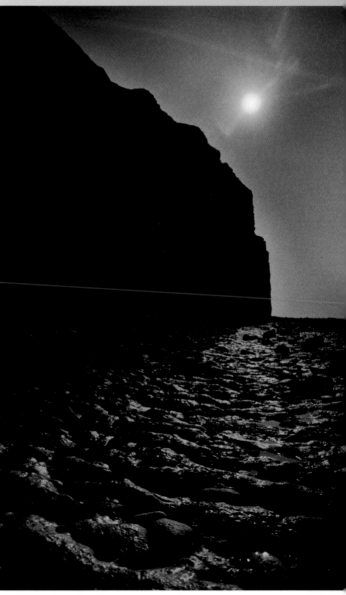

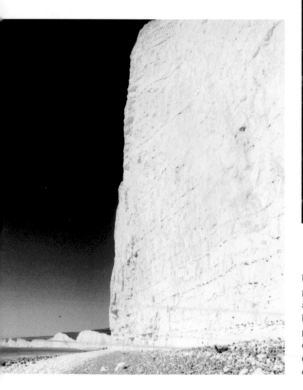

Fifteen minutes after I took the photograph above, I shot the cliffs from a different position, this time with the light behind me – the traditional front-lit picture of the white cliffs of Dover. Both of these photographs were red-filtered, darkening the sky and, in this shot, emphasizing the whiteness of the cliffs. JG

In daylight the sign at a restaurant called Ed's Diner doesn't have especially exciting colours, but night-time transforms it. I shot it on a compact camera using the auto mode and exposure compensation of $+\frac{1}{2}$ stop as the bright lights shining into the camera made the exposure meter misread the conditions. GH

Light review

- **The quality of the light can make the difference between a mundane photograph and a stunning one.**
- **The colour and angle of light changes throughout the day, giving very different effects; artificial light gives you extra choices.**

Project 1 Flash in daylight
This project is all about the balance between daylight and flash. If your photographs weren't as you hoped, the most likely reason is that you didn't underexpose the background sufficiently. Getting it right can be time-consuming but, once mastered, the technique will stay with you. Digital photographers can experiment and view the results as they go along; film photographers will need to bracket and note the settings for future use.

Project 2 Night photography
You may have encountered high-contrast situations that neither a film nor sensor can deal with, such as car headlamps in a dark street. If you expose for detail in the street, the headlamps will be overexposed; if you expose to make the headlamps less bright the street will become almost black. It's best to avoid extreme high-contrast situations at night. If your light-trail pictures weren't successful, the shutter speed may have been too fast.

Project 3 Candlelight
You may have found your subject underexposed because the bright light from the candle upset your metering. Taking a spot reading off the subject will solve this. If the colour balance was too warm, try the incandescent white balance setting, which cools the colour but still maintains a yellow/orange glow; if you want a strong orange colour, set the white balance to daylight.

Project 4 Photographing on a lightbox
If you had trouble getting the image sharp you may have gone closer than your lens can focus, in which case you need a macro lens or a close-up filter to shoot at that distance. In close-up shots of small objects the slightest movement of one of them can radically change the composition of the picture; if you weren't happy with your picture try rearranging them, remembering that the spaces between the objects (the negative shapes) are just as important as the shapes of the objects themselves.

Colour

Exploring colour

What constitutes a pleasing colour picture is a matter of taste – what one person considers a subtle arrangement of colours may be boring to someone else, while vibrant and exciting colours may strike some as just too bright.

I shot this picture on the Great Barrier Reef in Australia, using an underwater Nikon. The fish were silver, but the light coming through the water has acted as a blue filter. The blue dominates the picture, giving it a mysterious quality. JG

Colour is of course more than just decorative – it can touch us deeply on an emotional level. Two pictures containing the same pictorial elements but using different colours can arouse a very different reaction from the viewer.

Yet while it's universally recognized that colour exerts a psychological effect on us, (see pp.128–9) we all see and respond to colours in different ways. Childhood memories influence our attraction to various colour combinations – if you have wonderful memories of great times at funfairs, for instance, you may always retain a fondness for the bright, buzzy colours you saw.

Such memories of colour are lodged in our consciousness in the same way that smells and music recall past happiness.

This was an irresistible subject for a colour photograph. I was lucky that the fisherman's shirt was the same colour as the fish, which is so intensely red it seems almost unreal. The picture looks as it must have been manipulated in Photoshop, but no – that is the real thing. JG

They greatly affect how we choose to work with colour. The general environment we grew up in may play a part, too – perhaps a cool northern land with muted colours, or a hot country with brilliant light and vibrantly coloured houses.

Colour in photography

Early colour films were unstable, so the main effort of photographers went towards trying to reproduce colours that were faithful to the subject. However, during the 1960s photographers took colour photography to a new level. Ernst Haas, Pete Turner, Art Kane and many others used colour as the dominant feature in their images, making it the subject matter itself.

The tool that has revolutionized colour photography today is the computer. By using Photoshop or other image-editing software almost anything is possible. Every colour can be altered completely – even a red to a green, and so forth.

Although some prefer to juggle the colour balance of their pictures on the computer, many good photographers choose to manage colour in their digital cameras. However, you can make the image colour either warmer or cooler at the time of shooting if you wish to (film users can also achieve this by using filters) and still indulge yourself creatively on the computer later. This lesson is designed to encourage you not only to use colour in a way that will add to your photographs but also to have a go at revelling in colour as a subject in itself.

Seeing the bigger picture

The picture on pp.124–5 was taken on a rainy London night, when I had gone to Piccadilly Circus looking for reflections on the wet pavement. I was just entertaining myself by composing in colours – there was no story to tell. Turning the picture upside down has added to the abstraction of the composition. The exposure was easy – just normal on Program with my compact camera. JG

Emotional colour

All colour pictures evoke a response in the viewer which relies on both the nature of the individual colours and how they relate to each other in the composition of the image.

Colour has a profound emotional effect on us, both in images and in the general environment. We know that cool colours such as blues and greens tend to be calming and sometimes even lowering to the spirit; colours at the opposite side of the colour wheel (see p.152) tend to excite the viewer and maybe even induce anger.

The psychological use of colour is part of our everyday life. Advertising agencies rely on it to seduce the public into buying their products, while hospitals, for example, are often decorated in shades of restful green.

While many people aren't consciously aware of the impact colour has upon them, you as a photographer need to be mindful of the viewer's emotional reaction if you want to give your colour pictures more meaning and impact. A sophisticated use of colour will lift your photographs to another plane.

We think of waterfalls as being invigorating and refreshing, but this has turned out to be a rather melancholy picture purely because of the blue colours. The blue cast has been created by the shade light, and I added to the mood by blurring the water on a slow shutter speed of 1/4 second. JG

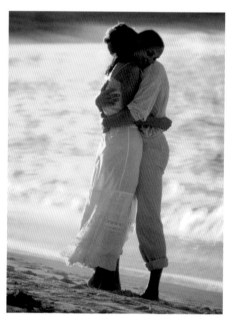

Here pink clothing is combined with pink light provided by the back-lit sunset with some help from a warming filter. While the models are posing in a loving way it's really the colour that sets the romantic mood. Had they been in bright clothes against a blue sea this would have been a very different picture. JG

To make a restful picture for a greeting card, I placed these lilies in front of a soft green background to give the idea of nature and freshness. The background harmonized with the greens of the plant, adding to the calmness of the image. It was lit by daylight diffused through a net curtain, with a silver foil reflector opposite the window. GH

The combination of the intense blue of the man's jeans, the blue on his skin and the ground, the distressed blue wall and the cool shade light have created a moody and mysterious feeling to this portrait. JG

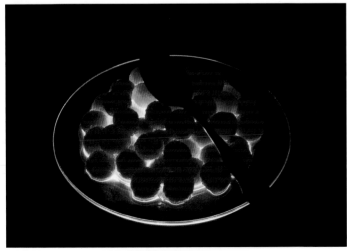

Red is a commanding colour that demands attention. To produce the back-lit effect I cut a hole in a piece of black card slightly smaller than the clear glass plate with the watermelon balls. I placed it all on a lightbox (see p.121). The back-light coming through the plate has increased the colour to the point where it looks as if it's on fire. I used a 55mm macro lens at f/16 with flash as the light source. GH

PROJECT 1

Saturated colour

This means colour at its most intense, and for this first project all you need to do is produce pictures filled with rich colours.

Here your task is to search out some subjects that have really strong colours, even if your personal taste is for softer hues. If you're shooting still life you'll have the advantage that you can select and combine colours of your own choice.

Remember that light greatly affects colours, so the time of day and the weather conditions will have a major influence on the saturation of colour in your pictures. Perhaps surprisingly, colours can really zing in low, stormy light.

You'll need to consider exposure and filtration too – slight underexposure and a warming filter will considerably increase the intensity of your colours. Digital shooters will be able to increase the colour saturation by adjusting their white balance.

For film users, the choice of film is obviously important. Both Kodak and Fuji produce films with a very saturated colour balance in both negative and transparency form (see p.27).

I used a polarizing filter on this tree to cut out unwanted flare. It has let the pure colour of the leaves show through as the surface shine has been removed by the filter. It has also darkened the blue sky, making the yellow leaves look even brighter. GH

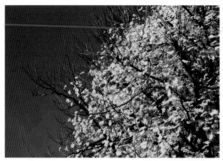

I underexposed this simple picture by -⅓ on exposure compensation – when I am looking for maximum saturation of colour I always make the picture slightly darker than the meter suggests. I used a warming filter to help maximize the colours in the subject; had I been shooting digitally I would have used a warmer setting on white balance. JG

This was an exercise in colour as the subject. It's part of a series called Road Art, in which I isolated the patterns from road markings. The original markings were red and yellow, but I inverted those in Photoshop as an experiment in colour. GH

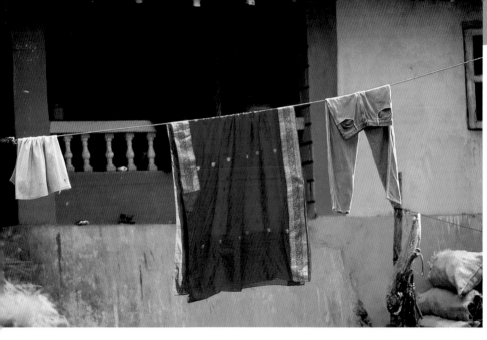

Washing day (every day) in Goa, India, presents many pictures like this, so I can't claim to have worked very hard to find this one. However, it's a good example of how a subject with saturated colour leaves you little to do other than compose to make a pleasing pattern and underexpose by -⅓ stop. JG

The morning light in the Mediterranean is famous for its bright, clean colours. This boat was in Corfu. The intensity of the colours made an irresistible subject and I didn't need to use a filter to enhance them. I underexposed by -⅓ stop. JG

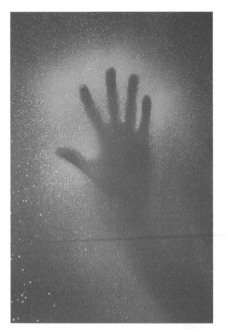

This blue hand was from a series I did using 'black light' – an ultraviolet fluorescent tube. I splattered some tracing paper with red and blue fluorescent paint from an art shop. The hand is behind the paper, with the light behind the hand. I shot on 100 ISO film with a long exposure as the purple-coloured black light isn't very bright. GH

PROJECT 2

Unsaturated colour

This is probably the most difficult of the projects in this lesson as you have to find subjects where the colour looks unsaturated and compose interesting pictures without the help of bright colours to catch the viewer's eye.

To get the hang of this assignment, it's important to be aware that it's the quality of the light that will decide whether the colour is unsaturated or not. Some examples of light sources that will work best for this are dawn, dusk, back-light and shade light. Of course, the choice of subject matter and the composition make the picture here.

If you succeed with this project you will have made a big step towards seeing and understanding how light works.

Here the sun is behind the improvised sunshade so there is no direct light on the picture; the main light source is the blue sky, which has reduced the colours at the warm end of the spectrum. No filters were needed to produce this subdued colour. JG

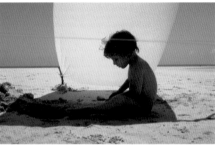

This dog was in the shade on a bright day. I was attracted by the strange colourlessness of the scene; the green of the grass beyond the fence has been washed out, overexposed by the sun. The back-lit halo effect surrounding the dog makes the picture. JG

The sparkle of frost on these leaves has muted the autumn colours beneath. The overall blue tint is the reflection of the soft light from the early-morning sky in the ice crystals. GH

Lions are usually most active when the light is low, either early or late in the day. Here the sun is almost gone and the lions are in shadow. The colours are true to life but very subdued. I could have warmed up the colour with a filter or with white balance but I liked the softness of the natural colours. JG

Colour relationships

Much has been written about the theory of colour relationships, but the main thing to know is that the way we perceive colours is affected by the ones they are juxtaposed with. Few are seen in isolation in an image.

PROJECT 3

Hot colours such as red and orange advance in a picture, while cool blues and greys recede – which is why blue is often chosen as a background colour. Indeed in nature it is often chosen for us, since aerial perspective, caused by particles in the atmosphere, bleaches distant views to pale hazy blues. Consequently, the viewer's eye will understand strong reds and oranges as being in the foreground, giving you a way to introduce depth to your pictures. For example, in a landscape, try to find a red building to photograph and see how it comes forward to the eye.

Opposing colours

It's generally accepted that juxtaposing colours at opposite sides of the colour wheel (see p.152) creates colour tension and vitality. Referring to the colour wheel, experiment with colours to learn the effect they have on each other – the obvious combinations to look out for are blue and yellow, red and green or purple and orange.

Children's toys, fruit and vegetables are good subjects for this, while a well-stocked flower garden is a perfect place to find any juxtaposition of colour you could imagine.

I could have used a blue or green background to contrast with these richly saturated courgettes. However, I thought that the warm magenta was more harmonious and gave the picture warmth. GH

The orange hat against the intense blue and green were a gift for a colour photograph. I helped it all along by using a polarizing filter and underexposing by -⅓ stop to give it more saturation. JG

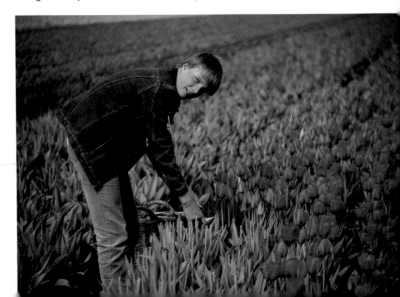

This picture, shot at tulip-picking time outside Amsterdam, uses an old trick of placing two opposite colours of the spectrum next to each other. Green and red together increase the vibrancy of each, but it was only later that I realized I had recorded a colour combination that artists have been using for centuries. JG

It's the blue sky reflecting in the windows within the structure of this building that makes the angled grid pattern so strong. If there had been a grey, overcast sky, I doubt I would have noticed the building at all. GH

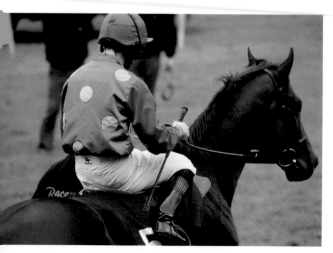

I wanted to maximize the colours on this shoot at a racecourse so I used Kodak very saturated (VS) transparency film, which added extra intensity. You could set the colour on your digital camera to vivid or add some saturation in Photoshop to get a similar result. GH

This was taken in Piccadilly Circus in London; the colours in the window are reflections of a giant advertising screen opposite. I set the camera on a tripod, framed the shot, and waited until a particular colour combination occurred – I took about 20 shots in all. It added a different dimension to an ordinary architectural picture. GH

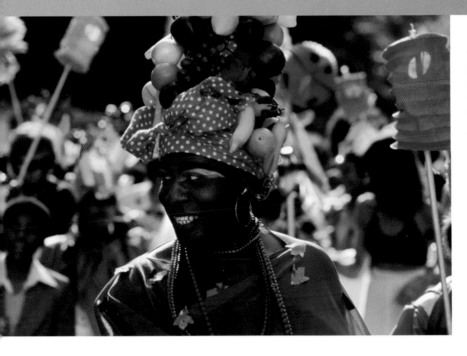

The zingy colours of carnival have enhanced the festive spirit, and the back-light from the afternoon sun has rendered them brighter. My zoom lens was set to 100mm and the exposure was 1/250 second at f/4.5. Slight underexposure of -½ stop made the colours richer still. GH

Colour review

- Colour is far from incidental to a picture – it dictates the viewer's emotional response to the image.
- Learning to handle colour in a sophisticated way will bring extra impact and meaning to your photography.

Project 1 Saturated colours

If you were disappointed with the saturation of your colours it may have been the case that the light was too cool on warm colours or vice versa and therefore didn't enhance them. Another reason for lack of saturation in your pictures may be that you overexposed the subject and bleached the colours out. Try again, this time underexposing by -⅓ or -½ stop.

Project 2 Unsaturated colours

Did you find the right subject for this tricky assignment? You need some strong shapes in the composition when you have no colours to help you out.

If you had trouble with desaturating the colour, the light you were working in may have introduced too much colour to your picture. The light that's typically found at sunset, for instance, would have added too much red to the subject.

However, with Photoshop, you have another chance to desaturate your pictures. This gives a different look from desaturated photographs obtained simply by the use of light and exposure, but it's very interesting and also allows you to experiment with composition in the absence of strong colour. Try it on some of your saturated pictures and see what happens.

Project 3 Colour relationships

Once you've deliberately manipulated colour in your images as you've done in this project, you'll remain conscious of how it's contributing to your work. Outside the still-life genre you won't necessarily be able to control colour, but you'll know how to make the best use of it.

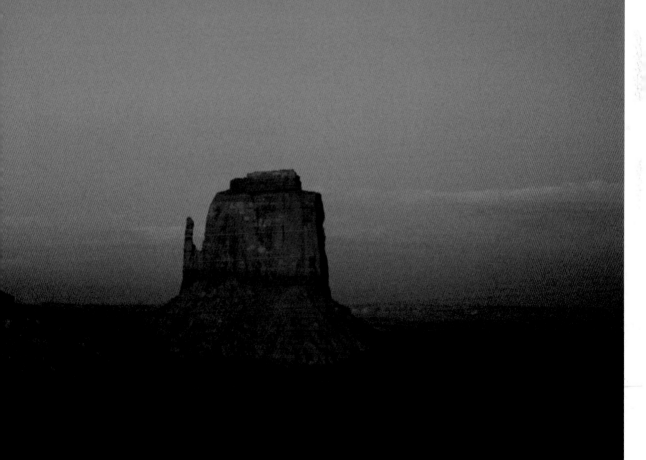

Filters

Transforming the image

With the use of filters you can correct and enhance colour, shoot in soft focus or add a range of special effects. Relatively inexpensive and light to carry, filters can transform your photography.

Filters were introduced in the early days of photography, when of course all film was black and white. Photographers learned that they could change the relationship of tones in the image by using blue, yellow, orange, green and red filters (see p.152).

Upon the introduction of colour photography, however, a very different approach to filtration was required. The filters used for black and white would be far too strong for general colour photography, unless special colour effects were wanted.

When it comes to shooting in colour most filtration is for colour correction, designed to enable photographers to produce a true reproduction of the subject.

In modern digital cameras some colour correction issues are now overcome by using the white balance function, and image editing on the computer gives you another chance to get the colour as you want it to be. Some digital cameras allow you to take a picture then make colour changes to it in camera. However, many photographers

For this portrait of the artists Gilbert and George I used a combination of polarizing filter and graduated neutral density filter in an attempt to reproduce the mood of one of their paintings. JG

By using a blue filter on the back light and a pink on the front, I turned the flat white paper sheets into a pattern of colour. GH

still prefer to use filters on the lens, as they want to see the final effect when they are taking the picture.

A change of mood

Colour enhancement is a more interesting use of filters, and many professional photographers always carry a set for this. In unpromising or downright dull locations there's often a need to enhance the picture to make a silk purse out of a sow's ear and thus produce pictures that the client will be pleased with.

There are a number of other filters that can effect a change of mood also. The most widely used are the polarizing filter, graduated filter and diffusing filter, but there are many special effects filters also available, for example starburst, rainbow, multi-image and so on. Of course, most filter effects are also available on the computer.

As well as using filters on the lens, you can alter the colour of the subject by adding sheets of colour filters (called gels) over your light source – and you can get some good effects by adding a filter to the built-in flash on your camera.

Experiment with your own special effects 'filters', too – try shooting through bottles, patterned glass or fabric, for example.

Seeing the big picture

The double-page photograph on pp.136–7 was taken in the spectacular scenery of Monument Valley in Utah, USA. I used two filters to do it justice – a KR6 warming filter to accentuate the pink light of the setting sun that was hitting the natural monuments, plus a neutral density graduated filter to darken the sky, thereby heightening the drama. JG

Your filter kit

The set of filters shown here will cover many eventualities, but with experience you will probably want to add others that give effects you particularly like.

Quick tip

• You need to be able to grab your filters quickly when the light is changing fast. Wearing a photographer's waistcoat and always carrying your filters in the same pockets is a useful trick.

There are two different filter systems: round filters that screw directly onto the front of the lens, and filters that slip into a holder attached to the lens with an adaptor ring.

These rings are available to fit all lens diameters, and the system is more economical because you need only one set of filters. You also have more control over graduated filters as you can slide them up and down in the holder to get the position right. The Cokin filter series offers more than 100 filters which are great value for money.

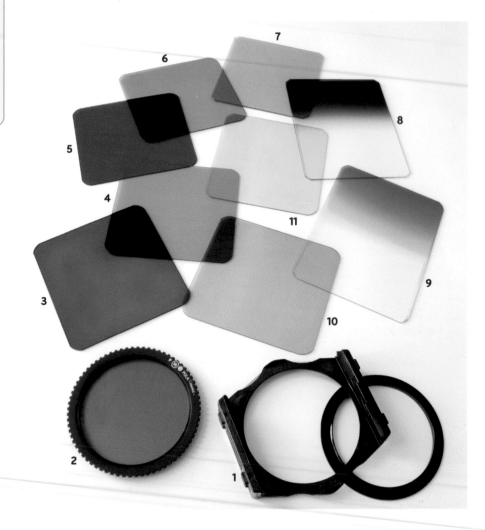

KEY

1 Filter holder and adapter ring.
2 Polarizing filter.
3, 4, 5 and 6. Set of black and white filters (see p.152).
7 Fluorescent correction filter.
8, 9 Graduated filters.
10 Cooling filter.
11 Warming filter.

The polarizing filter

This filter does the same job as polarized sunglasses – it cuts glare and minimizes the reflections that bounce off surfaces.

By reducing reflections the polarizing filter effectively intensifies colours, even on subjects that aren't obviously reflective.

You can vary the amount of polarization you get by rotating the filter, though how much effect it will have depends on the angle of the light source and the angle of the camera to the subject. The maximum effect will be when the light comes from over your right or left shoulder and is not quite flat on to the subject. There is no effect on back-lit subjects.

The polarizer is most frequently used to darken blue skies, thus emphasizing white clouds, and also to remove the reflections from windows and water. To get to know this useful filter, put it on your lens, choose a subject, and rotate the filter. When you see colours intensify and reflections disappear, stop rotating – it's that easy!

You can see from these before and after shots how the polarizer has completely removed a strong reflection of the sky from the window. I changed the camera angle until I got the maximum polarizing effect. GH

The polarizer has removed the reflection from the foliage, leaving the pure colour to come through. It has also darkened the sky, adding more saturation to the colours and emphasizing the white clouds. GH

Here the sun was coming from behind my right shoulder. The polarizer can also be used as a neutral density filter to cut exposure in very bright light such as this. It will reduce the light value by 2 stops. JG

PROJECT 2

Graduated filters

Photographers and cinematographers have used graduated filters for decades. In fact, if you look carefully at movies and TV productions, you will see that the 'grad filter' is used most of the time, especially in outdoor scenes.

These two shots of a boy fishing in Yosemite National Park demonstrate how a neutral density filter works. It has not introduced any colour, but the existing pale blue sky has been made darker by being underexposed 2 stops by the graduated neutral density filter. JG

These filters have colour or tone in half of the filter, graduating to clear in the other half. They are used when the exposure range from light to dark is too great for the film or sensor to be able to capture detail across the whole picture (usually in a landscape with a very bright sky).

Most photographers also employ them to add colour or tone to a portion of the picture (generally the top) for dramatic effect. They are available in a range of colours as well as neutral density, which has tone rather than colour and darkens any colour or tone it is filtering – most often the sky, though in the case of a grey and depressing sky professional photographers often turn to a blue grad filter instead to make the picture look more appealing.

Experimenting with graduated filters

Go out and try taking some shots with graduated filters, remembering that if you are darkening the sky, any objects such as a tree or building that are in the graduated filter area will be darkened or coloured also.

Graduated filters can also be used together, one colour on top and another on the bottom, for special effects. For instance, in a landscape photograph you could use a blue grad at the top to enhance the sky and a green grad on the bottom to make the grass more saturated.

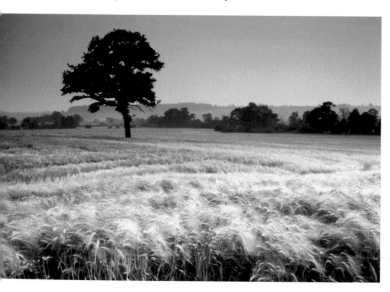

Faced with a clear white sky that looked uninteresting, I added a pink grad filter to darken it and give a slightly romantic look. GH

Diffusing filters

These filters were first employed by the great Hollywood cinematographers as far back as the 1920s to flatter their movie stars by softening their complexions and adding a romantic glow.

Today, soft-focus filters are still associated with romantic images. There are ready-made filters you can buy, but you can use a variety of ways to get the same effect. You'll find many materials suitable for diffusion – try muslin, net, a stocking or tights and clingfilm, for example.

A smear of Vaseline works well, but put it on a UV filter, which is clear (never directly on your lens). One of the prettiest effects is gained by breathing on your lens and shooting the picture before it completely clears. You can also give a soft filter effect in Photoshop, while in the darkroom a soft filter (which again can be material such as tights) over the enlarging lens is often more easily controllable than on the camera.

But be careful – if you use a strong diffusing filter, you are in danger of making the picture look simply out of focus.

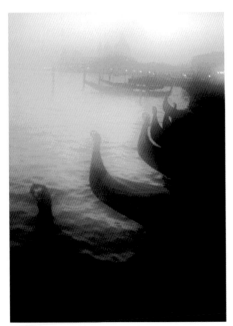

On a cold dawn morning in Venice I was really just messing around, breathing on the lens. You can get a wide variety of effects this way, from very foggy when you first puff to a slight diffusion when the lens is almost cleared. JG

This portrait was shot on a very dull day using two filters: the warming filter has made the rich skin tones and a slight diffusing filter has given a glow to the face and hair. A subtle soft filter is great for glamour portraits because modern lenses are too sharp and unflattering for the skin. JG

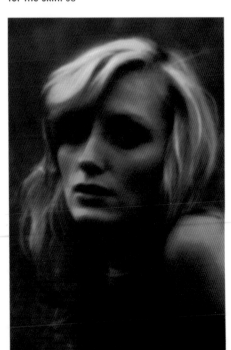

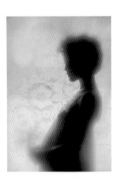

I made this filter myself by smearing a thin film of Vaseline around the edges of a UV filter. There is a sharp area in the centre and the edges are out of focus. The shot illustrated an article about pregnancy. JG

PROJECT 4

Filters on lights

Adding a filter to your lens gives an overall effect to a picture; by adding a filter to your light source you can choose an area you wish to add colour to.

The cream-painted walls in this laboratory were quite uninspiring. I decided to use the blue computer screen as the main point of interest. The unfiltered main light is aimed at the wall behind the computer, providing the illumination on the man's face. I used my red-filtered second light to put a wash of colour in the background and pulled a shiny table into the foreground to extend the colours. GH

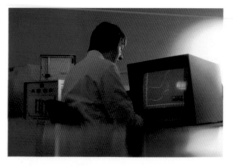

Adding colour like this is a big plus for the professionals when they are taking corporate shots in factories and so forth, which are often quite colourless and lack impact. Adding some colour, even if it is slight, can lift the shot and make it special.

However, you can also use this technique for more personal projects. If you're working with more than one light you can add different colours, but you'll have to be careful not to overdo it or the result may look like a 1980s disco picture (though this may of course be just what you're looking for). Make sure you buy gel filters that are specifically designed for hot lights, otherwise they may catch fire. Inexpensive filter sheets are available from professional photography dealers.

Ellie's face was lit with a diffused unfiltered light from the left. I added a blue-filtered light from the far left and a red from the right. I zoomed the lens during the 1/2 second exposure. GH

To give this shot some drama I turned the room lights off and lit the back with a blue filter and the front with green. The centre was lit with an unfiltered light so you can see the material the machine is producing. GH

Colour correction and enhancement

This is an area where you have several choices – a filter on the lens, using white balance or editing your pictures on the computer.

Colour correction and enhancement is an invaluable option however you choose to do it. There are occasions where it's critical for the image to be true to life and some correction may be needed to achieve that, but as professional photographers are usually required to make their subjects look better than they are in reality they constantly turn to filtration to enhance the colour.

Personal projects
Enhancement is also often used to interpret how a photographer feels about a subject rather than making a faithful recording of it. You don't have to accept the colour balance you find – you can improve it with filtration to get a more pleasing result. For this project, think also about the emotional impact of colour (see pp.128–9) as well as the look of your pictures.

Looking at my first shot, I decided that this very grey and unpromising day at the beach would be much improved by cooling it down to look as if it was seen at dawn. I used the incandescent setting on the white balance on my digital camera to add the blue. This has the same effect as adding a strong cooling filter. GH

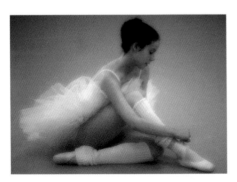

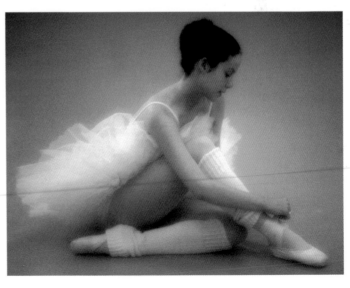

I shot the ballerina on film under fluorescent light that has thrown a green cast over the picture. I had no fluorescent correction filter with me, so I corrected the colour balance in Photoshop. If I had been shooting digitally I could have got a similar result by setting the white balance to fluorescent. JG

First I focused on the woman then I held a small mirror diagonally in front of the lens to add the reflection of the tree branches. As I was shooting at full aperture of f/4.5 on a 100mm lens, the edge of the mirror was out of focus and can't be seen. GH

Here the street lights of Venice are shot with a star filter. These filters add a star around any bright light source and are available in 2 to 16 star points. JG

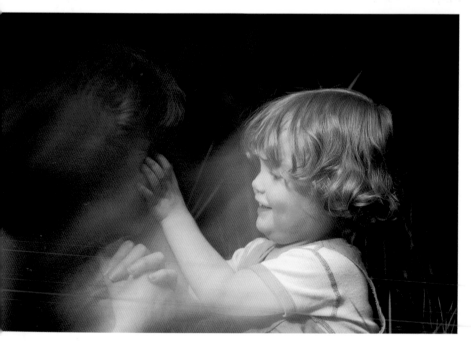

I used a home-made distortion filter for this picture. The filter can be made by heating a piece of clear Perspex then, when it's soft, bending it to a flat S shape and letting it cool. Hold the filter in front of the lens and move it about until you get the desired effect. Here it gives the picture a feeling of movement. GH

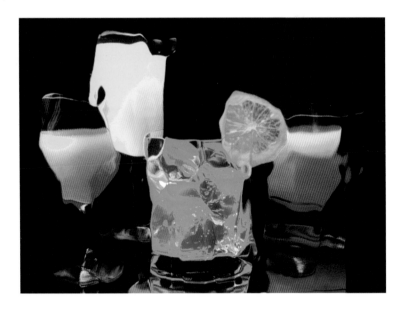

I shot these glasses of fluorescent dye through a small sheet of rippled glass 15cm (6in) in front of the glasses. The camera was also 15cm (6in) from the glass. The rippled glass has given the picture a Cubist look. GH

Filters review

- Filters are a great way of bringing new aspects to your photography as well as allowing you to correct colour.
- You can buy a huge range of colour and special effects filters, but home-made ones are inexpensive and encourage you to be creative.

Project 1 The polarizing filter
If the sky was unevenly polarized, the light was probably too much to the side – try again with the sun over your shoulder. If you were using a very wide-angle lens this may also have caused uneven polarization; such a lens includes a huge area of sky and the sun has to be in the perfect position.

Project 2 Graduated filters
If you were using a wide-angle lens and got a sharp edge where the graduated filter ended you may have stopped down too much, pulling the filter into focus. Next time, use a wider aperture.

If you have trouble with flare on the filter, you'll need to shade it from the sun with your hand or a piece of card. If your meter has been fooled into overexposure by the graduated filter, bracket your exposures.

Project 3 Diffusing filters
Did the picture look soft and romantic or did it look plain out of focus? If the latter, you may have been using too much diffusion. Disappointing results may also be caused by choosing the wrong subject or lighting; try again on a more potentially romantic subject.

Project 4 Filters on lights
This project is an easy one, as what you see is what you get. However, what looked good in reality may seem over the top in a photograph; experience will help.

Project 5 Colour correction and enhancement
Do you think that the colour balance you chose was appropriate for the subject? Colour balance is subjective. Ask friends what they understood from the picture to see if that corresponds with the feelings you were trying to express about the subject.

Black and white

The power of black and white

There was a time when photographs and films could only show our world in black and white. When colour film was invented it might have seemed that it would sweep black and white aside altogether, but it remains popular.

Early photographers experimented with toning, handcolouring and processes such as gum bichromate to introduce colour to this new medium, but it was laborious work and the photographic image in all its forms remained largely monochrome. Today, the situation is reversed – the vast majority of photographs are in colour, and black and white is regarded as an art form that deserves skill and patience in the making of an exhibition-quality print.

To understand the immense power of black and white imagery, rent out DVDs of movies such as *Citizen Kane*, *Gilda*, *The Third Man* and the great Westerns made by John Ford and Howard Hawks; nearly every frame is a dramatic photograph. It's very important to look at the masters of black and white photography too, such as Edward Weston, Ansel Adams, Paul Strand and, among today's practitioners, Albert Watson, Sebastião Salgado and Sarah Moon.

Using a red filter has rendered the blue sky almost black and increased the contrast of highlight and shadow, greatly dramatizing the picture and adding to its graphic quality. JG

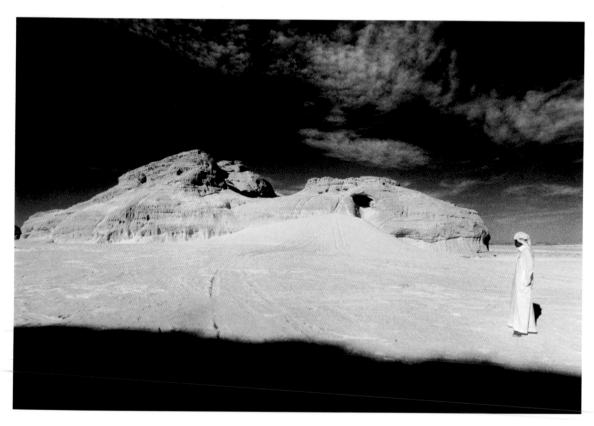

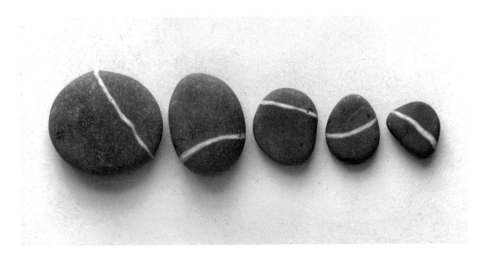

This shot is intended as a metaphor of life, symbolic of the way our lives are always changing directions – we never go in a straight line but we get there in the end. GH

Seeing in black and white

It's the very fact that we are surrounded by colour images that makes black and white photographs so noticeable and dramatic. Of course, our reality too is coloured and this step away into the unreal, partly abstract world of black and white imagery makes it stand out as a separate art form. It's a powerful creative medium that requires a different approach from colour, and it's difficult to visualize a subject equally well in both mediums at the same time.

This is because black and white relies on tone, and the absence of colour draws attention to texture and form. A scene full of vivid colour can look as if it will make a great shot, but if those colours are all of similar tone the black and white image may be rather flat. Conversely, texture and tonal contrast may go unnoticed when the viewer's attention is distracted by colours, and if the latter don't work well together the picture as a whole may fail to attract the eye.

Digital versus darkroom

The quality of digital printing is now so improved that it's possible to make really good black and white prints. Some paper manufacturers have produced inkjet paper that resembles fibre-based glossy darkroom paper, while the matt watercolour papers are, to some people, preferable to a darkroom print. Other people continue to enjoy darkroom work for its history, its craft techniques and its image quality.

The bottom line is that whether digital or analogue, the art of black and white photography is visualizing our colour world in tones of grey. The projects will teach you the techniques you need to do just that.

Seeing the bigger picture

The double-page shot that opens the lesson was taken at an air show. I was in the right place at the right time to be able to see the juxtaposition of scale that makes the huge Vulcan appear to have taken off from the tail of the plane in the foreground. I used a red filter to darken the sky and also printed the picture darker and increased the contrast to add to the drama. JG

Filters

Using coloured filters on the lens in black and white photography has the effect of differentiating the tones in objects where they are similar.

These peppers placed on a blue background all stand out by virtue of their colour.

Shot on film without any filtration, the tonal range is very close, especially between red and green.

An orange filter has lightened the yellow and red areas while the blue and green are darker.

A red filter has increased the contrast between the tones even more than the orange filter.

A green filter has lightened the green and yellow areas and darkened the red and blue.

A blue filter has lightened the background considerably and darkened all of the peppers.

Translated into tones of grey, colours such as red and green are rendered very much alike – a problem if you are photographing a red flower with green foliage around it, for example. A coloured filter on the lens which lightens the colours in its own part of the colour wheel (see below) and darkens the colours opposite is the solution.

For example, if you shoot a black and white picture of a red-brick house in a green field using a red filter, the red areas will be lightened and the greens darkened. The photographs here demonstrate how effective filters are in this respect.

Digital users can set their camera to black and white and use the filters to get a similar effect, or convert a colour shot using the channel mixer in Photoshop. Go to: Layer > New Adjustment Layer > Channel Mixer. Tick Monochrome and adjust the sliders to give the filter effect you want.

Here the colour spectrum is shown in the form of a wheel. A filter will lighten the colours on its own side of the colour wheel and darken the colours on the opposite side.

Colour to black and white

Visualizing your existing colour images in tones of grey is a good way of learning how to see and think in black and white instead.

When you desaturate your colour images or change them to Grayscale they may look a little dark and flat. If so, use Brightness/ Contrast or Levels in Photoshop to give them more sparkle.

This is one of a number of colour portraits I took of fishermen in Sicily. When I was editing them on the computer I decided to make a black and white version of this one to see how it looked in tones of grey. I prefer it, as I don't like the reddish skin tones that the incandescent lamp added to the colour version. I also think the subject looks stronger and more traditional in black and white. JG

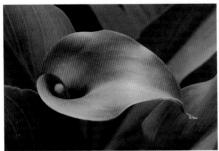

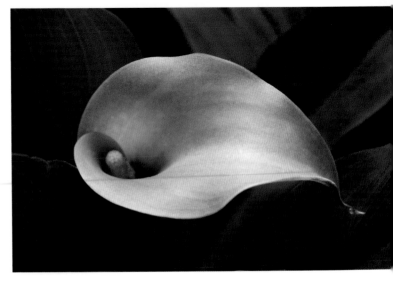

This seemed an interesting image to convert to black and white. With the green leaves dark grey and the pink tones of the flower lighter grey it made a great monochrome image and didn't require any manipulation on the computer. It was shot with a 55mm macro lens at f/8, which kept the leaves slightly out of focus. GH

Print quality

A high-quality print makes all the difference to a black and white image, where contrast and gradations of tone are important to attract the viewer.

This is the original negative, showing a range of tones from the dark of the sky to the light areas of foliage in the foreground.

This landscape, shot on both colour and black and white film, demonstrates the range of tonal contrast that you can achieve from a black and white negative. It was printed in the darkroom using variable contrast paper.

If you are not already versed in darkroom printing, you will find many books that will take you through the basic stages. Here, and on p.156, the intention is to point out what to look for in a good print, for if you are working alone in a home darkroom it's easy to keep on producing prints that don't quite make the grade without ever recognizing it.

The fine tuning of contrast and tone in a black and white print is equally possible for digital photographers using Brightness/ Contrast or Levels in Photoshop.

Here it is printed low contrast to show how a very flat range of grey tones looks. Flat prints don't usually have any areas of black or white and tend to look very insipid.

This high-contrast print also has a very limited tonal range, with areas of solid black and white and only a small range of mid-tones. The hills in the background have disappeared completely.

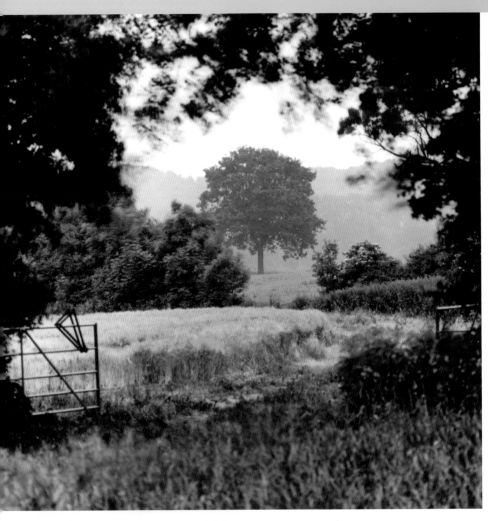

This is the final print. If the negative had been normal contrast it would have printed well at grade 2. However, the print at that grade was a bit flat so I increased the contrast to grade 3, retaining a full range of tones but giving the print more sparkle; brightness is vital to a fine print, unless the intention is to create a deliberately sombre effect to suit a particular subject. GH

This version shot on colour film shows how the colours have translated into monochrome. GH

Quick tip

• If you are having trouble getting a print right in the darkroom, split-grade printing might help. By masking off areas and exposing them separately at a different grade you can boost or reduce contrast where needed. This is very useful when you have a tricky negative to work with.

Final prints

Part of the pleasure of black and white is fine-tuning the final print, making carefully considered adjustments to take it to a new level.

In my first print (below) the fish is too dark and lacks a silvery glow, the tones of the background below the fingers are distracting and the fingertips are too light. I also decided that the top third could be a bit darker. For the final print, I shaded the fish for 10 seconds during the basic 22-second exposure, then burned in the background for 12 seconds. The fingers and the top of the arm were burned in for a further 5 seconds. I used a grade 3 filter and a warm-toned semi-matt fibre-based paper. The following day I decided to selenium tone the print to give it more warmth. JG

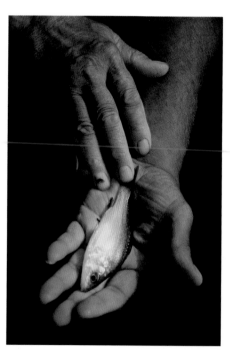

Whether you print in the darkroom or with the computer, the most important thing is to know what a good print looks like and how to make yours reach that standard. The images here show how you can improve a straightforward print with burning and dodging, or even combine painting with photography by handcolouring a print with a range of media.

A black and white print can be transformed by handcolouring. I shot this ginkgo leaf on a textured background in window light. I printed it lighter in tone than normal so there weren't many black areas to apply the colour over, using matt paper so the colour would adhere. Using colour pastels and pencils, I applied the colour, blending it with cotton buds. There are also specialized oil paints for colouring prints. GH

Toning

The toning of black and white prints has a long history and is still popular, both to change the colour and to add longevity.

Traditional darkroom prints are treated with either single-bath toners or bleached first and then toned. The toners can be used at different strengths to vary the colours, and likewise bleaching can be done to a greater or lesser extent; for example, while people associate sepia prints with the overall faded brown of old photographs you can choose to retain the blacks in a print and use a weaker solution of sepia toning to give a light golden colour. It's something you can experiment with for many hours to find out what you like best, and what will suit individual photographs.

Increasing the archival life of the print is of great importance when it comes to selling art prints. Selenium, gold and sepia are the toners traditionally used for this.

Digital toning

Alternatively, you can get the same colour effects using your computer software – the prints shown here were produced with Photoshop. When you have your black and white image on the computer screen, go to Image > Mode, make sure you are in RGB colour mode then > Image > Adjustments > Hue/Saturation and check Colorize. Use the Hue slider to choose your colour and the Saturation for the intensity. That's it, without having to mix chemicals.

It's also possible to produce duo-toned prints (two colours) with both toning methods, giving you even more choice of colour to play with.

Quick tip

• Selenium toner produces beautiful colours but is carcinogenic. Always wear gloves to use it and work in a well-ventilated room – you don't need to be in the dark for toning as the prints are already fixed.

Black and white digital print

Blue-toned digital print

Green-toned digital print

Sepia-toned digital print

Red-toned digital print

PROJECT 1

Red and orange filters

The essential kit of any photographer shooting in black and white should include red and orange filters. If you have never tried them, you will be pleasantly surprised by the difference they make.

Red and orange filters are most often used for landscapes – in fact you will have trouble holding any sky detail without one. However, they are also useful for any subject that requires the tones in the red/orange end of the spectrum to be lightened.

A red filter on a portrait has a cosmetic effect, lightening any spots and smoothing out skin tones. This works best with front lighting – an old trick used by the Hollywood portrait photographers. JG

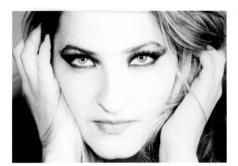

Orange filters produce tones that are a natural interpretation of blue sky and white clouds, while red filters exaggerate the contrast between them. The project here is to use an orange and red filter on the same landscape to see the difference – remember this will only work with a blue sky. The second part of the project is to try a red filter on a portrait.

When you are working with filters on film, you will need to overexpose by +½ or +⅔ stop. This is because the increased contrast could leave you with insufficient shadow detail. If you are shooting digitally, set the camera to black and white and just use the normal exposure settings, checking the result on the screen as you go.

An orange filter is a less dramatic alternative to a red filter for landscapes. Here it has made the sky and clouds stand out, but more subtly than in the red-filtered photograph on p.152. JG

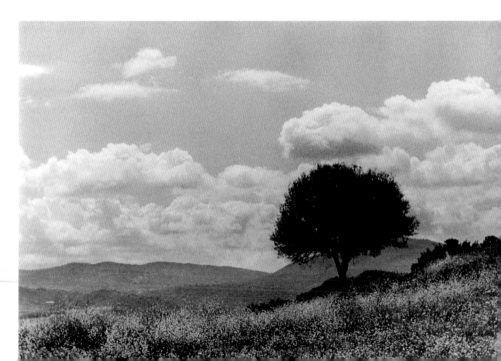

Available light

Many photographers working in black and white are devoted adherents of natural light wherever possible. Its atmospheric quality lends an air of the caught moment, giving intimacy to the shot.

There is a great tradition of available light reportage photography, and indeed some of the greatest photographs ever taken could be described as available light pictures.

The use of available, or natural, light tends to be associated with photographs shot indoors in low light without the addition of flash. Because the light is of low intensity, it does not necessarily follow that it is of poor quality – in fact it is probably alive with drama. Many photographers have the lazy habit that if the light is low they just turn on the flash, killing the atmosphere of the picture which may be the very thing that attracted them in the first place.

Making the most of light

A traditional photojournalist would not dream of flashing an intimate indoor picture, and with today's fast films and digital photography working with low natural light has become even easier. Kodak TMAX 3200 ISO can be pushed to 12000 ISO, for example, and large-aperture lenses mean that it's nearly possible to 'shoot a black cat in a coal cellar', as the saying goes.

This is an exercise in turning off your flash and learning to see low-level indoor light. On digital you can set the ISO at 1200, though some of the top-range cameras can operate at an amazing 25600 ISO. For subject matter, try both individual portraits and shots of gatherings such as a birthday party. Directional window light may leave some areas in deep shadow, but it's easy to throw some light into this if necessary by using a white card or sheet as a reflector.

Here a dancer is waiting to go on stage at the Royal Opera House in London. Flash would have killed this picture stone dead. JG

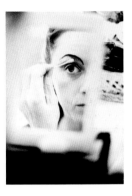

In the dressing room, the reflection of a ballerina putting on her make-up interested me more than a straightforward portrait. Like the other shots on this page, it was taken on film rated at 6000 ISO and with a 50mm lens set at f/1.2. JG

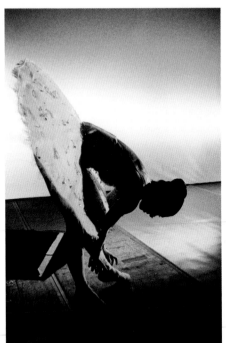

A ballerina checking the ribbons on her ballet shoes in the wings. The ability to see the light possibilities like this silhouette take time to acquire – available light photography is a constant learning process. JG

PROJECT 3

Shooting tonal abstracts

For this project, the task is to search for patterns in the ordinary things around you and isolate them into tonal compositions.

In both of the examples used in this project you will see that it's the light and shadow creating the tonal pattern that is really the subject, not the materiality of the objects.

This project requires you to abstract a subject in a similar way. Try to forget about what its purpose is in everyday life and see it merely as shapes of grey tones. In your treatment the subject might not even be recognizable – the picture could just be a purely abstract form.

It's worth while spending a good deal of time on this exercise, because once you have begun to isolate tonal patterns from the subjects around you and turned them into interesting black and white pictures this will influence all your work. If the subject has contrasting colours you can use filters to separate them and create a more dramatic tonal composition. For some great examples of this style, look at the work of Ralph Gibson and Lee Friedlander.

I noticed that the interior lights in this building threw the stairs into silhouette and created some very pleasing graphic tonal shapes. GH

The tables and chairs next to me in a Pittsburgh diner were strongly cross-lit from the front window. I wasn't seeing them as tables and chairs, just as shapes of grey. JG

Quick tip

• If you find it hard to dissociate objects from their everyday use, turning them upside down will help you to view them in terms of just shapes and patterns.

Sun prints and photograms

You don't actually need a camera to produce a photographic print – all that is required is a subject, sensitized paper and some light.

These techniques take us back to the origins of photography when people experimented with materials to record images on paper. The processes shown here both produce negative prints, but they can be turned into positives by contact printing them onto another sheet of photographic paper, or by scanning them into your computer and inverting them in Photoshop.

Experiments with light

This type of photography is not for those in a hurry, but the craft element of it is immensely satisfying. You will of course need to do tests to determine your correct exposure, as you would with ordinary darkroom work, but for the sun print this will take a bit more experimentation.

Photograms are quicker to try out and more predictable. If you use solid objects you will get a silhouette; translucent objects work best as the light can penetrate them, giving you a range of tones. For inspiration have a look at Man Ray's wonderful photograms, which he called Rayograms.

Historical methods of printing are referred to as alternative processing. It is growing in popularity, and if you want to explore it further you will find websites such as www.apug.org where enthusiasts discuss techniques and suppliers of chemicals.

I placed hammers on a sheet of unprocessed photographic paper and took them out into low-angled sunlight. After exposure for 5 minutes, I used photographic fixer to stabilize the print; the sun had formed the image already, so there was no need for development. Finally I washed the print in the normal way. GH

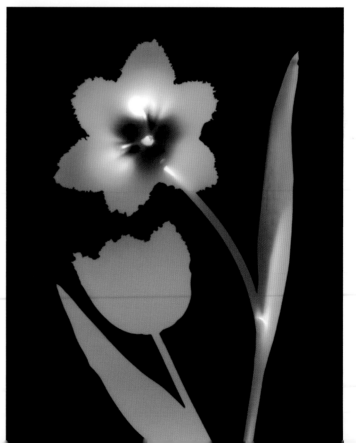

A photogram is similar to a sun print but is made in a darkroom. I placed the two flowers on a sheet of photographic paper under the enlarger and exposed them for 15 seconds before developing, fixing and washing the paper as usual. GH

It was the ball of sun behind the clouds that attracted me to take the picture of this burnt-out tree trunk. The sun formed the focal point and created the silhouette. I have played with tonal composition here. The tree is not a tree – just a dramatic shape. I used a red filter and exposed on aperture priority with +1½ stops exposure compensation. JG

I would never have dreamed of shooting the kettle, but the sun coming through the window created a shadow that presented me with an entirely different possibility. I shot it in colour but decided it made a much stronger black and white image. The exposure was as the meter calculated, with no compensation needed. GH

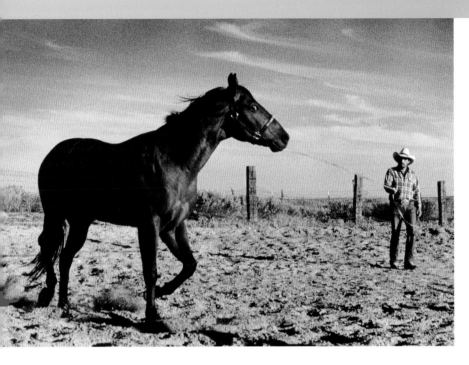

This picture of a Texan cowboy breaking in a horse has been simplified by shooting it in black and white; I like the graphic relationship of the shapes of the horse and the cowboy. I used a red filter to darken the blue sky and a 24mm lens to enhance the composition. Kodak TMax 3200 ISO film has given a grainy image. JG

Black and white review

- Using black and white rather than colour requires you to think about images in a different way, seeing them as tones of grey.
- Manipulating black and white prints allows you to take pictures to another level and express your feelings about the subject.

Project 1 Red and orange filters
If the red and orange filters didn't work very well on the landscape the sky might not have been a strong enough blue. Check the shadow detail in the negatives – you may have underexposed them. If the portrait didn't produce a smoother than real-life complexion you either underexposed at the negative stage (try again +1 stop) or you printed too dark or at too low contrast – try grade 4 or even 5.

Project 2 Available light
If there wasn't enough detail in the pictures, the film may have been underdeveloped. Test the first six frames if you are processing yourself, or if you are using a lab, ask them to test a clip of six frames first to be sure. If shooting digitally, you can check your exposures on the back of the camera and learn what works as you go.

Project 3 Shooting tonal abstracts
If the results are a bit boring, it was probably that the light wasn't sufficiently interesting to create strong tonal compositions, or perhaps you weren't close enough and didn't isolate the vital components. Print with high contrast, which tends to isolate and separate the blocks of tone in your composition.

Project 4 Sun prints and photograms
With luck you'll have produced some really interesting images, but this low-technology style of photography isn't for everyone. It's worth spending time exploring it, though, as the prints are unique and have a special quality.

Image
enhancement

The digital revolution

While many people using black and white film tinkered about with their images in the darkroom, colour film was altogether more tricky. With image manipulation software, however, a whole new world opened up.

What you can achieve on the computer, from simple retouching to a complete transformation of the image, is exciting – but there are pitfalls. One is that the ease with which you can sort out faults in your photographs can lead to a mindset of 'That'll do, I'll fix it later in Photoshop,' when you are taking them. It's so easy to fall into a lazy way of thinking that before you know it your standards can take a nosedive and you find you are no longer shooting with the discipline and precision that you once were.

A second pitfall is that many people are so entranced by what they can do they lose sight of whether it's a good idea to do it at all. Just because you can make a person or animal sprout wings it doesn't necessarily mean you should! Having said that, the retouching and enhancing tools are wonderful aids to image-making as long as you don't let them take you over.

Using Photoshop

This lesson is not an in-depth teaching class on Photoshop techniques; there are many excellent books on that subject already. What you will find here are some simple ideas and instructions that you can use to improve your pictures in Photoshop, and some special effects to change things for the sheer fun of it.

All the manipulation and retouching here was done on the basic Photoshop Elements package, which is often included with printers and scanners when you buy them. There's nothing in these pages that is at all intimidating, but there are very effective ways of enhancing your pictures in one way or another.

Nearly every magazine you see on the newsagents' shelves demonstrates the potential of Photoshop. Magazine covers are now so retouched that the people on them look almost plastic, like photographic cartoons. Nothing real is allowed; no wrinkles or laughter lines that reveal the character of the subject. In the case of celebrities, perhaps they are indeed frightened to reveal themselves to us.

However, most of the people you photograph will be friends or family, and although it's tempting as a photographer to make everything perfect because you can, where do you stop? There's a danger that we will lose faith in the truth of photographs that we once thought of as the records of our visual history – so use Photoshop with care and good judgement.

Seeing the big picture

For the double-page picture that appears on pp.164–5, I photographed pieces of green, mossy tree bark from above on a white background. I wanted them to look not like bark but a shoal of surreal fish, so I used Photoshop to invert the positive image to a negative. I then filled the spaces between the pieces of bark with a contrasting yellow. GH

These images were all enhanced with Photoshop Elements techniques using Hue/Saturation, Solarize filter, Brightness/Contrast and Film Grain filter. They are from a small calendar, in which I used individual pictures for each month of the year and matched the colours to the seasons they were in. GH

Quick tip

• Photoshop Elements is the most popular of the image manipulation software programs, but there are many others available. They include:

• Corel Paint Shop Pro Photo X2

• Roxio PhotoSuite

• GIMP GNU Image Manipulation Program. This is available as a free download from the website www.gimp.org.

PROJECT 1

Cropping

When you haven't had time to compose a photograph carefully, or have had a change of mind about the composition, cropping is the answer.

The crop tool is very simple to use. Find some images that are crooked, or where you didn't get close enough to the subject or couldn't exclude unwanted items around the edge of the image.

 Select the crop tool, click and drag your cursor across the picture to make the crop you want. If you would like it to be a certain size or ratio, use the palettes bar to choose the size and resolution.

Judy has a collection of art and sculptural figures and I wanted to photograph her with them. I made a simple crop to a panoramic format to exclude the unwanted parts of the picture, such as the plants and ceiling cornice. GH

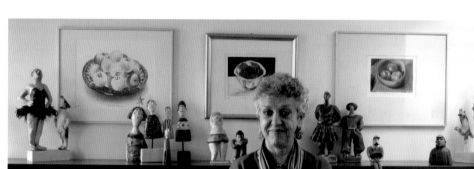

It's interesting looking back on old pictures and reassessing them. Photoshop gave me a second chance at composing this picture, and I decided to try a radical adjustment. I still like the original (left), but I find the second a more intimate portrait of the Maasai girl. JG

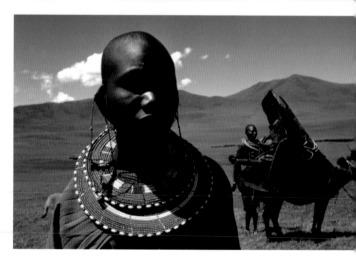

Colour correction

One of the most useful aspects of image manipulation software is that you can correct colour where your filters or white balance didn't do the job.

If you have a scanner, you could make this a project for sorting out colour problems in your old slides or colour negatives. The steps I used to adjust these images and render them more acceptable are typical of the sort of adjustments you will need to make.

This shot was taken in a market in Goa. The bare tungsten bulbs have sent the daylight transparency film very red. I didn't have a colour correction filter with me. Photoshop has taken out the aggressive red (right), keeping the colours warm but natural. JG

1 Scan a 35mm slide or negative.
2 Open the picture in Photoshop.
3 Enhance > Auto Colour Correction.
4 Enhance > Adjust Colour > Hue/Saturation > Saturation -15 to make the colour less bright.
5 Enhance > Adjust Lighting > Brightness +15 / Contrast +25.

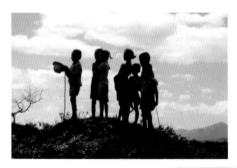 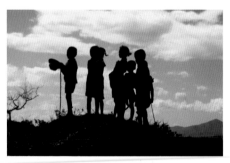

Madagascar, early morning; when I first saw this picture I wished I had used a polarizing filter on the lens to make a deeper blue sky. So I added blue in Photoshop and though it looks a bit melodramatic, I like it. JG

1 Scan a 35mm slide or negative.
2 Open the picture in Photoshop.
3 Enhance > Adjust Colour > Colour Variations. Tick midtones, intensity amount medium.
4 Decrease Red 2 clicks. Increase Blue 2 clicks.
5 Enhance > Adjust Lighting > Brightness –20 / Contrast +17.

Removing unwanted details

You're certain to have pictures where you couldn't help including unwanted passersby, street furniture and so on – have a go at tidying them up, as here.

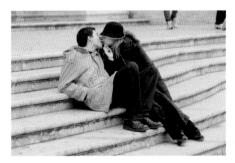

This was a quick reflex shot – the couple looked up and the moment was gone. When I saw the picture, the feet in the background had to go. I retouched them out in Photoshop. JG

The Healing Brush Tool was used to remove the legs and feet in the background, but the Patch Tool and Clone Stamp Tool would have worked equally well.

1 Using the Navigator panel, zoom the image to 100%.
2 Select the Healing Brush Tool in the toolbox.
3 Adjust the brush size in the brush palette. I chose 150 pixels diameter.
4 I set brush hardness to 35% so it is slightly soft around the edges.
5 Healing Brush > Set Mode to Replace, Source to sampled, and tick the Aligned button.
6 Sample an area next to the bit you want to remove then move the brush over a portion of the unwanted area. Click and drag the mouse, so the brush paints the sampled area over the unwanted area. I repeated this a number of times until the legs were gone. Make sure you change the sampled source area so you blend it to look as natural as the background around it – if you use the same piece you will get noticeable repeats.

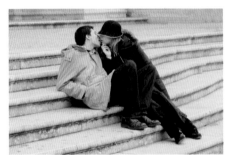

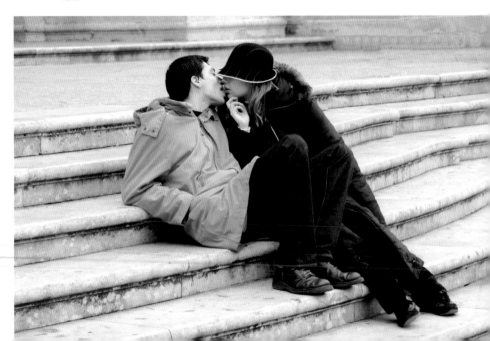

I decided to remove the colour, preferring the image in black and white, then adjusted Brightness +15/Contrast +10 to give it a crisper look.

Toning

On the computer you can tone your images in all the colours that are available to the darkroom printer, and more.

For this project, choose a colour or black and white picture and tone it to a single colour of your choice. Pick one you are pleased with – it's a mistake to think that a bad picture can be rescued by some toning!

This is a traditional Sardinian pastry that is an Easter treat for children. To me, the picture has a sculptural look so I added the blue tone to give it a cool marble feeling. JG

1 Open the picture in Photoshop.
2 Go to Image >Mode and make sure RGB is selected, even if the picture is black and white.
3 Enhance > Adjust Colour > Adjust Hue/Saturation.
4 Make sure Preview button is turned on, and turn Colorize on.
5 Gently slide Hue back and forth to get the colour you want.
6 Adjust Saturation to get the strength of colour you want. I reduced it a bit so it wasn't so bright. Using the Lightness slider isn't a good way of doing this.
7 Select OK. Use Enhance > Adjust Lighting > Levels or Brightness/Contrast to get the picture looking great.

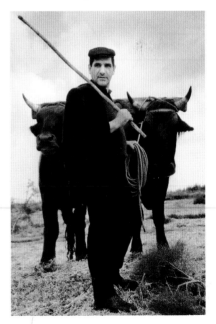

This portrait was taken four years ago but it looks as if it could be 40 years ago. I added the sepia in Photoshop to enhance the old, traditional feel of the picture. JG

PROJECT 5

Hue/Saturation

Here is another creative use for the Hue/Saturation option, this time to bring some strong colour into subdued images.

This method works well on an image that has very limited colour. You can't use it on black and white, however – even though the images shown here are bland there are colours hidden in them.

Find some photographs that are lacking in strong colour and practise using the Hue/Saturation tool to amplify them. The results will depend on the images you use and the effect you want.

I often take pictures of shadows. These usually fall on plain walls or colourless pavements, so I find I have a very monochromatic picture. This is a way of making striking colour images with them. GH

1 Open your picture in Photoshop.
2 Enhance > Adjust Colour > Hue/Saturation. Make sure Preview is turned on, but leave Colorize off. Choose a single colour channel in the Edit box.
3 Push the Saturation slider to the right until you get an effect. If nothing happens, maybe your image doesn't have the colour you have chosen in it. Try the other colours one by one.
4 To colour the seat in the bike shot I used the Paintbucket tool set to black.
5 Add a bit of Brightness/Contrast and it's finished.
6 If you want to change the overall colour, use the Hue slider.

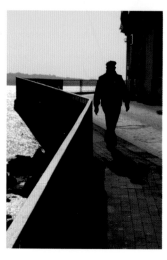

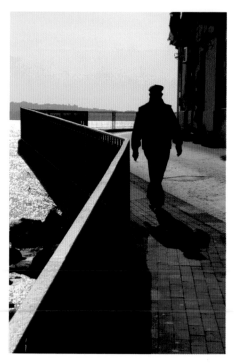

The light conditions produced an almost monochromatic picture. I like the black and white starkness but was interested to see how much colour was recorded by the sensor. I have just amplified the small amounts present. JG

Adding colour

This method of adding colour can also be used on black and white images. If you wish to, you can pick out just one or two elements in a composition.

Shown here is a basic, straightforward way in which to fill in areas of colour. There are more subtle and sophisticated means of doing it, using the selection tool and Layers, but as a starting point try this Paintbucket method.

You can use a colour or a black and white picture; I chose this photograph of barrel lids, as it is simple and has no detail in the areas I wanted to colour. It was shot in black and white and is a favourite of mine. If you are using a black and white (Grayscale) picture, make sure you put it into RGB mode before you start.

The Paintbucket tool will fill any area with the colour you select. If you have edges such as the black lines around the lids in my picture, Paintbucket will fill the space confined by the lines. This picture was perfect as it has large contained areas that seemed to be begging to be filled with vibrant colour.

I shot this photograph at a barrel factory on an overcast day where the sky acted as a giant softbox. I spread a large sheet of black felt on the ground and composed the lids, then used a 28mm lens to get some perspective. GH

1 Open the picture in Photoshop.
2 Image > Mode > RGB.
3 Click on the foreground colour window in the toolbox, and use the eyedropper to select the colour you want.
4 Select Paintbucket in the toolbox. Place the Paintbucket icon over the area you want to fill in and click to fill with colour.

Solarization

This technique was perfected in the darkroom by Man Ray, though its origins lay in many instances where negatives or prints were exposed to light in error.

Solarization is a technique that mixes a negative and positive image together, achieved by exposing a photographic negative or print briefly to light during development of the image.

It has mainly been used in black and white photography, but the photographer Richard Avedon pioneered colour versions of the technique with pictures of the Beatles in the 1960s.

This was an experimental project, playing with ideas for a poster. GH

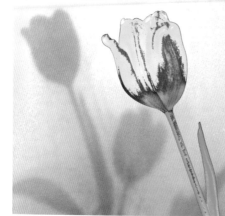

1 Open the picture in Photoshop.
2 Filter > Stylize > Solarize.
3 I used Enhance > Adjust Lighting > Brightness/Contrast to lighten my picture. I didn't like it much as the background was too dark so I decided to invert it to negative.
4 Filter > Adjustments > Invert. This worked better with a lighter background.
5 Enhance > Adjust Colour > Hue/Saturation. I changed the Hue to make the flower yellow.
6 Enhance > Adjust Lighting > Brightness/Contrast to fine-tune the picture.

I decided to have a look at this portrait solarized. It's not a question of which version of the portrait is better – rather it's showing an interesting alternative way of presenting the picture. JG

1 Open the picture in Photoshop.
2 Image > Mode > Grayscale.
2 Filter > Stylize > Solarize.
3 Enhance > Adjust Lighting.
4 Brightness/Contrast to adjust if needed.

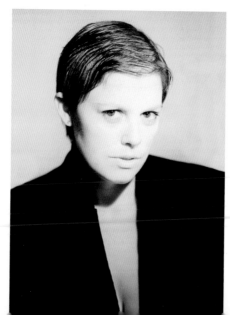

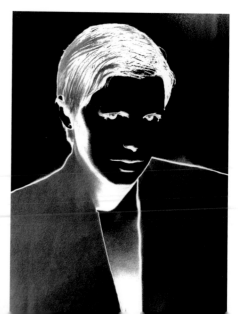

Posterization

This digital technique reduces both colour and black and white images into fewer tones, giving a graphic effect such as you might see on a poster.

Posterization breaks up the large range of continuous tones in a photograph into a much smaller number of steps, thereby simplifying the tonal range throughout the image. As a starting point, look for photographs that contain simple bold shapes with a small range of colours and work up to more complicated compositions as you gain experience with the Posterize dialogue box settings.

The photograph in its original state (left) has an interesting structure but fog has muted the colour and tone. Because it has large flat areas it looked a good candidate for posterization, which has turned it from a photograph into a graphic design. GH

I tried several different pictures to see how posterization would affect them. Most of them didn't work well as they had too much detail. However, I felt the boat picture in Hong Kong was interesting; the smooth sky has broken into steps, giving the image a 1950s retro look. GH

This method is the same for both pictures.
1 Open the picture in Photoshop.
2 Filter > Adjustments > Posterize. I used level 5 in the Posterize dialogue box. The lower the number, the more pronounced the effect. Try from 2 to 9 and see what happens.
3 Enhance > Adjust Colour > Hue/Saturation. I made slight changes to the colour to arrive at the final image.

Quick tip

• Once you have posterized a picture to your satisfaction, use the Type Tool in Photoshop to finish off the image by adding a title and your name in whatever colour and layout you want. It will make a stunning and individual poster for your wall.

REVIEW

I twisted this picture anti-clockwise when I cropped it to make the pumpkins look as if they were trying to keep balanced. I then introduced colour to the black and white photograph using Photoshop as I did for the leaf image below. GH

Here I coloured a black and white picture using Hue/Saturation and selecting the Colorize button, then applied the Solarize filter. I returned to Hue/Saturation to tweak the individual colour channels to my satisfaction. GH

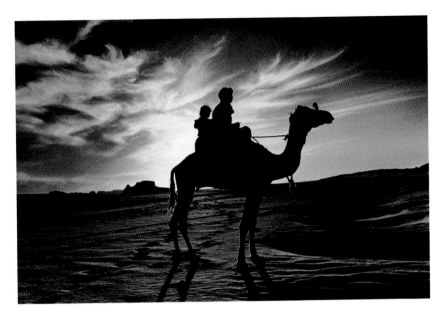

This photograph was shot in black and white at sundown in the Sinai Desert. I decided to experiment in Photoshop for a poster idea. After scanning it from a print I toned it, giving the look of a red desert sunset. JG

Image enhancement review

- **The arrival of digital photography and image manipulation software has made it easy to transform your pictures on the computer.**
- **Photoshop is a vast and complicated software program, but you can achieve effective results using quite simple techniques.**

Project 1 Cropping
Did you enhance your pictures by cropping, or did you just change their shape? Don't be afraid of being very radical – try using a quite small section of the original.

Project 2 Colour correction
This is an exercise to use colour correction to improve the colour balance without changing the spirit of the photograph. Don't overdo it and kill the original picture.

Project 3 Removing unwanted details
This is another subtle exercise – you are improving your picture by just tidying it up. As in the example, getting rid of one little thing can make a big difference.

Project 4 Toning
If you feel you have overdone the toning, try using a slight blush of colour just to alter the mood.

Project 5 Hue/Saturation
There is a danger of this project resulting in some corny pictures – try it on very simple images to avoid this.

Project 6 Adding colour
If the colour bled out of the area you wanted you will have to close the gap it found in the barrier by retouching with the Clone Tool or Paintbrush.

Project 7 Solarization
This is a foolproof technique – whether the end result is over the top or elegant is a matter of taste!

Project 8 Posterization
This project is a good way of using older pictures to get a feel for how an image is constructed. Posterization can revive pictures that you think lack originality.

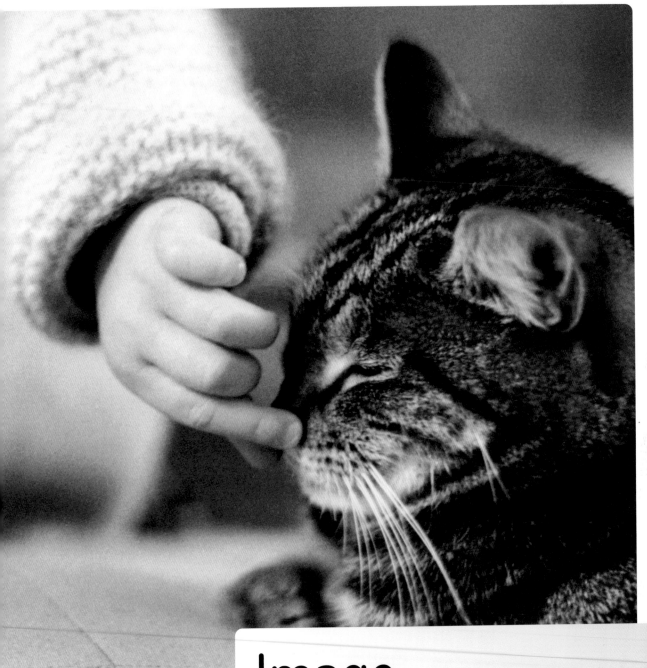

Image
management

Organizing and displaying your images

Finding a use for your pictures can be as much fun as taking them – but to do that you'll need to work out an efficient filing system so that you can keep track of just what you've got.

Filing

It's often the case that a great deal more enthusiasm goes into the taking of pictures than the management of them later. Film photographers can easily accumulate boxes of negatives and transparencies very quickly, and the filing task becomes so formidable that it never gets done. The answer is to get your filing system worked out so that you can just add in any new set of negatives straight away. Whether you decide to file by subject matter or date, use an index book to cross-reference them and make a note of which negatives have been printed for future reference.

Digital images can get into just as bad a state of chaos as film negatives and slides. Image management software should be supplied with your camera, but there are a number of more sophisticated programs available, such as Thumbs Plus, Adobe Lightroom, Corel Snapfire, Google's Picasa and so on. It's a matter of deciding which suits you and your pocket best.

A good way of managing your digital pictures is to cross-reference them by keywording or tagging them. Most of the software systems have a way of doing this. The time you take on this will be saved later when you are searching for your pictures.

It makes sense to back-up your pictures in case your computer crashes. This could be on a separate hard drive or on CDs or DVDs.

Scanning

If you want to translate film into digital images you will need to do this by using a scanner. As with most technology, you get

Getting down to the business of filing, in this case using Photoshop Elements.

Preparing transparencies and negatives in sleeves on the lightbox ready for filing.

what you pay for. If you're only intending to put your pictures on the internet the quality of scanning isn't critical, but if you aspire to high-quality A3 or A2 prints, for instance, you'll need a good scanner.

The best results come from dedicated film scanners, though there are now flatbed scanners that can scan prints and film and make nearly as good a job of the latter as a dedicated scanner. However, if you need high-resolution scans for important prints, taking your negatives to a professional laboratory for drum-scanning is the solution.

Many people now scan their old family portraits and restore them in Photoshop with very good results. If you don't have a scanner you can simply photograph them with a digital camera, using a very even light source.

Printing

Before the arrival of digital photography, nearly all photographs taken outside the professional arena were returned from laboratories processed and printed. In the digital era, the majority of pictures that are shot are never printed; they are viewed only on computer screens.

Emailing photographs back and forth and putting them up on the web is a wonderfully spontaneous way of sharing them with friends and family. Nevertheless, there is still something very satisfying about holding a beautiful photographic print in your hand or seeing it on your wall.

You can either make your own prints after working on them in Photoshop as discussed on pp.168–75 or have them printed at your local pro lab or mini lab. Another popular alternative is to order them online from one of the many companies offering this service.

As a starting point towards accurately reproducing the image you see on your screen as a print, buy a good-quality photo printer from a manufacturer such as Epson, Canon or HP. Use their recommended ink sets and their own printing papers, which have been matched to the machine and inks.

If you decide to take printing very seriously, however, you may want to use some of the papers produced by other manufacturers such as Hahnemühle. To

An A3 printer is more expensive than an A4 one but offers you greater choice as to print sizes.

A dedicated film scanner will scan both negatives and transparencies in black and white and colour.

fine-tune colour and tone and achieve consistency you'll need to calibrate your monitor screen by means of software such as the Gretag MacBeth Eye-One systems and have an individual profile made for your printer and the paper you are using. Some of the paper manufacturers offer the latter service when you buy their products.

Online galleries

Via the web, there are many ways to show your pictures to the world. Online photo-sharing sites such as www.flickr.com and picasa.google.com have millions of people around the globe looking at each other's pictures and commenting on them. These sites give you a great incentive to take new pictures and keep in touch with other people who share your hobby.

Books and albums

There are more ways than ever to store and present your pictures in print form, and many are surprisingly inexpensive. The photo album that has been the traditional way to collect your prints together is still going strong, but digital technology has introduced the photobook, which has become very popular. There are many companies on the internet that offer this service, including www.blurb.com. You upload your images and, using the layouts provided, design your own photobook, adding text too if you wish. The book is then produced and mailed back to you. Some of these books are of extremely professional standard and it's a very exciting way to have your pictures presented.

Personal projects

You may also enjoy a more handcrafted way of using your pictures. Themed handmade books and greetings cards, for example, make very personal gifts for friends and family. An easy way of making the latter is to buy inkjet paper in greeting card form, scored ready for folding. Making your own books is very satisfying and not necessarily difficult; you'll find plenty of websites, books and workshops to set you on the right path.

Traditional photograph albums now come in a wide range of styles from classic to contemporary, and the arrival of the digital photobook offers another option.

A painstakingly printed photograph deserves a place on the wall. Ready-made frames are cheap to buy, but a visit to a framer will give you choices as to how you mount the print too.

Every Valentine's Day I make a card for my wife bearing a photograph with a heart-shaped theme, so I am always on the lookout for leaves or any other heart-shaped objects that might work for next year's card. Shown here are four from the series. GH

I made this box of jewellery pictures by hand for the jeweller Barbara Christie. Little boxes of themed prints make great personal presents. GH

Personalized photo gifts

• Via photo service websites such as www.photobox.com you can have your photographs printed onto nearly anything these days, including T-shirts, mugs, coasters, calendars and mouse mats.

Conclusion

After reading all the information in this book and carrying out the projects, where do you go next? No matter how good your grasp of technique and composition is, if you can't think what to use it for it's not of much use at all.

Rather than anything technical, the question we are most often asked is 'What shall I take pictures of?' The answer is: what are you are interested in, what do you feel passionate about, what really angers you? It's very difficult to keep up momentum and enthusiasm if you are using a scattergun approach, just taking pictures of everything with no particular aim in view.

Finding a theme

Like many photographers, we both work on themes. You may realize that you have already begun doing this without having made a conscious decision about it. For example, by picking up leaves and shooting them, you may soon become fascinated by their variety and beauty and before you know it you will have accumulated a body of work on the subject. One of the most famous photographic themes is Elliot Erwitt's hilarious dog series, which he has been working on for some 50 years.

If you develop a theme it will give you a discipline and focus that will help you to progress as a photographer as you explore it further. You'll also need to exercise your creativity to keep finding fresh ways of tackling the same subject. There's no doubt that the more you test your abilities, the better your photography will become.

This is just a sample of the growing collection of hand pictures that I have been making over a number of years. JG

Over the last 14 years I have been working on a large series of leaf pictures in both colour and monochrome. GH

Themes to consider

- Portraits of family and work colleagues.
- Architectural details.
- Animals.
- Transport.
- Interiors.
- Flowers.
- Water.
- Shadows, silhouettes and reflections.
- Abstracts.
- Household still life.

Further reading

Books

The list below contains useful practical books and some examples of the photographers we like. Not all of the latter are still in print, but the internet has made tracking down secondhand books very easy and you may also find them in your library.

Adams, Ansel, *Examples: The Making of 40 Photographs*. Little, Brown (New York, 1983)

Avedon, Richard, *Evidence: 1944–1994*. Random House (New York, 1994)

Bavister, Steve, et al., *Collins Complete Photography Manual*. Collins (London, 2007)

Cartier-Bresson, Henri, *Aperture Masters of Photography*. Aperture (New York, 1997)

Erwitt, Elliott, *Son of Bitch*. Thames & Hudson (London 1975)

Evans, John, *Adventures with Pinhole and Homemade Cameras*. Rotovision (Hove, UK, 2003)

Freeman, John, *Collins Digital SLR Handbook*. Collins (London, 2007)

Michel Frizot (ed), *A New History of Photography*. Konemann UK (London, 1998)

Garrett, John *Mastering Black and White Photography*. Mitchell Beazley (London 2003)

The Art of Black and White Photography. Mitchell Beazley (London 1990)

John Garrett's Black and White Photography Masterclass. Collins & Brown (London, 2000)

Gibson, Ralph, *Refractions*. Steidl (Göttingen, Germany, 2006)

Glenwright, Jerry, *Digital Photography Step-by-Step*. Collins (London, 2008)

Haas, Ernst *The Creation*. Studio (London, 1971)

Ibbotson, Janet, & Thomas, Gwen, *Beyond the Lens: Rights, Ethics and Business Practice in Professional Photography*. The Association of Photographers (London, 2003)

Jeffrey, Ian, *The Photography Book*. Phaidon (London, 1997)

Leibovitz, Annie *A Photographer's Life, 1990–2005*. Jonathan Cape (London, 2006)

Penn, Irving *Still Life: Photographs 1938–2000*. Thames & Hudson (London, 2001)

Rock, Sheila, *Sera, The Way of the Tibetan Monk*. Columbia University Press (New York, 2003)

Traeger, Tessa, *The Gardener's Labyrinth*. Booth-Clibborn Editions (London, 2003)

Waite, Charlie *The Making of Landscape Photographs*. Collins & Brown (London, 1993)

Magazines

There is a huge range of photography magazines available. Most have an online magazine as well, offering a wealth of information.

Amateur Photographer
www.amateurphotographer.co.uk
The world's number one weekly photography magazine, started in 1884.

Aperture Magazine
www.aperture.org
The premier art photography magazine, over 50 years old.

Black and White Photography
A monthly magazine covering traditional and digital black and white photography.

The British Journal of Photography
www.bjphoto.co.uk
A weekly magazine for professional and amateur photographers.

Digital Camera Magazine
www.dcmag.co.uk
Focuses on new developments in the camera market, with technique articles and reviews.

Image Magazine
www.the-aop.org
The Association of Photographers' monthly magazine.

Photography Monthly
www.photographymonthly.com
Reviews, competitions, where to shoot, etc.

Popular Photography
www.popphoto.com
News, podcasts, fine art photography and photojournalism.

Websites

www.ephotozine.com
Book reviews, techniques, forums, galleries and shooting locations.

www.shutterbug.net
Tools, techniques and creativity.

www.photoanswers.co.uk
Digital camera advice, video tutorials, photo galleries and reviews.

www.dpreview.com
In-depth reviews of digital equipment.

www.luminous-landscape.com
Photography information and reviews.

Glossary

Aperture
The adjustable opening in the lens which allows light to enter the camera to expose the film or sensor. Aperture size is measured in f-stops.

Aperture priority
A semi-automatic camera mode. The photographer selects the aperture and the camera chooses the shutter speed for correct exposure.

Archive
Copies of images on a hard drive, CD or DVD to ensure safe storage for future use.

Auto focus
The camera focuses the lens automatically on a chosen area in the frame.

Available light
The existing light, most often used to describe low indoor light.

B (bulb)
The next setting after the longest shutter speed on the camera. The shutter remains open for as long as the shutter button is pressed.

Back-light
Light that comes from directly behind the subject.

Bracket
A series of exposures taken over and under the normal meter setting. Most modern cameras have an auto bracket setting; alternatively, it can be done using exposure compensation.

Bounce flash
Where the flashgun head is tilted so that the light bounces off a reflective surface before hitting the subject.

Cable release
A cable that connects to the shutter button, used for long shutter speeds to reduce camera vibration. Modern cameras need a remote control unit.

Calibration
Matching the scanner, printer and monitor to make a print that is the same as the image on the screen.

CD and DVD
Recordable discs to archive images.

Centre-weighted metering
Through-the-lens (TTL) metering that is concentrated on the centre of the frame.

Clip test
Processing a small length of a film clipped from the roll as a test.

Close-up filter
A single-element lens placed in front of the camera lens to enable it to focus closer.

Colour correction filter
A filter used to either warm or cool the colour of the light.

Colour temperature
The measurement, in degrees Kelvin, of the colour of a light source, for example daylight is 5500 degrees Kelvin.

Compact camera
Small automatic point and shoot camera, 35mm or digital.

Continuous auto focus
On the C setting of the auto focus mode the lens focus will follow a moving subject.

Diaphragm
A mechanical device in the lens that changes the aperture.

Dedicated flash
Flashguns designed to work with the through-the-lens (TTL) metering system of the camera.

Default
The basic settings applied to equipment by the manufacturer, until changed by the user.

Depth of field
The distance in front and behind a picture's point of focus that is kept sharp.

Development
The process of converting the latent image on an exposed film into a visible image by using developing and fixing chemicals.

Diffuser
A translucent material placed between the light and subject to soften the light source.

Diffusing filter
A filter placed over the lens to soften the sharpness of the image. This may be from a manufacturer's range or home-made, such as a stocking, Vaseline or breath on the lens.

Download
Moving information from one digital source to another, for example from memory card to computer.

Exposure
The light entering the camera that produces a photographic image on the film or sensor.

Exposure compensation
A method of overriding the automatic camera exposure in steps of plus or minus ⅓ and ½ stops, up to approximately 3 stops.

Exposure meter
An instrument used to measure the amount of light on the subject in order to calculate a correct exposure. Most can measure incident light (light falling on the subject) and reflected light (light reflected off the subject). Most handheld meters also take flash readings. All SLR and compact cameras now have a built-in reflected light exposure meter.

Extension tube
A tube that fits between the camera and lens to enable the lens to focus closer.

f-number
The measurement of the aperture of a lens.

File format
Digital information is stored in files; the most common formats used in cameras are JPEG, TIFF and RAW.

Filter
A piece of glass, plastic, or any other material used to alter the appearance of the subject being photographed. It is placed in front of the lens or light source. Filtering can also be applied by image manipulation software on the computer.

Flashgun
A separate flash unit, more powerful and versatile than the built-in flash.

Focal point
The critical area of a picture that will attract and then hold the viewer's attention.

Frame
The area that is seen through the camera's viewfinder.

Gel
A filter material placed in front of a light source to alter its colour and contrast.

Grain
The photographic emulsion of a film is made up of silver halide crystals. When the film is developed the crystals become grain, making up the image. The faster the film, the larger the crystals are.

Grayscale
A digital colour image converted into 256 shades of grey, making a black and white image.

High key
A term used to describe a light,

almost shadowless image with very little highlight detail, often looking like a line drawing. It is mainly used in black and white photographs.

Histogram
The exposure represented as a graph that shows shadow, middle tone and highlight values.

Hot shoe
The bracket located on top of a camera that holds a flashgun and synchronizes it to the camera's through-the-lens (TTL) metering system.

ISO (International Standards Organization)
The unit for measuring the sensitivity of a film emulsion and image sensor to light.

JPEG (Joint Photographic Experts Group)
A file format capable of being compressed to one hundreth of the original file size.

Kelvin
Degrees Kelvin is the unit of measurement for the colour temperature of light.

Lens hood
A shield fitted to the lens to stop unwanted light from scattering on the lens.

Low key
An lighting effect produced with predominantly dark tones.

Macro lens
A lens capable of doing high-quality close-up photography.

Matrix metering
Called matrix mode (Nikon) or evaluative metering (Canon), this averages the exposure over the whole viewfinder frame.

Memory card
A card used to store the images in the camera.

Micro lens
See Macro lens.

Noise
In digital photography, a break-up of the image similar to film grain, caused by high ISO speeds and long exposures.

Opening up
A term used to mean increasing the size of the aperture, letting more light in.

Overexposure
Allowing too much light to expose the film or sensor.

Panning
Following a moving subject with the camera, generally used in action photography.

Pinhole camera
A light-tight box with a pinhole instead of a lens, through which light enters and exposes a piece of photographic film or paper placed directly opposite.

Pixel
The pixel (a term standing for picture element) is the smallest single element that makes up a digital image, comparable to a grain in a film emulsion.

Polarizing filter
A filter that eliminates reflections, adds saturation to colours and darkens the sky.

Prime lens
A fixed focal-length lens.

RAW
A file format that holds the complete information produced by the sensor without the camera processing it, equivalent to a negative in film photography.

Reflector
Any material of any size that will reflect light.

Selective focus
Where the focus is on one plane and the rest is thrown out of focus by using a large aperture.

Sensor
The light-sensitive chip in a digital camera on which the image is recorded.

Shutter
The mechanism in the camera used to control the length of time that the light acts on the sensor or film.

Shutter priority
A semi-automatic camera mode where the photographer selects the shutter speed and the camera automatically chooses the aperture.

SLR (Single Lens Reflex)
A camera design that uses a mirror and prism to enable the photographer to see in the viewfinder the identical image that will be recorded by the camera.

Spot metering
An exposure meter reading taken off a small area of the picture.

Stopping down
A term used to mean decreasing the size of the aperture, letting less light in.

TIFF (Tagged Image File Format)
An uncompressed file format system, available on some digital cameras.

Telephoto lens
A long focal length lens, also known as a long or tele lens.

Underexposure
Not allowing enough light to reach the film or sensor, resulting in a picture that is too dark.

White balance
A system used in digital cameras to control the colour casts in different light sources.

Wide-angle lens
A short focal length lens, also called a wide lens.

Viewfinder
The part of a camera where you view the subject you are shooting.

Zoom lens
A lens with a variable focal length.

Index

Biographies

John Garrett

John was born in Australia and spent his early years as a photographer working in Melbourne, where initially it was necessary to be an all-rounder to make a living. By the time he moved to London in the 1960s he had already begun to specialize in fashion photography, and in the Swinging Sixties both fashion and advertising offered plenty of opportunities for a young photographer.

However, photojournalism had always been John's first love. Influenced by the great photo stories of *Life* magazine and *Paris Match*, he changed direction and became contracted to *Paris Match* during the 1970s, shooting everything from wars to ballet. He began contributing regularly to newspapers and magazines such as the *Sunday Times*, the *Observer*, *Stern* and *Time* and wrote a number of books on photography, including *The 35mm Photographer's Handbook*, co-written with Julian Calder, which sold 2,000,000 copies.

John's other activities include directing 30 television commercials and chairing the judges for a worldwide photography competition sponsored by Ballantine's Whisky, in which capacity he gave workshops and lectures around the globe. His website can be seen at www.john-garrett.com.

Graeme Harris

Born in Australia, Graeme gained his early photography experience at Helmut Newton's studio in Melbourne, where his friendship with John Garrett began. He moved to London in 1971 and began work as a people and still-life photographer, mainly for the advertising and publishing industries, before going on to specialize in corporate annual report work.

Graeme has held a number of workshops for degree and A-level students, teaching camera skills and printing. He is also a tutor at two London colleges and a private photography school, where his students range from beginners to those doing advanced foundation and diploma courses. His courses include Creative Photography, Black and White Darkroom Printing, Digital Imagery and Learning to Use Your Camera, and it was teaching the latter that gave rise to the idea of writing this book.

As well as his commercial assignments and teaching, Graeme pursues personal work which includes his children, landscapes, found objects and a series of natural subjects, particularly leaves, flowers and shells. The latter have been used extensively on posters and cards, available in Ikea and other retail outlets. His website is www.graemeharris.com.

Acknowledgements

We would like to thank the many people who have been very supportive to us while we have been writing and shooting this book. They are:

Michelle Garrett and Margaret Harris for help and sound advice; Nick and Matt Garrett, Katherine Spencer and Jon Harris for allowing us to use pictures of them taken in the near and distant past.

Thanks also to Christine Richard, Andrea Alfonso, Yamila Navarro, Antonio D'Ario, Diego Alfonso Celis, Cecile Deneuville, Ines Parada Vilafani, Claire-Marie Ponthieu, Andrew and Ian Spencer, Chris and Ellie Knowles; to Vincent Forrester at Jessops for his kindness, letting us shoot pieces of equipment and giving advice on high street trends; to Howard Woodruff at Flash Photodigital for his technical advice and help; and to Norman Craig (Normko) for his support and internet advice and Judy Craig for her magnificent fruit cake that sustained us for some time.

Special thanks to our commissioning editor, Julia Thynne, for her enthusiasm and panic-free communications; to Denise Bates and Cathy Gosling, who kept faith with the project and got it under way; to Emma Jern for putting up with two very fussy authors and coming up with such good design solutions; to Diana Vowles for sensitive editing of our material; and to Kathryn Gammon for putting the book together with style.